← **Artist:** PichiAvo for Upfest, 2016
Photo: Colin Rayner **Location:** Masonic
Pub, 112 North Street, Bristol, UK

Contents

3

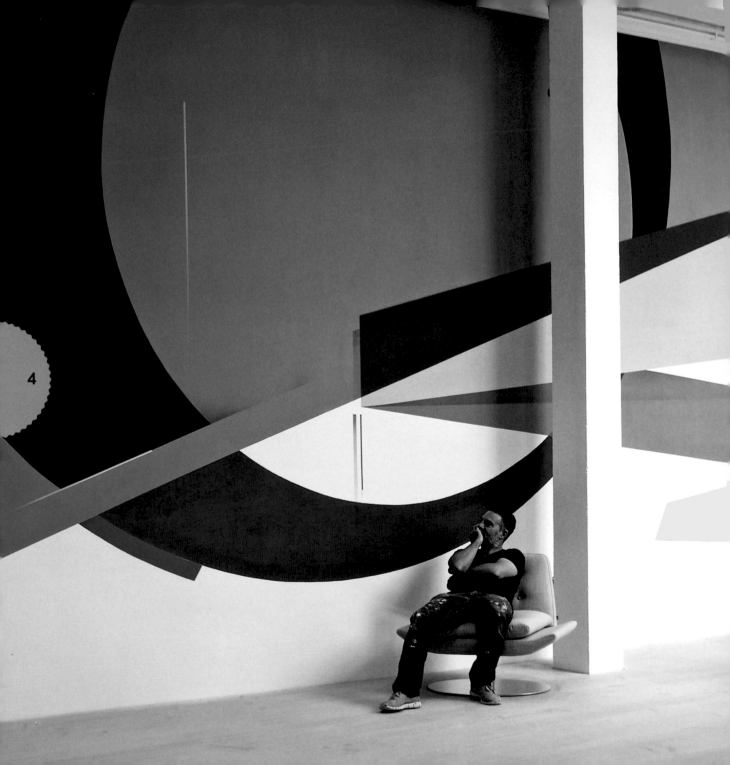

'It's not the word "graffiti" that bothers me, it just doesn't accurately explain the entire story.' — Futura 2000

Foreword

by Remi Rough

I started painting walls in 1984. I was sucked into hip-hop culture when it was at its most prominent in Europe, and graffiti played a huge part in the attraction. It began with a boy at school bringing in a book called *Subway Art*, which had a much greater impact on me than anything I was learning in class.

The scene blossomed in London at the perfect time – Thatcherite Britain was a mess. London was a rough city to grow up in during the early 1980s, but graffiti gave us a voice in much the same way it did for the kids in the bankrupt and broken New York of the late 1970s. Few people recognise that graffiti is the only art movement in history to be conceived and taken forward essentially by kids. I am very proud to be considered part of that legacy.

The first really big wall I painted was in West London in 1999 – a commission piece for a computer games company. It was only three storeys high, but it felt ginormous, and it remained in place for years after. It was quite a feat for me at the time, and it ignited a passion for painting bigger walls that still excites me today.

My focus began to shift from traditional graffiti about 11 years ago when I started exploring abstraction in art, and thinking about how I could take my work in a more contemporary direction. At the same time the landscape was also changing dramatically – street art was becoming ever more popular and specialist galleries started popping up all around the world, bringing it indoors and into people's homes. The market for screen prints exploded and artists previously known only for their street work were suddenly having sold-out exhibitions, with hundreds of people cramming into each opening. I think most people knew that they were witnessing the birth of an exciting new scene.

That feeling was rubber-stamped when the Tate Modern organised a major exhibition dedicated to street art in 2008 – things escalated considerably after that. Artists began forming collectives and curating their own grandiose projects, and an increasing number of dedicated street art festivals were attracting artists and fans to interesting locations around the world. I was once even flown out to the Gambian jungle to paint mud huts for the Wide Open Walls project.

Fast-forward to today and it's hard to find a city that doesn't have some kind of organised mural programme. Purists might argue that street art has all gone a bit 'mainstream', but it has become an intrinsic part of the cultural fabric of our cities. Street art has added something very special to our urban landscapes, and books such as this one only help to cement the impact of the movement.

As long as the artists and organisers continue to respect their environments – and most importantly the communities within them – the future of street art can only get brighter.

Remi Rough, 2016
www.remirough.com

Introduction
by Ed Bartlett

I n preparation for writing this introduction, I added up the number of people living in the cities featured in this book. The total came to over 150 million. That's more than twice the combined annual visitors to the top 10 most visited museums in the world, all potentially being exposed to different forms of street art on a daily basis.

Surprised? This is just the tip of the iceberg. Street art is now present in almost every city, town and village in the world, from Aachen to Zwolle. Its true audience is measured in the billions. And given that the first record of homo sapiens painting on walls is thought to date back around 40,000 years, it's actually more surprising that street art has taken so long to flourish.

After the well-documented graffiti boom of the 1980s, the advent of stencil art – as well as the widespread proliferation of digital cameras, smartphones and social media – led to a new wave of artists consciously eschewing galleries in favour of the streets. As the 20th century drew to a close, street art was everywhere, and everyone was talking about it.

It's impossible to discuss the rise of street art without mentioning Banksy. His work – public, relevant and relatable, with a subversive edge – combined with the enduring mystery of his identity, captured the imagination of the mainstream press in a way that the traditional art world rarely does. A growing army of highly engaged fans would travel to see each new piece in person as soon as it appeared, and trade in his prints and paintings became frenzied. This, in turn, encouraged other street artists to produce limited editions of their work, and even tempted some 'traditional' artists and designers to engage with the streets. A raft of specialist galleries began to appear, and a whole new generation of counterculture art collectors was born. Banksy's success – and the growing ecosystem around him – elevated street art to an entirely new level.

Of course, one man does not make a movement. The street art scene of today is flourishing thanks to a global cast of creative and highly motivated individuals, many of whom are self-taught. This collaborative DIY attitude is what makes street art's growth – and its growing cultural importance – all the more impressive and exciting.

Today, the proliferation of legal walls and organised festivals around the world makes it possible to encounter thought-provoking, transformative art in the most unexpected of places. People are travelling to the four corners of the globe specifically to experience

street art, which can often mean meeting and watching the artists at work – a rare privilege among the contemporary visual arts.

It has been argued that street art is losing some of the grit and edge that characterised its formative years – there are some, no doubt, who would point a cynical finger at the very existence of this book as evidence. And yes, perhaps more investigation needs to be done into the increasingly visible role that street art seems to play in gentrification. But we should also be careful not to be overly critical of what is, after all, a comparatively young, developing art form. The majority of street artists pride themselves on taking an uncompromisingly conscientious and independent stance with their work, and there remains a strong underground scene.

With so much to see, it's unrealistic to expect to fully document such a ubiquitous yet transient art form. This book is intended as a starting point to your journey, highlighting a selection of some of the key cities around the world to experience street art today, and providing guides to each city's street-art hotspots to enable you to explore further. We've also included insights from some of its most important figures.

Instagram, Flickr and Google Maps are incredibly powerful supplemental tools to help you to discover and locate works, and many street artists are now active on social media. By uploading and tagging the things you find along the way, you too can play a valuable role in the community. But the real power of street art comes from how it can pop into your day unexpectedly, adding some colour, a smile or even a provocation – so keep your head up and don't be afraid to explore!

As a teenager in the 1980s I grew up obsessed with hip-hop and the New York graffiti scene. I was fortunate to move to London in time to experience the initial street art explosion first-hand – as bystander, photographer, collector and curator. Twenty years on, I am still exploring, and still surprised and amazed by what I find. Researching and compiling this book has opened my eyes to a number of exciting destinations and artists, and I hope it inspires you in some way too.

My eternal gratitude goes to those who have so graciously helped me with this project – it would have been much more difficult without the knowledge, passion and dedication of all who participated – not least the artists, without whom the world would be a less colourful, interesting and inspiring place. In particular I wanted to thank Lucy Langdon for her copyediting skills (and being a general daily inspiration), Hector Campbell for his tireless help with research and image sourcing, and Remi Rough, for whom the word 'no' apparently doesn't exist. And, of course, to you, for whom the art – and this book – has been created. I'd love to hear your feedback and personal recommendations.

Ed Bartlett @edbartlett
The Future Tense
www.thefuturetense.net

7

Amsterdam

Holland

Amsterdam is world-renowned for its art, with Dutch masters such as Van Gogh, Vermeer and Rembrandt all on show at the city's awe-inspiring Rijksmuseum.

For the younger generation, however, the most exciting examples of contemporary art can be found on the streets and canals of the city. Traditional graffiti has always had a strong following in the Netherlands, and Amsterdam is the centre of it all. There are major street art galleries in Flevopark and NDSM, as well as around the red light district. Just be careful where you point your camera!

Off the streets, galleries such as Kallenbach and Vroom & Varossieau specialise in contemporary urban art and frequently host exhibitions of local and international artists. The latter has been working closely with the Keith Haring Foundation to restore one of his largest murals in the city. Meanwhile, the Stedelijk Museum is also restoring the late artist's vellum in its staircase, scheduled for re-installation during the summer of 2017.

Amsterdam will also soon play host to the world's biggest urban art museum. In 2017, the northern banks of the city are set to be transformed into an outdoor museum, with 25m-high walls and some 6500 sq m of exhibition space. Expect to see giant canvases and installations from a global 'who's who' of contemporary street art.

8

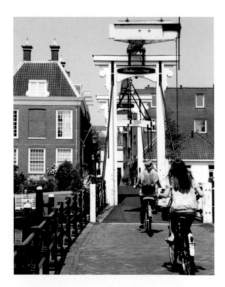

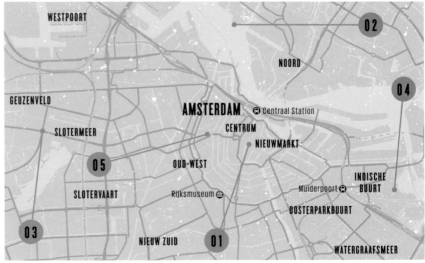

01 Red Light District

The infamous quarter astonishes not only with its windows of barely clad women, but also with its subversive art. Look for red-lit drawings of rodent pin-up girls – part of the Red Mice District project – on walls throughout the neighbourhood, along with trippy erotic murals. The district is close to the heart of the city, near Central Station.

02 NDSM Wharf

NDSM is a derelict shipyard-turned-arts-community 15 minutes upriver. The area gives off a distinctly post-apocalyptic vibe: abandoned trams rust on the streets, and graffiti scrawls across every available surface. It's a great place to walk and gawk. Eduardo Kobra's kaleidoscopic, warehouse-side portrait of Anne Frank is the star of the show. Take the NDSM ferry from behind Central Station.

03 Nieuw-West

This suburban quarter west of downtown houses the open-air Street Art Museum, home to more than 50 murals by international artists. The most spectacular images riff on Vermeer and Rembrandt, but anything goes on the brick apartment blocks. The museum's guided tours (www. streetartmuseumamsterdam.com) are a great way to cover the vast district.

04 Flevopark

Flevopark is home to Amsterdam's original Graffiti Hall of Fame, where it's perfectly legal to unleash your spray cans. The action happens on the pillars under Zuiderzeeweg, a raised street by the leafy park. You'll almost always see artists at work. It's east of downtown; take tram 14 to the end of the line.

05 The Jordaan

Just west of the centre, the Jordaan teems with cosy pubs, offbeat galleries and funky markets squashed into a grid of tiny laneways. Street art abounds in this bohemian atmosphere, like the smiley-faced wall by The London Police at Prinsengracht 70. Hop on the tram to Westermarkt and wander along the canals to find the best hidden art.

Additional locations

- **Artist:** Stinkfish **Location:** Doctor H Colijnstraat 61, Amsterdam
- **Artist:** Victor Ash **Location:** De Boelelaan 589, Amsterdam
- **Artist:** Btoy/Kenor/Uriginal **Location:** Dirk Sonoystraat, Amsterdam
- **Artist:** Various **Location:** NDSM Wall of Fame, NDSM-werf, Tt Neveritaweg, Amsterdam
- **Artist:** Various **Location:** Flevopark Wall of Fame, Insulindeweg 1000, Amsterdam
- **Artist:** Various **Location:** Amsterdam Street Art Museum, Slotermeer/Geuzenveld, Amsterdam Nieuw-West, Amsterdam
- **Artist:** Parra **Location:** Tuinstraat 172, Amsterdam

9

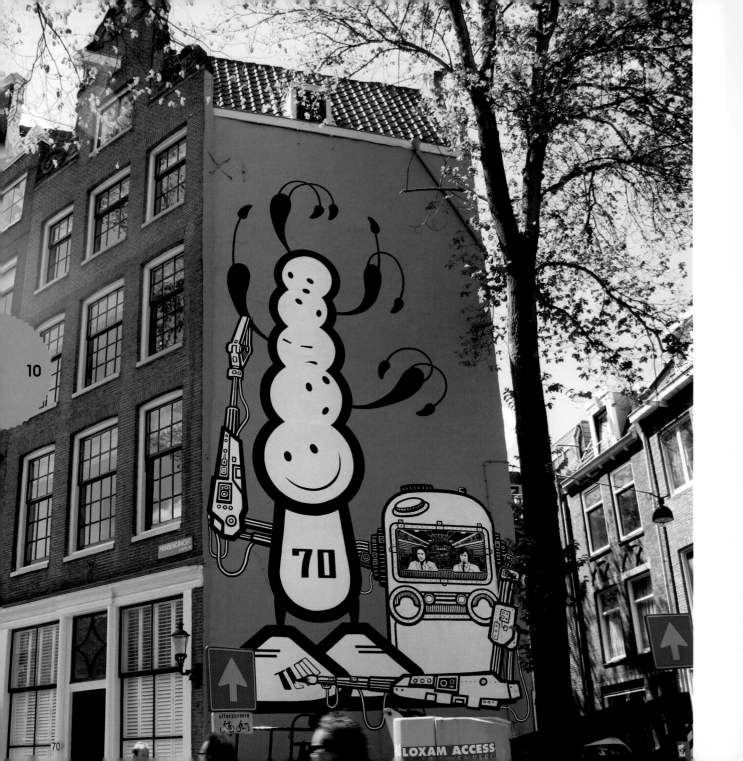

← **Artist:** The London Police
Photo: Chinny Bond **Location:**
Prinsengracht 70, Amsterdam

→ **Artist:** Skount **Photo:** Skount **Location:**
Johan Brouwerpad 28, Slotermeer-
Noordoost, Amsterdam

↓ **Artist:** Invader (AMS_04) **Photo:** Invader
Location: Bloemgracht 4, Amsterdam

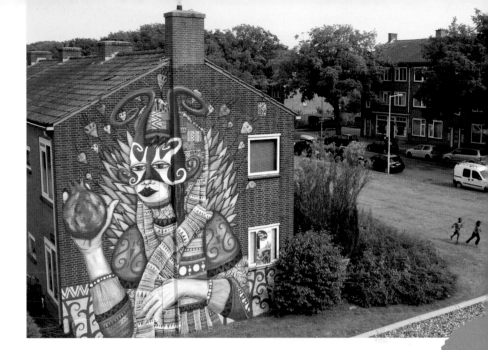

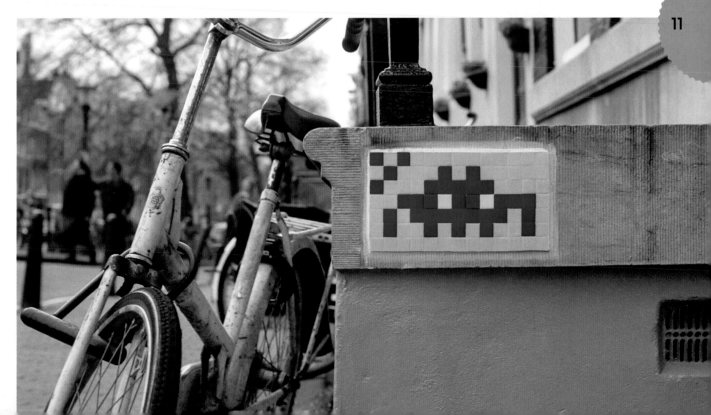

Artist: D*Face Photo: Peter Baas courtesy of Vroom & Varossieau Location: The Student Hotel Amsterdam West, Jan van Galenstraat, Amsterdam

12

Athens
Greece

Athens has an unexpectedly vibrant street art scene – perhaps less surprising when you consider that the word 'graffiti' is derived from the Greek '*graphi*', meaning 'to write'. Tagging in Athens is as old as the city itself, with ancient words and phrases found scratched into the very streets. Today, you can't go far in Athens without encountering street art. Parts of the city are so covered with tags that even the *pichadores* of São Paulo would be impressed. Look beyond the crude tagging, however, and you'll find a trove of unexpected street art interventions and large-scale murals by renowned local artists such as Alexandros Vasmoulakis and INO, and a cast of visiting names. The ongoing Greek financial crisis and the recent influx of refugees have also motivated politically conscious artists to produce insightful, powerful works.

Thanks to its history, architecture, climate and culture, exploring the streets of Athens is generally a joy. A good starting point is Psirri, with street after street of painted doorways and shutters making it feel more like traversing an open-air gallery. The area immediately surrounding the Technopolis – housed in a former gasworks – also features some interesting larger murals from the likes of OSGEMEOS.

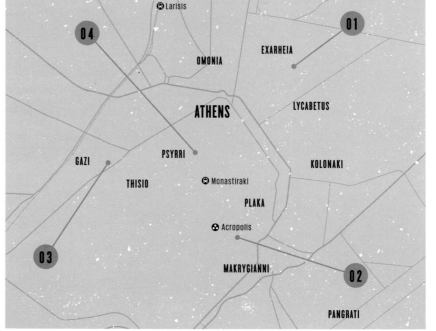

 Exarheia
Bohemian Exarheia has an alternative culture and history that sets it apart from Athens' other districts. A hotbed of students and anarchists, Exarheia's homegrown graffiti is a bold treat, mixing excellent painterly technique with sharp messaging. Wander north and east from the Panepistimiou metro station to take it in.

 Plaka
In the heart of historic Plaka, with its neoclassical mansions and homes dating from the Turkish occupation, longtime ex-pat Irish Tom has co-opted the corner of Iperidou and Sotiros streets for his vibrant wraparound billboards. His visual take on current events is a cheeky blend of political satire and naïve art.

03 Gazi
The broad boulevard of Pireos Street skirts the edge of the renovated gasworks known as Gazi, whose vast exterior walls have been turned over to the creation of sweeping murals. As cars zip by, stylised figures and sci-fi scenes unspool along the broad whitewashed brick walls. Head here from the Keramikos metro stop.

04 Psyrri
Exploring the higgledy-piggledy warren of interlocking streets of Psyrri, you'll discover unexpected graffiti and murals around almost every corner. Easily accessed from either the Monastiraki or Thisio metro stops to its south, Psyrri invites a strolling visual adventure along its crumbling walls.

15

Additional locations

- **Artist:** Borondo **Location:** Acharnon 440, Athens
- **Artist:** Kashink **Location:** Sofokleous 41, Nikea, Athens
- **Artist:** Various **Location:** Park area behind Hotel Ermou, Ermou 152, Athens
- **Artist:** Various **Location:** DADA Club, Sarri 6, Athens
- **Artist:** Wild Drawing **Location:** Arachovis 44, Athens
- **Artist:** OSGEMEOS/Nunca **Location:** Pireos 99, Athens
- **Artist:** Various **Location:** 6 Artemisiou, Athens

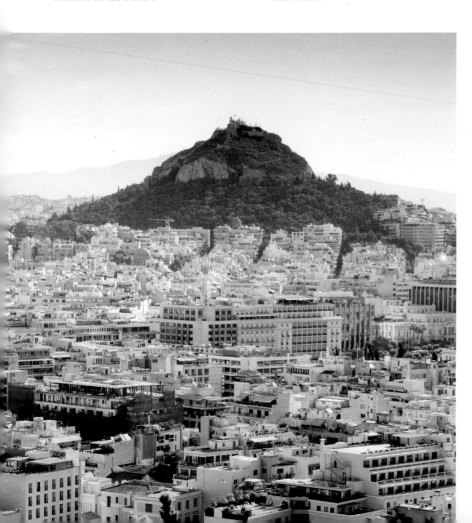

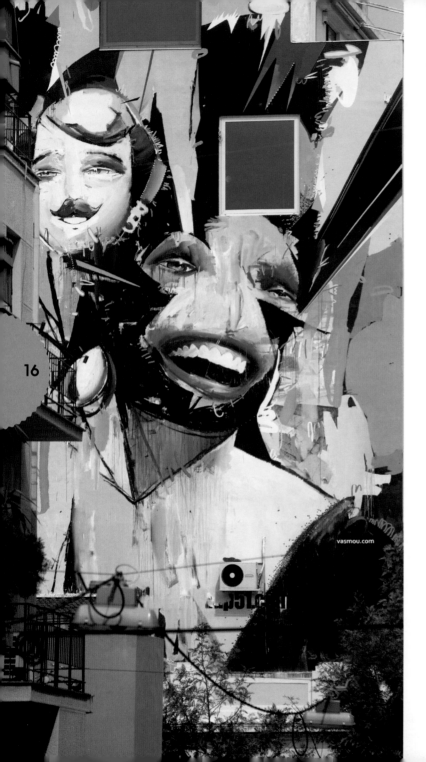

← **Artist:** Alexandros Vasmoulakis **Photo:** Zacharias Dimitriadis **Location:** Pl Iroon, Athens

↑ **Artist:** C215 **Photo:** C215
Location: Unknown

→ **Artist:** INO **Photo:** aestheticsofcrisis/ Julia Tulke **Location:** Pireos 33, Athens

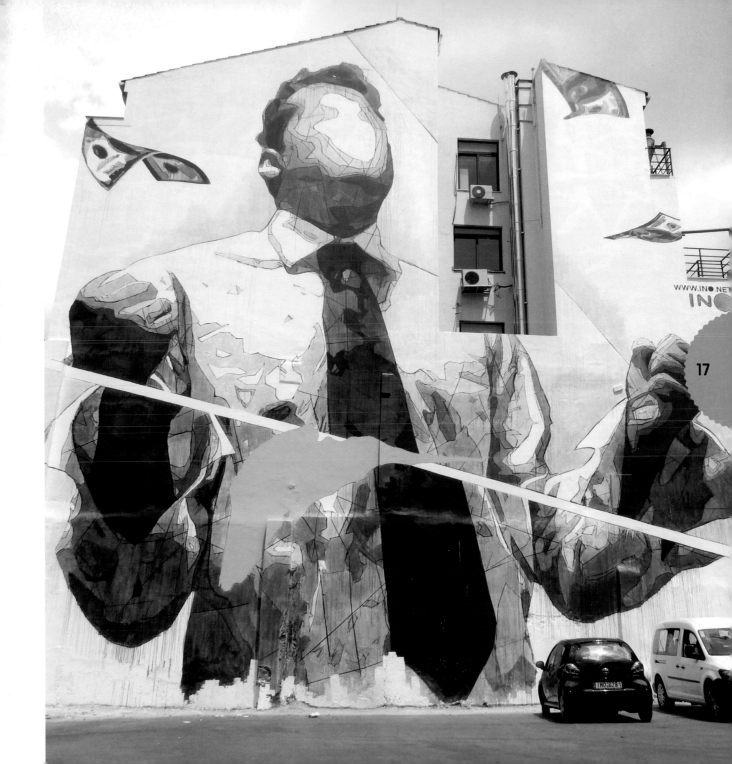

18

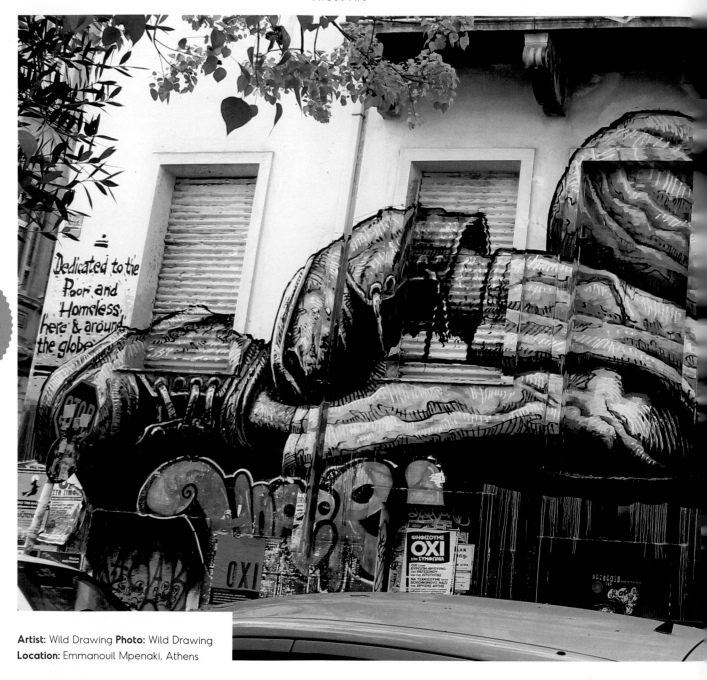

Artist: Wild Drawing **Photo:** Wild Drawing
Location: Emmanouil Mpenaki, Athens

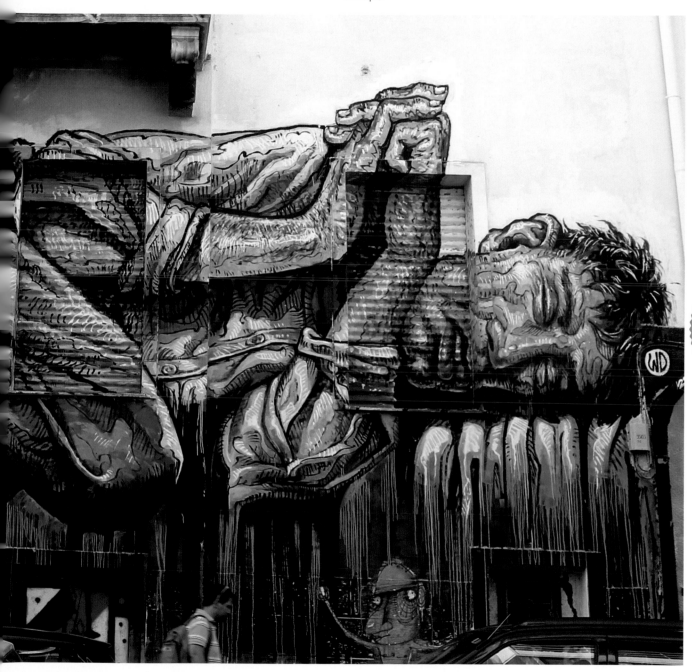

Barcelona

Spain

Wander through the claustrophobic confines of Barcelona's Barri Gòtic and you'll find plenty of crude graffiti, but for more artistic endeavours you may need to venture beyond the tourist trail. Anyone who visits the city will almost certainly come face to face with a grinning fish, however – and not just in one of the many seafood restaurants. Barcelona artist El Pez has made a name for himself worldwide for his relentlessly cheery fish character, and nowhere is this happy aquatic resident more prevalent than in his hometown.

The former industrial zone of Poblenou is currently the most exciting neighbourhood in the city for street art. As the big businesses moved out, the artists moved in, with the dilapidated warehouses becoming the perfect canvases for bold, contemporary art. Like many such big-city neighbourhoods, Poblenou is undergoing a period of gentrification, leaving the landscape for street art in an even greater state of flux. Connoisseurs with an eye for history will also want to make a trip to MACBA (Barcelona Museum of Contemporary Art) to see the recovered and restored Keith Haring mural there.

20

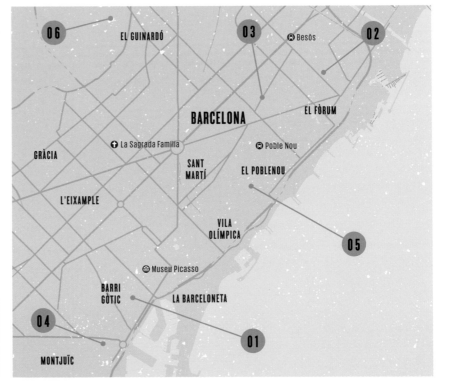

01 Base Elements

This urban art gallery in the heart of the Barri Gòtic showcases the work of the city's finest *grafiteros* – on the facade alone, you'll see work by Btoy, SM172, J.Loca, El Pez, Justin Case and El Arte es Basura. American owner Robert Burt can give you tips on where to spot more of their work.

02 Besòs Mar

Just outside the Besòs Mar metro station, in the unloved *barrio* of La Mina, you'll find a huge mural adorning the Cine Pere IV building, a former cinema turned youth centre. Local artist Kamil Escruela has created a vast cartoonish look at the possible activities housed within, painted in the style of his idol, Barcelona artist Javier Mariscal.

03 La Escocesa

This former textile factory is now a shared studio space for 21 artists, many of whom have left their mark on the interior walls. Technically you can only visit during the building's occasional open days, but in practice you can normally just wander in, as long as there are people at work.

04 Jardins de les Tres Xemeneies

At the port end of the Avinguda del Paral·lel you'll find a large expanse of benches and poplar trees, flanked by a wide wall. This is a designated canvas for street artists, and though the work on display changes regularly, all the greats have painted here at some point.

05 Poblenou

Poblenou has long been the epicentre of the best work by Barcelona's urban artists. In the streets to the north and east of the Parc del Centre del Poblenou, you'll find 20m-high murals splashed on the sides of abandoned textile factories and apartment blocks marked for demolition.

06 Guinardó

At the very top of Carrer de Lepant is a stunning surrealist piece by the celebrated Miss Van, while down at number 424 you can spot a 32m-high abstract mural commissioned by famed Catalan artist SIXE. SIXE has painted walls all over the globe, including the facade of Tate Modern in London for its 2008 street art exhibition.

21

Additional locations

• **Artist:** Victor Ash **Location:** 187 Carrer de Dos Maig, Barcelona
• **Artist:** Blu **Location:** Carrer del Santuari 153, Barcelona
• **Artist:** Claudio Ethos **Location:** Avinguda de la Mare de Déu de Montserrat 13, Barcelona
• **Artist:** Various **Location:** Tres Chimeneas, Avenue del Parallel 29, Barcelona
• **Artist:** Miss Van **Location:** Carrer de Lepant 409, Barcelona
• **Artist:** Various **Location:** La Escocesa, Carrer de Pere IV 345, Barcelona
• **Artist:** Sam3 **Location:** Carrer de les Escoles 29, Barcelona

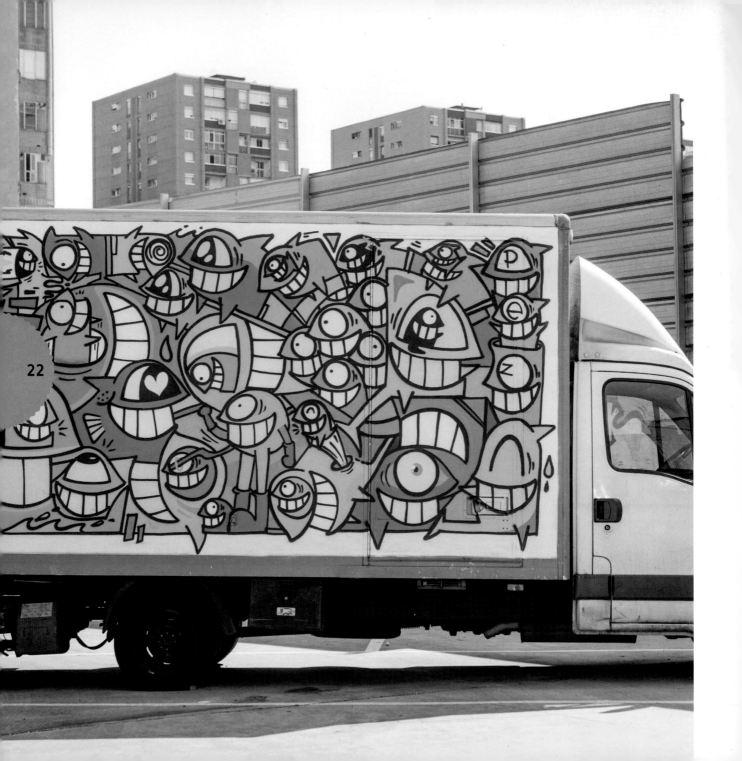

← **Artist:** Pez **Photo:** Pez **Location:** various

↑ **Artist:** Borondo **Photo:** Joan Brebo
Location: Carrer de Pallars 282,
Barcelona

→ **Artist:** Jorge Rodriguez-Gerada **Photo:**
Joan Brebo **Location:** Carrer de la Selva
de Mar 215, Barcelona

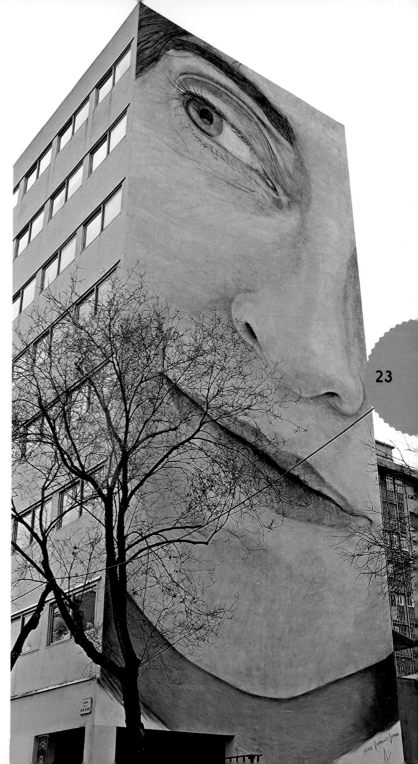

23

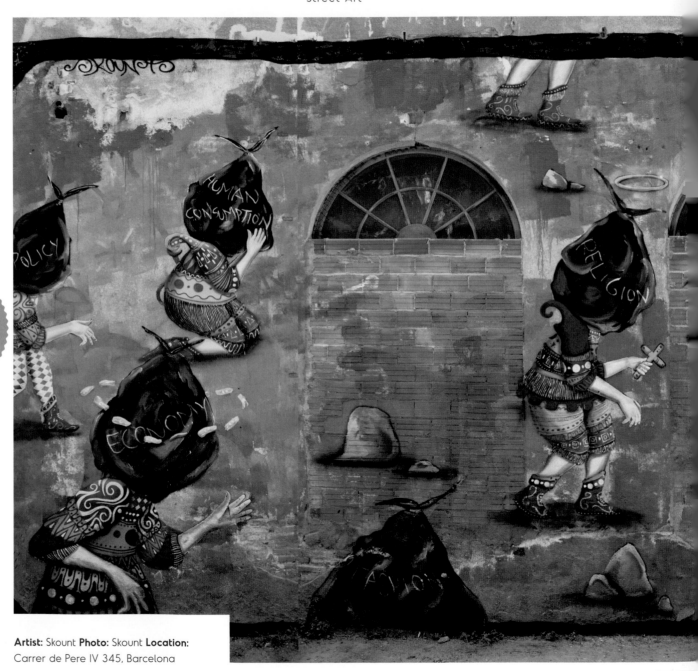

24

Artist: Skount **Photo:** Skount **Location:**
Carrer de Pere IV 345, Barcelona

Berlin
Germany

Berlin is a rich hub of street art. Post-reunification, an abundance of large, empty buildings, a relatively cheap cost of living and a thriving counterculture have combined to bring an influx of artists and musicians to the city. Berlin was prominent during the early street art boom, and has become an essential pilgrimage site for visiting artists – it's now known ironically as 'the most bombed city in the world'. This time, though, the bombing is with spray paint, paste-ups and stickers, as well as alternative mediums like Lego (as seen in Jan Vormann's colourful creations) and even yarn.

During the Cold War, the Berlin Wall was a symbolic target for politically motivated art, though only the west side was covered in graffiti – it was impossible for residents on the east side to get close enough. A section of the original wall, replete with contemporary graffiti, can still be seen on Mühlenstrasse.

Other street-art hotspots include Friedrichshain (home to RAW Gelände) and Kreuzberg. In 2017, Schöneberg will become home to the Urban Nation Museum, a brand new centre dedicated to the creation and celebration of urban contemporary art. The same organisation is responsible for numerous street art events across the city, including some impressive murals in Kreuzberg and Schöneberg, and are also very active abroad (see Reykjavík, page 66).

26

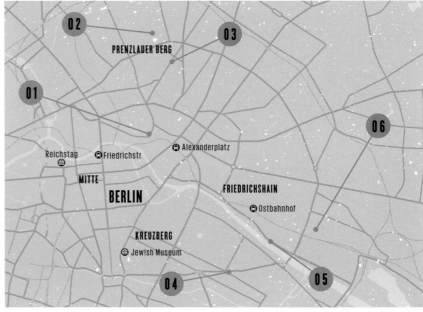

01 Haus Schwarzenberg

Run by a nonprofit artist collective, Haus Schwarzenberg is a subcultural refuge in the heavily gentrified central Mitte district. Nose around the building's courtyard where metal monster sculptures watch over facades slathered in edgy urban art, often with a political bent. Process your impressions over beer in the arty bar out the back.

02 Mauerpark

Famous for its Sunday flea market and outdoor karaoke, Mauerpark is an anaemic patch of green forged from the Berlin Wall's death strip in the handsome northern district of Prenzlauer Berg. Budding graffiti artists legally polish their skills along a shortish section of original wall on the park's eastern side.

03 Tuntenhaus

For a sampling of works by Berlin heavyweights Alias, El Bocho and XooooX, push open the heavy door to K86, an unrenovated former squat on boho-chic Kastanienallee, not far from Mauerpark. The provocative signage on the façade – 'Capitalism Normalizes, Kills, Destroys' – leaves little room for doubt about the political leanings of its residents.

04 Skalitzer Strasse

Gritty-hip Kreuzberg is street-art central. Skalitzer Strasse and its side streets are especially fruitful hunting grounds for monumental murals created during the urban art festival Backjumps 2007. Prime eye-catchers here include Victor Ash's space-race-inspired *Astronaut/ Cosmonaut* and ROA's *Nature Morte*, a morbid black-and-white display of animal carcasses.

05 East Side Gallery

Birgit Kinder's wall-busting Trabant car is among the iconic images of the East Side Gallery, a 1.3km-long stretch of the Berlin Wall that was turned into an outdoor gallery after the barrier's demise in 1989. Less famous, but no less intriguing, are the ever-changing musings by local graffiti artists brightening up the Gallery's Spree River–facing side.

06 RAW Gelände

Near the East Side Gallery, the RAW Gelände, an offbeat urban party village on the sprawling grounds of a defunct train repair station, is also a popular graffiti-artist playground. It's fun poking around the derelict buildings, although some of the finest art can be found at the Urban Spree art gallery.

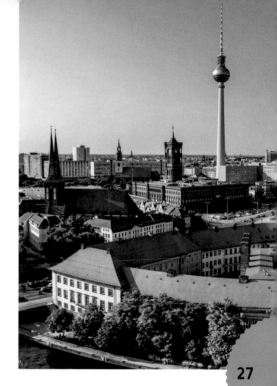

27

Additional locations

- **Artist:** Victor Ash **Location:** Oranienstrasse 195, Berlin
- **Artist:** Bordalo II **Location:** Urban Spree, Revaler Strasse 99, Berlin
- **Artist:** Nunca **Location:** Corner of Feurigstrasse 61 and Herbertstrasse, Berlin
- **Artist:** Don John **Location:** Mehringplatz 29, Berlin
- **Artist:** Various **Location:** Beelitz Heilstätten Sanitorium, Beelitz
- **Artist:** Tristan Eaton **Location:** Am Friedrichshain 33, Berlin
- **Artist:** Fintan Magee **Location:** Bernauer Strasse 133, Berlin
- **Artist:** OSGEMEOS **Location:** Oppelner Strasse 3, Berlin

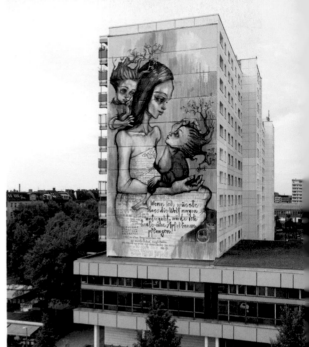

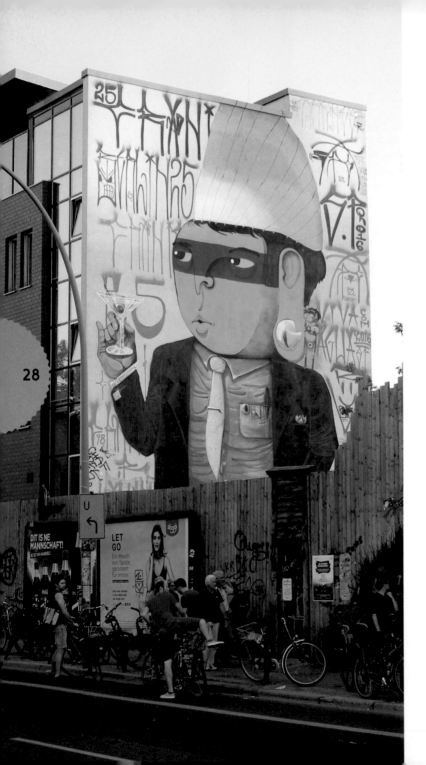

← **Artist:** Cranio *www.cranioartes.com*
Photo: Cranio **Location:** Holzmarktstrasse 19-30, Berlin

↑ **Artist:** Herakut **Photo:** Herakut **Location:** Greifswalder Strasse 87, Berlin

→ **Artist:** The London Police **Photo:** Nika Kramer **Location:** Neheimer Strasse 6, Berlin

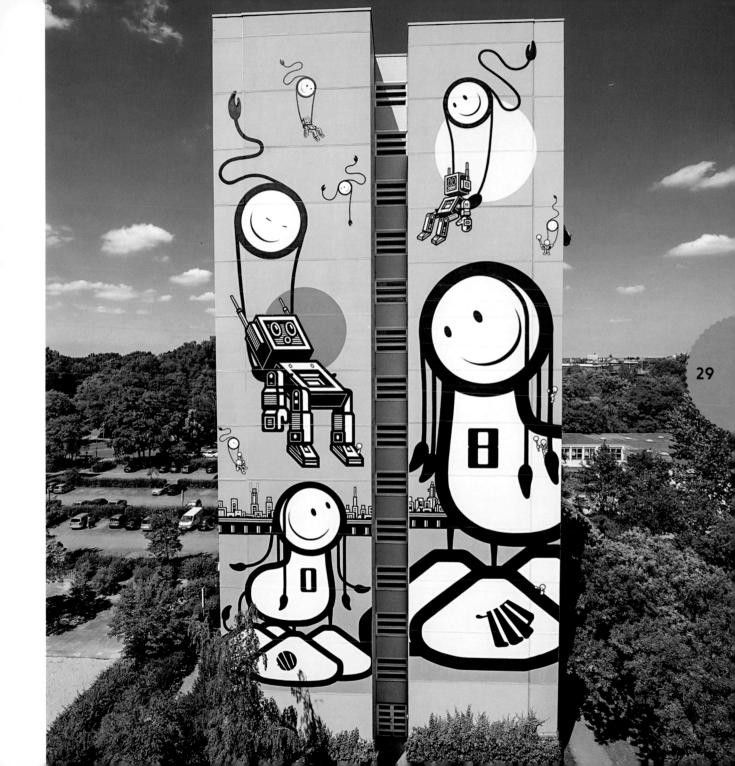

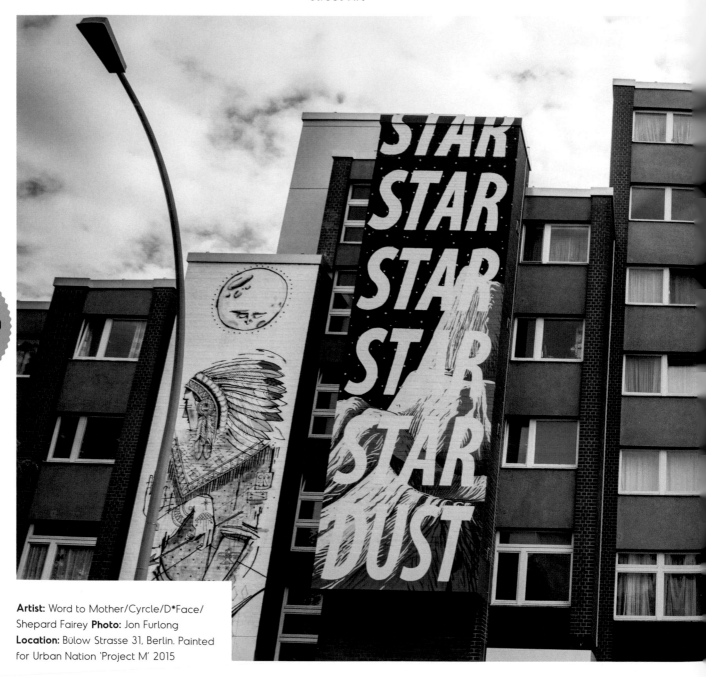

30

Artist: Word to Mother/Cyrcle/D*Face/
Shepard Fairey **Photo:** Jon Furlong
Location: Bülow Strasse 31, Berlin. Painted
for Urban Nation 'Project M' 2015

Copenhagen
Denmark

Copenhagen is one of the best cities in the world for cyclists, and there is no better way to explore its eclectic street art scene. There are even pedal-powered tours of street art highlights. Old-school graffiti fans might prefer to use the trains, however – Copenhagen has an active underground scene, and it's common to see train sides covered in spray paint. For those who prefer to blaze their own trail, the city offers rich pickings. The thriving urban art community is complemented by renowned architecture and design,

which makes exploration a joy on the eyes. Danish photographer Søren Solkær has helped to bring a number of major international street artists to the city as part of his SURFACE project, and local gallery 'V1' is very active on the scene.

Street art has not always been welcome in Copenhagen, however. In

2011, American artist Shepard Fairey was assaulted after a row with locals over a misunderstanding about a commissioned work. Today, things are a little calmer, but there remains a visible tension between traditional graffiti writers and 'street art' – the latter is often defaced if it's within easy reach of taggers.

32

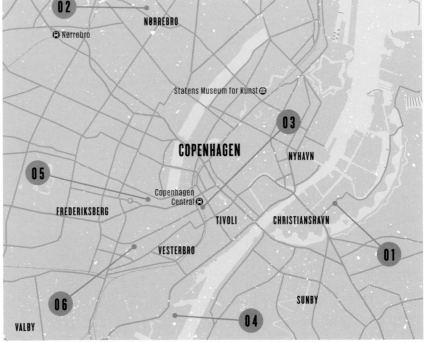

NØRREBRO
Nørrebro
02
Statens Museum for Kunst
03
COPENHAGEN
NYHAVN
05
Copenhagen Central
FREDERIKSBERG
TIVOLI
CHRISTIANSHAVN
VESTERBRO
01
SUNBY
06
04
VALBY

© Aleksandar Mijatovic / Shutterstock

01 Entrance, Christiania

The district of Christianshavn harbours Christiania, a city within a city, with its own distinct rules and way of life. The entrance to the commune is marked by a giant colourful mural of a verdant flowering tree, with a Chinese dragon and several William Blake-esque naked winged women floating around the place. It's accessible from the Christianshavn St Metro stop.

02 BaNanna Park, Nørrebro

Multicultural Nørrebro (S-train line F) is a mix of ethnic eateries, edgy urbanity, new-found cool and street art that sings from every surface. BaNanna Park, an ex-toxic wasteland reborn as a neighbourhood green space, is the centre of Nørrebro street art – look out for an unusual take on the three wise monkeys and a climbing arch covered in piles of cartoonish bones and black-and-white flowers.

03 Metro ring

A short walk from Copenhagen Central station, 17 under-construction Metro stations (to be completed in 2018) are concealed by 6km of hoardings. They form an astounding outdoor gallery, highlights of which include Alina Vergnano's distinctive profiles, the toe of a vast orange sneaker and a wall of painted cross-stitch.

04 Evolution, Vesterbro

Close to Sydhavnen is a beautiful 170m-long painting by local artist Ulrik Schiodt. The huge mural, which was completed over two summers in 1999 and 2000, progresses from the Big Bang through the dinosaur era to prehistoric animals and fantastical sea creatures.

05 Tullinsgade, Vesterbro

Among the hipster cafes of Vesterbro you'll spot a building-sized painting by Irish artist Conor Harrington of two men wrestling. Their mustard and brick-red frock coats merge beautifully with the surrounding architecture, while notable other works nearby include a distinctive bird by the Chinese artist DALeast.

06 Sankelmarksgade, Vesterbro

A brilliant vision of African sunshine lights up the end gable of a grey Copenhagen housing block in Vesterbro (a short walk from Copenhagen Central Station). It's the work of former policeman Hashim Bushiri Mruta, who painted the mural in the Tanzanian Tingatinga style as part of the 1991 Images of Africa Festival.

Additional locations

- **Artist:** Aryz **Location:** Vallensbæk Strandvej 3, Valby
- **Artist:** Victor Ash **Location:** B&W Hallerne, Refshalevej 177B, Copenhagen
- **Artist:** Retna **Location:** Nygårdsvej 5, Copenhagen
- **Artist:** ROA **Location:** Gasværksvej 34, Copenhagen
- **Artist:** Maya Hayuk **Location:** Saxogade 71, Copenhagen
- **Artist:** GR170 **Location:** Søllerødgade 55, Copenhagen
- **Artist:** Various **Location:** Hillerødgade 12, Copenhagen

33

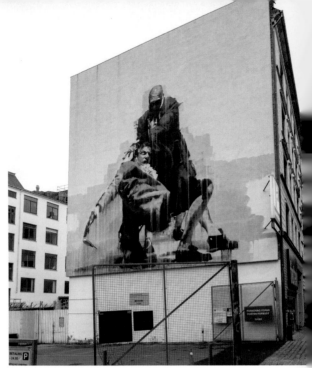

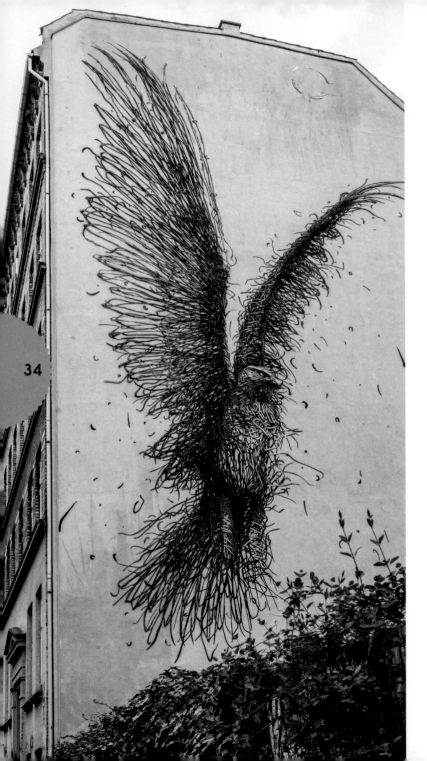

← **Artist:** DALeast **Photo:** Antonio Sena
Location: Oehlenschlægersgade 74-76,
Copenhagen

↑ **Artist:** Conor Harrington **Photo:**
Antonio Sena **Location:** Tullinsgade 21,
Copenhagen

→ **Artist:** Borondo **Photo:** Ferdinand
Feys **Location:** Vesterbrogade 62,
Copenhagen (find the secret door...)

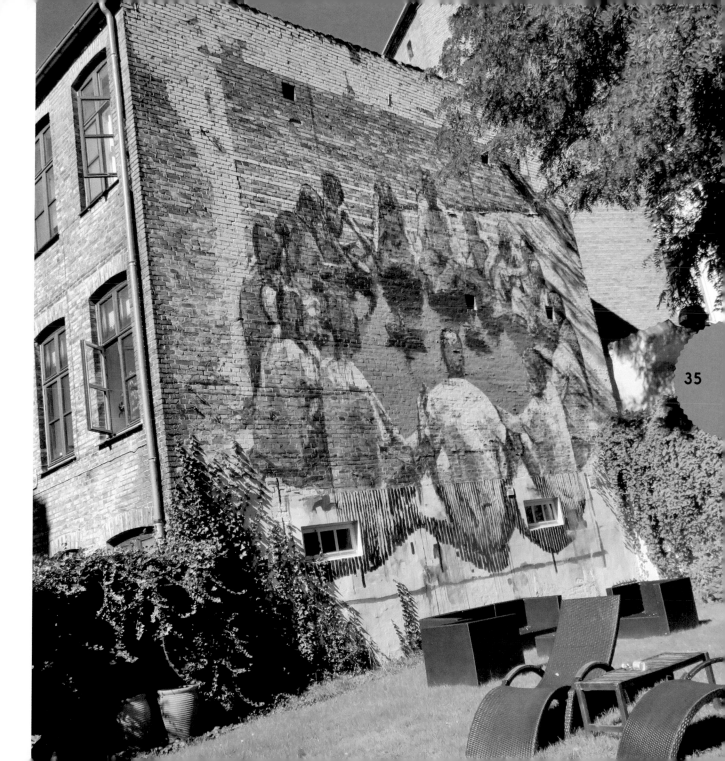

Dublin
Ireland

Mention murals and Ireland in the same breath and your thoughts will almost certainly go straight to cities such as Belfast and Derry in Northern Ireland, with their unrivalled history of political wall paintings. Almost 2000 individual murals have been documented in that region since the 1970s, with hundreds still on display today. When it comes to contemporary street art, however, it's Dublin (as well as the lesser-known Waterford, with its inspiring Waterford Walls project) that is making a name for itself on the international scene. This is partly thanks to the profile of talented local artists such as Maser and James Earley, but also to the forward-thinking Dublin City Council, which promotes and sponsors street artists.

Unsurprisingly, renowned Irish artist Conor Harrington's work features throughout the city. You can see his incredible, painterly murals tucked away in the cobbled back streets of Dublin's theatre district, as well as on Merrion Row near St Stephen's Green. While there are plenty of interesting examples of street art dotted across the city, Dublin also has a number of well-established locations where many artworks can be spotted at once. Fans of traditional graffiti should make a beeline for the famous Tivoli Theatre car park, while the backyard of the Bernard Shaw pub and the surrounding area is also a must-see.

36

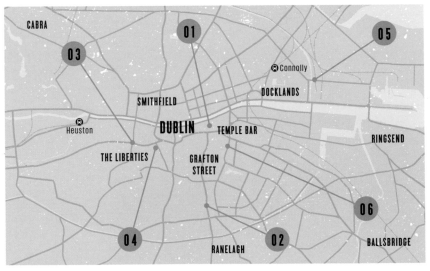

01 Temple Bar
Slap-bang in the city centre, Temple Bar is Dublin's quasi-bohemian quarter with cobbled streets lined with vintage shops, galleries, bars and restaurants. Street art is part and parcel of its character and the area hosts Ireland's most monumental outdoor artwork, James Earley's art nouveau celebration of James Joyce's *Ulysses* painted on the exterior of the Blooms Hotel.

02 Wexford St, Camden St and South Richmond St
Lively, colourful and rough around the edges, this busy southern inner-city thoroughfare plays host to multiple artworks on shop fronts, empty lots and shutters. Don't miss Liberty Lane or the Bernard Shaw pub, a champion of urban art that holds a Paint Jam every September. Take bus 14 or 15 from Dame Street.

03 The Liberties
Gloriously vibrant and diverse, the partially regenerated Liberties is an inner-city area where down-at-heel discount stores sit next to long-established antique shops and hip new media and tech hubs. Street art covers the gable walls, doorways and boarded-up windows of derelict buildings awaiting gentrification. Walk west along Thomas Street from Christ Church.

04 Tivoli Car Park, Francis Street
One of Dublin's most celebrated street art sites, the Tivoli Car Park is set in the Liberties next to the historic Tivoli Theatre. An urban artists' playground, the car park has been transformed into an outdoor art gallery thanks to the annual All City Jam, usually held in May. Walk along Thomas St from Christ Church.

05 Docklands
A legal graffiti wall by U2's recording studio on Windmill Lane kick-started Dublin's street art scene, and although both the studio and the wall are gone, the city's partially redeveloped docklands are still a favourite haunt for urban artists. Look out for the artist-in-residence programme at Gibson's Hotel. Walk east from O'Connell Bridge along the quays.

06 Around Grafton Street
The small side streets lined with independent shops to the west of Grafton Street – Dublin's main shopping drag – harbour a cluster of colourful works hidden away in recessed doorways and quiet lanes. Most impressive, though, are the large-scale political works that are often found on the four-storey gable of the Mercantile building on Dame Lane.

Additional locations
- **Artist:** James Earley **Location:** City Quay, Dublin
- **Artist:** Maser **Location:** 28 Richmond Street South, Dublin
- **Artist:** Conor Harrington **Location:** Crampton Court, behind Olympia Theatre, off 72 Dame Street, Dublin
- **Artist:** Okuda & Remed **Location:** Dury Buildings, Dury Street, Dublin
- **Artist:** El Mac **Location:** Francis Street, Dublin
- **Artist:** Conor Harrington **Location:** 11 Merrion Row, Dublin
- **Artist:** Various **Location:** Windmill Lane, Dublin
- **Artist:** Various **Location:** Tivoli Car Park, 142-143 Francis Street, Merchants Quay, Dublin

37

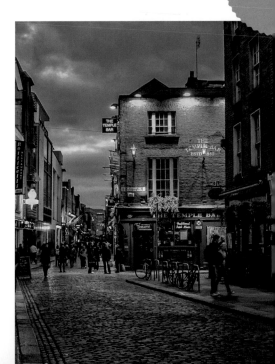

38

← **Artist:** Conor Harrington **Photo:** Patrick Collins **Location:** Sycamore Street, Dublin

→ **Artist:** Various **Photo:** William Murphy **Location:** The Bernard Shaw, 11-12 Richmond Street, Dublin

↓ **Artist:** Maser **Photo:** Patrick Collins **Location:** Grantham Street, Dublin

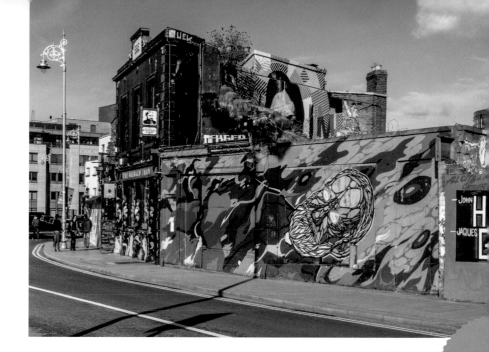

40

Artist: Fin DAC **Photo:** Norman Ross
Location: Rear of The Gibson Hotel,
Castleforbes Road, Dublin

Kyiv

Ukraine

Ukraine's capital Kyiv has slowly been building a reputation as one of the most vibrant cities in the world for contemporary street art. Since the Euromaidan protests of 2013 and the resulting Russian annexation of Crimea in 2014, the tone and content of the city's street art has become increasingly political in nature – arguably a return to the true roots and power of the artform. As is often the case, conflict inspires creativity, and 2016 saw the launch of ArtUnitedUs,

a groundbreaking urban art project that aims to bring together 200 leading street artists from around the world to raise public awareness of war, aggression and violence.

Kyiv was the launch city for the project, resulting in the creation of two-dozen hard-hitting murals painted in association with the Mural Social Club Festival. This festival, run for the first time in 2016, involved the installation of 30 murals across Kyiv (as well as in Odessa and

Chernihiv). This concentration and combination of leading international artists and challenging subject matter, as well as the sheer scale of some of the installations, marked Kyiv as a particularly vital and vibrant destination for street art. Notable works included Australian artist Fintan Magee's 17-storey-high painting *The Visionary*, and NYC-based artist Li-Hill's large-scale mural on the side of the Cultural Arts Centre, *The Impact of Discovery*.

42

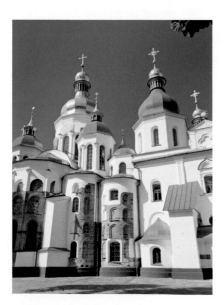

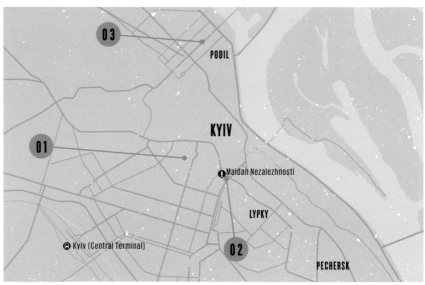

© VoraVale / Getty Images

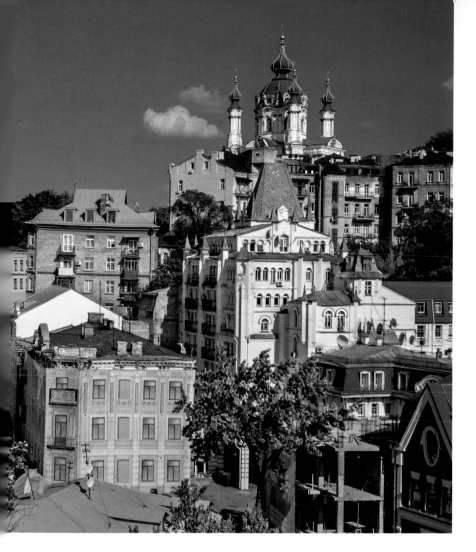
© Leonid Andronov / Getty Images

01 St Sophia's Cathedral

On one corner, a serpent coils around a globe. Another is decorated with a jigsaw of human body parts. Street art around gold-domed St Sophia's Cathedral mixes cartoonish style with uneasy themes. Look for gymnast Hanna Rizatdinova, suspended mid-air in a mural by Fintan Magee; her frozen pose captures the uncertain fate of her homeland, Crimea.

02 Independence Square

Independence Square was the nucleus of successive Ukrainian revolutions, and murals nearby reflect this history of struggle. Meet the piercing gaze of Serhiy Nigoyan – the first demonstrator shot during 2014's revolution – memorialised on Mykhailivska St. On nearby Olhynska Street look for Seth GlobePainter's haunting faceless figures – with arms entangled, they form a defiant human wall.

03 Podil

Stacked along the banks of the Dnieper River, Podil's multistorey blocks are vast canvases for street art. Here, in one of Kyiv's oldest neighbourhoods, you'll find buildings adorned with magical themes: rainbow-tressed women, children soaring through clouds. Stroll northwest along Voloska Street for an enormous mural of a man and reindeer forging through a luminous lake.

43

Additional locations

- **Artist:** Kenor **Location:** Peremohy Avenue 114, Kyiv
- **Artist:** INO **Location:** Mechnykova Street 18A, Kyiv
- **Artist:** AEC Interesni Kazki/Aleksei Bordusov **Location:** Velyka Zhytomyrska Street 38, Kyiv
- **Artist:** Elian **Location:** Obolonskyi Avenue, Kyiv

- **Artist:** Milo **Location:** Mykhaila Verbytskoho Street 8, Kyiv
- **Artist:** Li-Hill **Location:** Kyiv Polytechnical Institute (Cultural Centre)
- **Artist:** Vhils **Location:** Heavenly Hundred Garden, Shovkovychna Street 8/20, Kyiv
- **Artist:** Sasha Korban **Location:** Heroiv Stalinhradu Avenue 60, Kyiv

44

← **Artist:** Guido van Helten **Photo:** Guido van Helten **Location:** Lesi Ukrainky Boulevard 36, Kyiv

↑ **Artist:** Agostino Iacurci **Photo:** Agostino Iacurci **Location:** Pravdy Avenue 64, Kyiv

→ **Artist:** Fintan Magee **Photo:** Fintan Magee **Location:** Strilets'ka Street 12, Kyiv

Lisbon
Portugal

The first half of the 20th century saw Portugal stifled by a right-wing dictatorship, but the 1974 revolution resulted in an upsurge in politically motivated public art. By the time this trend had abated in the early '90s, the arrival of traditional graffiti artists had taken up their forebears' mantle. In recent years, Lisbon city council has actively supported street artists, and the advent of organised efforts such as 'Underdogs' and the CRONO Project – as well as the emergence of homegrown artists like Vhils (see interview p52) – has attracted a high-profile roster of international names to the city. Today, Lisbon is one of the best locations in the world to experience street art in all its forms.

Many of the city's street art gems can be found in and around the Bairro Alto area, with key hotspots including a series of legal walls along the Calçada da Glória, as well as along the river to the south. One of the most famous and photographed locations is the series of dilapidated buildings on the Avenida Fontes Pereira de Melo, although these are earmarked for eventual demolition – a common situation for a transient artform so closely linked to gentrification. Keep in mind that Lisbon isn't known as 'the city of seven hills' for nothing – plan your route carefully!

46

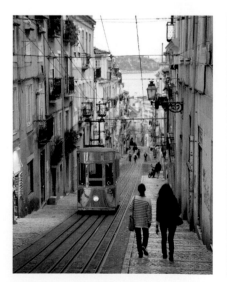

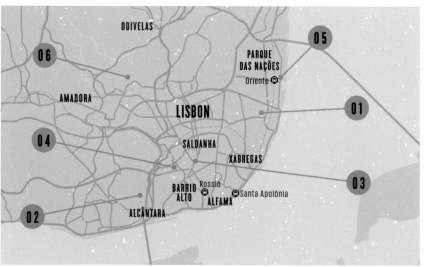

ODIVELAS

06

PARQUE
DAS NAÇÕES
Oriente

05

AMADORA

LISBON

01

04

SALDANHA

XABREGAS

BARRIO
ALTO Rossio
ALFAMA Santa Apolónia

03

ALCÂNTARA

02

01 Braço de Prata and Marvila

For some of Lisbon's best street art, head to the neighbourhoods of Braço de Prata and Marvila in the city's east. Full of crumbling warehouses, these former industrial areas have escaped the waves of gentrification that have swept Lisbon. Fábrica do Braço de Prata has been converted into a cultural centre, and both the factory and the walls along Avenida Infante Dom Henrique are covered in graffiti and murals. Don't miss the Underdogs Gallery (www. under-dogs.net), a short walk to the east. Also check out an installation of *azulejos* (Portuguese tin-glazed tiles) by French artist Olivier Kosta-Théfaine (Rua Doutor Estevão de Vasconcelos 36).

02 Alcântara

Industrial Alcântara, in the west of the city, has seen a major urban renewal. LX Factory (www. lxfactory.com) is a cultural hub where you can see work by some of Portugal's leading street artists such as Add Fuel, Mar, ±MaisMenos± and Mário Belém. Nearby, Village Underground Lisboa features a vast anamorphic mural by Portuguese visual artist AkaCorleone. The area also showcases one of the finest wall carvings by Vhils, Lisbon's most famed street artist. Many main buses and trams stop at the hub in Largo do Calvário; the Alcântara Mar train station is also nearby.

03 Avenida Fontes Pereira de Melo

This central avenue is where some of the most significant murals were created between May 2010 and May 2011 as part of the CRONO project. Start from the corner of Rua Andrade Corvo: the first building features a piece by Brazilian artists OSGEMEOS. On the second building, spot a mural by Spanish artist Sam3. The third building features a composition by Italian artist Ericailcane, and a piece by English artist Lucy McLauchlan. This area is accessible from metro station Picoas.

04 Amoreiras Graffiti Wall of Fame

This is Lisbon's oldest art wall, stretching along Rua Conselheiro Fernando Sousa and Rua Marquês de Fronteira. The first group of artists began working here in late 1994 and there is a small area located in its northeast corner that still features original paintings dating back to 1996. Take the metro to Rotunda (Marquês de Pombal) and walk up Avenida Engenheiro Duarte Pacheco.

05 Parque das Nações-Oriente

This modern district, in the east of the city along the Tagus River, is home to three major urban art interventions, all along Via Recíproca. The first is an impressive mural composition by Italian artist PixelPancho, created in 2013 as part of the Underdogs Public Art Programme; the second a delicate composition signed by Brazilian art collective Novecinco; and the third a vast composition by American duo Cyrcle. The area is well served by public transport; metro station Oriente is across the street from the murals.

06 Bairro Padre Cruz

In May 2016, Lisbon's Galeria de Arte Urbana (GAU), organised Festival Muro, inviting artists to paint Bairro Padre Cruz's walls and façades. The festival transformed the neighbourhood into a street art bonanza, tallying up more than 50 murals by Portuguese and international artists. Take the metro to Pontinha station and walk up Rua Regimento de Engenharia 1 and Estrada da Circumvalação.

Additional locations

- **Artist:** OSGEMEOS/Sam3/Ericailcane/Blu **Location:** Avenida Fontes Pereira de Melo 22, Lisbon
- **Artist:** Low Bros **Location:** Bairro Padre Cruz, Lisbon
- **Artist:** Bicicleta Sem Freio **Location:** Clube Naval de Lisboa, Cais do Gás, Letra H, Lisbon
- **Artist:** Nunca **Location:** 167 Rua do Vale Formoso de Cima, Lisbon
- **Artist:** Interesni Kazki **Location:** Praça Olegário Mariano, 1170 Lisbon
- **Artist:** Odeith **Location:** Metro Amadora Este, Praça São Silvestre, Amadora, Lisbon

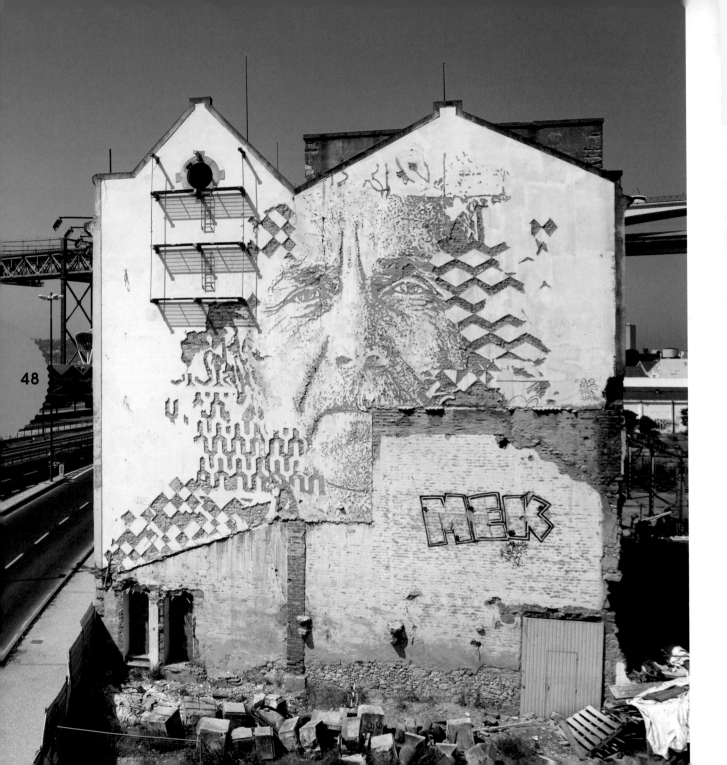

48

← **Artist:** Vhils **Photo:** Alexander Silva
Location: Avenida da Índia 28, Lisbon

↑ **Artist:** Cyrcle **Photo:** Cyrcle
Location: Via Recíproca 1800-142, Lisbon

→ **Artist:** C215 **Photo:** C215 **Location:**
Travessa dos Brunos, Lisbon

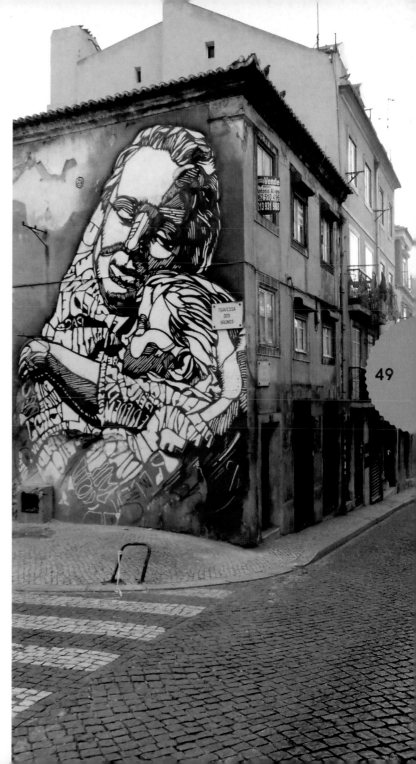

49

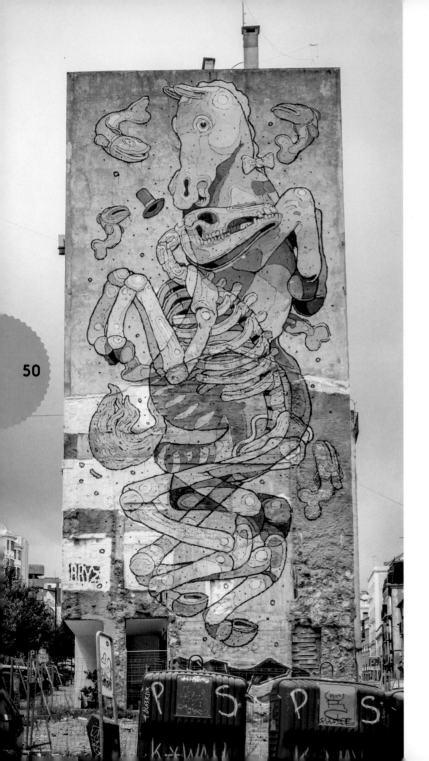

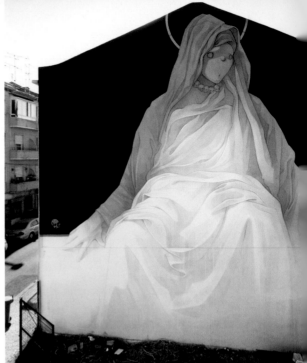

← **Artist:** Aryz **Photo:** Jonathan Bullman
Location: Rua Rodrigues Sampaio 6,
Lisbon

↑ **Artist:** INTI **Photo:** INTI **Location:** Rua
Veríssimo Sarmento 52, Lisbon

→ **Artist:** Telmo Miel **Photo:** Telmo Miel
Location: Rua Professor Pais da
Silva, Lisbon

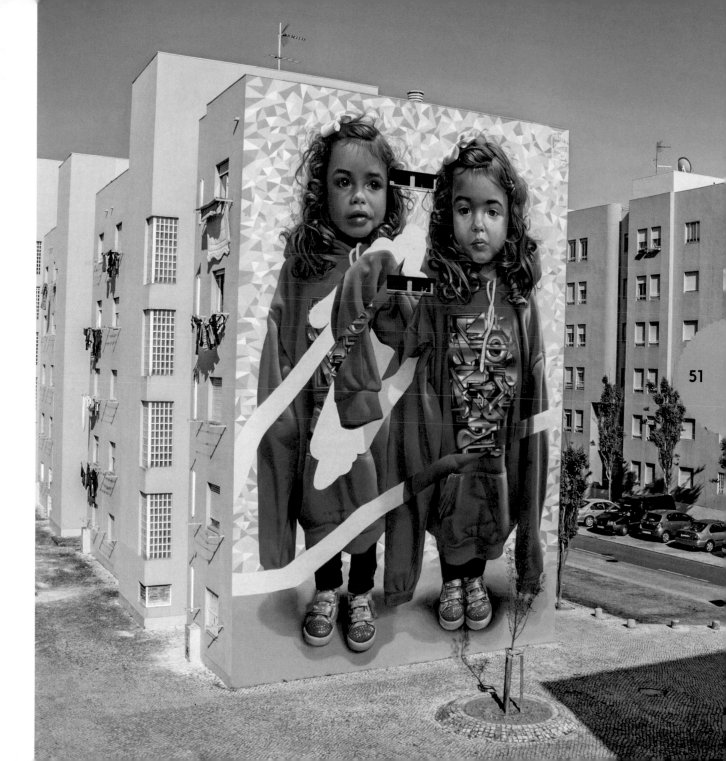

Interview

Vhils

Portuguese artist Alexandre Farto has been painting under the name Vhils since the early 2000s, and his groundbreaking reductive carving technique makes him one of the most unique and recognisable artists working on the streets today. Vhils grew up in the industrial suburb of Seixal and was deeply influenced by Portugal's urban development during the '80s and '90s. He was particularly inspired by the way city walls absorb the social and historical changes that take place around them. By applying his methods of 'creative destruction', Vhils acts as a contemporary urban archaeologist, restoring meaning and beauty to the discarded dimensions buried beneath.

What was behind your original inspiration to create art on the streets?
I started exploring the city as a young graffiti writer – I spent my adolescence interacting with its streets and trains. As I grew older I became interested in broadening the scope of this interaction from the tight-knit circle of graffiti writers to the public at large, and so I started developing a more reflected type of interaction.

You have developed some very unique artistic processes. How did this come about, and what would you say are your main influences?
I was heavily influenced by the poetic decay and crumbling walls that surrounded me while growing up in Lisbon. This decay made me aware of how the layers that form the walls reflect the passage of time and history, exposing bits and pieces of the past to passers-by. I had been using stencils for a while when it occurred to me that I could reverse the process – instead of creating images by adding layers, I could achieve a similar result by removing them. I started carving through the layers of advertising posters accumulated on public walls. It was like accessing the city's recent history, and I began looking at this process of carving as an act of contemporary archaeology. Eventually this led me to carving the walls themselves – exposing its layers and substratum – and I started the 'Scratching the Surface' project, which became a reflection on the different layers that form us all as individuals; our cultures and our histories.

With most artistic processes there is the chance to make changes and corrections, but your methods make this almost impossible. Does this affect the way you work, especially since you are usually operating under public scrutiny?
I've always intended for the results to include and harness some of the randomness of nature. I never wanted to control the entire process. Ultimately, the risks and mistakes, the randomness of the results, local conditions, the weather, the nature of the materials, the tools, how tired we are – these factors are actively embraced as a part of the process and are included in the final result.

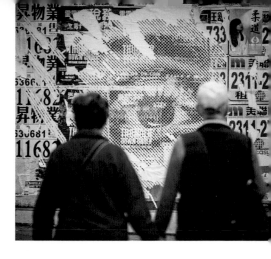

→ **Artist:** Vhils **Photo:** Jose Pando Lucas
Location: Hong Kong

↓ **Artist:** Vhils **Photo:** Vhils **Location:** Paris

What's your opinion on the current global street art scene?
Like all underground phenomena that grow popular and become accepted into the mainstream, it has both positive and negative points. For me, the idea behind working in the public space is fundamentally to humanise it in some way. I believe that the relationship between a city and its citizens is like a complex network of reciprocal stimuli – cause and effect – and that art in general can contribute to create a better environment for its people and its communities.

You have been involved with some interesting community projects around the world. Why do you think that street art as a movement has such a strong social conscience?
Perhaps it is because the artists are able to access the city's underbelly. Since you often tend to work in the most neglected areas of the city, you become aware of what surrounds you. Street art has always been about confronting these realities. Its essence lies in its subversive and protest-driven nature.
www.vhils.com

53

London
England

From the late '90s to mid 2000s, London was pivotal in the explosive growth of the street art scene, centred on the back streets, alternative galleries and underground drinking dens of the post-industrial East End. This trend peaked around 2008, when the Tate Modern staged a groundbreaking street art exhibition on the banks of the Thames and Banksy pioneered his 'Cans Festival' in the Leake Street tunnel – still a graffiti hotspot today.

The scene remains fairly focused on the East End – particularly the now ultra-trendy Shoreditch, and neighbouring Brick Lane and Hackney areas, where cobbled roads and streets of painted and pasted walls exist side-by-side with members' clubs, Michelin-starred restaurants and high-end boutiques.

Further east, a slew of converted warehouses in Hackney Wick near the Olympic Park are home to many artists, while Brixton in the south and Camden in the north should feature high on the hit list for street art lovers. You can also find events in a range of locations, from outdoor galleries in upmarket Dulwich to the 'Wood Street Walls' project in Walthamstow.

Unusually for such a major city, the retail and arts districts in the West End are relatively devoid of street art, although fans can always visit Lazarides Gallery – run by the former manager of Banksy and home to a diverse roster of artists.

54

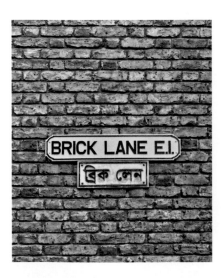

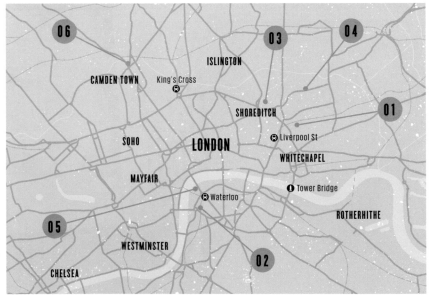

01 Brick Lane
Famous for its market and curry houses, multicultural Brick Lane also has more street art than practically anywhere else in London. The main drag and side streets are awash with works, from fantastical animals to surreal cityscapes, including signature pieces by Phlegm, Banksy and ROA, whose giant crane covers an entire wall on Hanbury Street. Some are easy to spot, others are well hidden – so keep those peepers peeled while you browse for vinyl and vintage togs.

02 Leake Street Tunnel
On the south side of the Thames, round the corner from Waterloo Station and the London Eye, this is one of the capital's most legit (and legal) graffiti spots. The 300m tunnel is splattered end to end with technicolour creations, although pieces rarely last too long before being tagged or painted over, so there's no telling quite what you'll find. Repeat visits recommended.

03 Shoreditch
Whether it's hipster beards, cereal cafes or spoon-carving workshops, Shoreditch prides itself on its eccentricity, and many of London's street artists debut new works here. You'll see art all over the place between Shoreditch High St and Old St – Stik's trademark stick-figures are a fixture – so pick up a flat white, hop on your fixie and see what you spot.

04 Hackney Road
Once a dubious part of town, Hackney's revival has been marked by increasingly impressive artworks. It's still far from the prettiest street in town, but there are many gems to be found in among the kebab shops, dodgy pubs and council blocks, particularly around Clare Street. Afterwards, you can browse around Broadway Market, or daydream about the good life at Hackney City Farm.

05 The Undercroft
This concrete space and skate park beneath the Southbank Centre was saved from redevelopment following a long and passionate grassroots campaign. It's now one of the few examples of genuinely public space left in the capital, owned by no-one, and open to all – and that includes graffiti artists, for whom the Undercroft's slabs present a ready-made canvas.

06 Camden Market
London's most notorious weekend market sprawls over a huge area between Camden Town Tube station all the way to Camden Lock, taking up every inch of space – canal-sides, courtyards, warehouses, alleyways and everything in between. It's all rather chaotic, so the numerous street murals here provide the perfect backdrop – including several works by Bambi, sometimes known (much to her annoyance) as the 'female Banksy'.

55

Additional locations
- **Artist:** Alex Void **Location:** Corner of Scawfell Street and Hackney Road, London EC2
- **Artist:** Invader **Location:** 11 West Central Street, London WC1
- **Artist:** D*Face **Location:** 64 Sclater Street, London E1
- **Artist:** Invader/Shok1 **Location:** 617 Forest Rd, London E17
- **Artist:** Rotating artists **Location:** 12-16 Clerkenwell Road, London EC1
- **Artist:** Banksy (Falling Shopper) **Location:** 25 Bruton Lane, London W1
- **Artist:** Various **Location:** Elys Yard, The Old Truman Brewery, 91 Brick Lane, London E1
- **Artist:** Jimmy C David Bowie mural **Location:** Dorrell Place, Brixton SW9
- **Artist:** Steve 'ESPO' Powers **Location:** 10 Great Eastern Street, London EC2

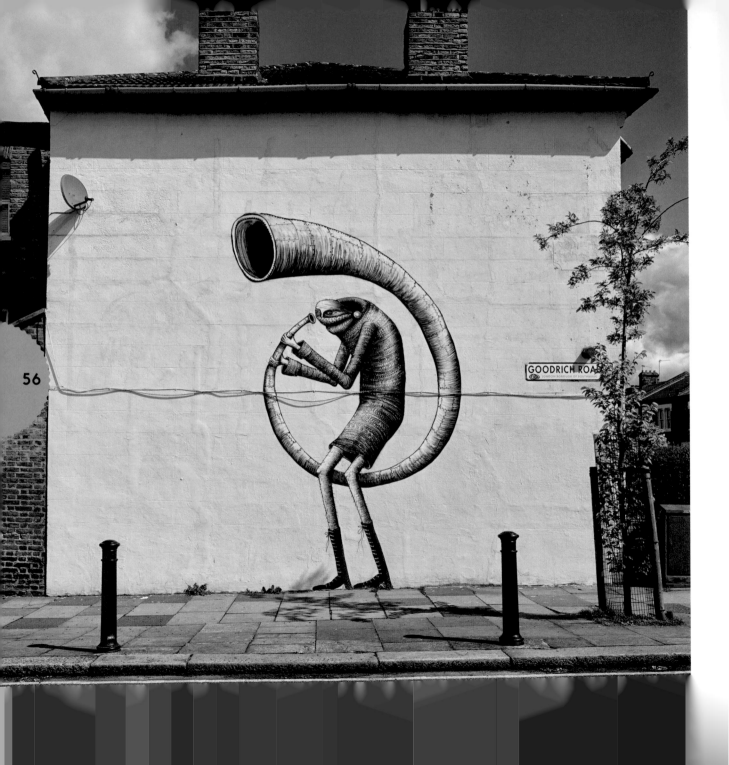

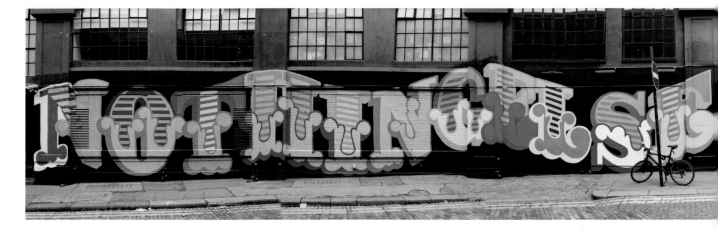

← **Artist:** Phlegm **Photo:** Patrick Collins **Location:** 67 Goodrich Road, East Dulwich, London SE22

↑ **Artist:** EINE **Photo:** OliveTruxi **Location:** Ebor Street, Shoreditch, London E1

→ **Artist:** Remi Rough/Steve More/ Augustine Kofie/LXOne/AOC **Photo:** Remi Rough **Location:** Megaro Hotel, Belgrove Street, Kings Cross, London WC1

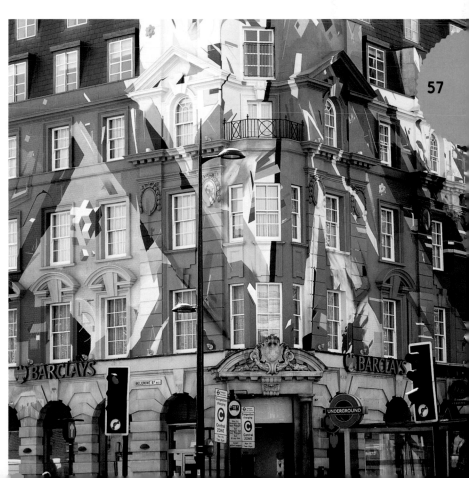

57

Paris

France

With its reputation for revolution and love of the avant-garde, it's no surprise that France has taken graffiti and street art to its heart. Arriving into the city's Gare du Nord by train will immediately expose you to France's famous trackside graffiti, while trips on metro lines 2 and 6 are also great for spotting art on the move. On foot, Le M.U.R. and the surrounding streets of Oberkampf feature rich pickings – try walking from here to Belleville via Ménilmontant. On the Left Bank,

the 13e arrondissement is a hotspot of contemporary street art.

Paris was at the forefront of the emergence of urban street art, with Blek le Rat (see interview p64) widely credited as the first artist to adapt spray paint stencils from propaganda and protest to more artistic purposes. Stencils are still very popular, with regular appearances from the likes of C215 and Jef Aérosol. The city's

most infamous contemporary street artist, however, is the Parisian artist Invader. Since 1998 the secretive artist has 'invaded' more than 60 cities around the world with his videogame-influenced mosaics. Thanks to their (often amusing) placement – out of the reach of all but the most determined or foolhardy – thousands of his pieces still exist, particularly in Paris.

58

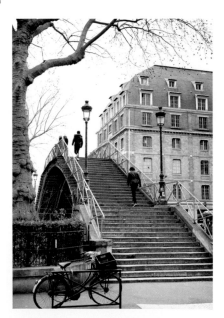

01 13e arrondissement

Hot zone for tracking down mosaic-tile Pac-man and Space Invaders by Invader, this working-class district in southeast Paris is edgy. Across the train tracks from Chinatown's Asian grocers and eateries, near Bibliothèque François Mitterand metro, Galerie Itinerrance (http://itinerrance.fr) is the spearhead of the city's street art renaissance. Hood-wide, look up for murals by Shepard Fairey and down for sensational staircase art by Parisian duo Zag & Sia.

02 Le M.U.R., 11e

A compelling fortnightly performance is guaranteed on rue Oberkampf, a once-shabby but now achingly cool street laced with café pavement terraces and independent boutiques in the fashionable 11e. At number 109, Right Bank hipsters quaff coffee and cocktails at distressed Café Charbon and catch artists in action at neighbouring Le M.U.R. (www.lemur.fr), a billboard-turned-canvas for modular (M), urban (U) and reactive (R) aerosol art.

03 Rue Dénoyez, Belleville

Old haunt of Edith Piaf, new haunt of hipsters – the urban-art climax of overwhelmingly working-class and multicultural Belleville in northeastern Paris is rue Dénoyez. Near Belleville metro station, the busy pavement terrace of 1950s cabaret-turned-buzzing corner cafe Aux Folies announces the start of the only street in Paris where trash bins, flowerpots, lamp posts, window shutters – everything – is brilliantly tattooed head to toe in ephemeral art.

04 Place Igor-Stravinsky, 4e

Eyes flit frenetically in all directions on this head-turning square in central Paris, a hop, skip and toss-of-a-coin-in-a-busker's-hat from the Centre Pompidou. Look beyond the whimsical firebird, frog and plump red lips of the iconic Jean Tinguely and Nikki de Saint Phalle fountain to gorge on the surrounding murals. The gigantesque *Chuuutt!* (*Hush!*) self-portrait here by French stencil artist Jef Aérosol is a permanent fixture.

05 Place des Abbesses, Montmartre

In hilltop Montmartre, fashioned from old-world cobbled lanes and Paris' only vineyard, who can possibly resist a selfie in front of the romantic *Je t'aime* (*I Love You*) wall? Hidden in a tiny bench-clad park shaded by maple trees, the mural by artists Frédéric Baron and Claire Kito features the immortal phrase 'I love you!' painted in 250 different languages on dark-blue enamel tiles.

06 Art 42, 17e

Ephemeral tags get a new-found permanence at France's first street art museum, radically at home in an avant-garde computing school in northern Paris. Art 42 (www.art42.fr) showcases the personal collection of urban-art aficionado Nicolas Laugero Lasserre with guest works by emerging and established street artists. The opportunity to view Banksy, JR et al under one roof is a real treat.

59

Additional locations

- **Artist:** Invader **Location:** Pont d'léna, Quai Branly, Paris
- **Artist:** Seth **Location:** Belvédère de Belleville, 27 Rue Piat, Paris
- **Artist:** Various (graffiti) **Location:** Rue Denoyez, Paris
- **Artist:** Cranio **Location:** 123 Avenue de Choisy, Paris
- **Artist:** André **Location:** 7 Rue de la Fidélité, Paris
- **Artist:** Ludo **Location:** Passage Saint Sébastien, Paris
- **Artist:** Reka One **Location:** 34 Rue Hélène Brion, Paris
- **Artist:** ROA **Location:** Rue Marguerite Duras, Paris
- **Artist:** Nick Walker **Location:** 107 rue Oberkampf, Paris

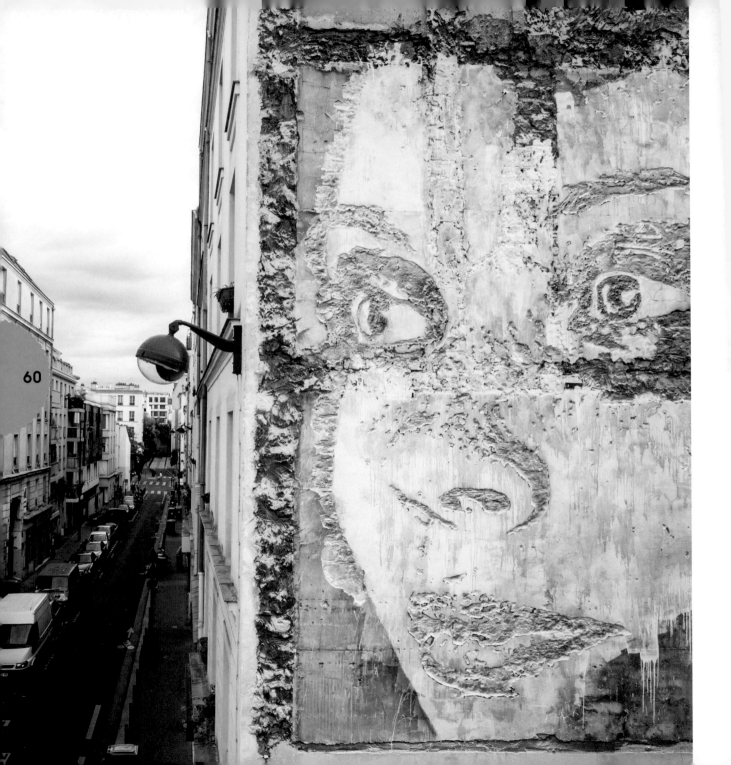

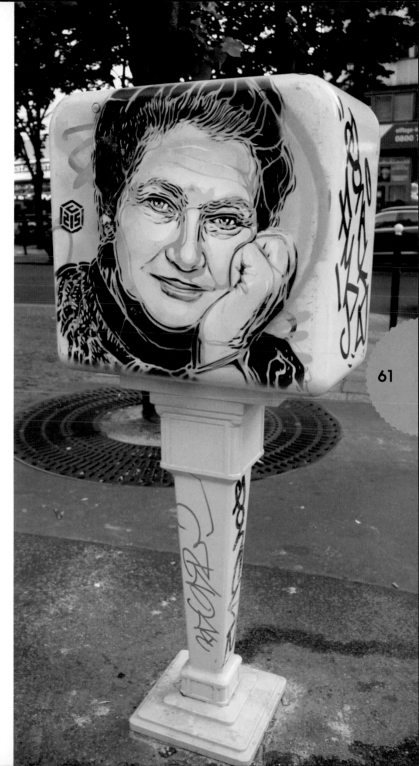

← **Artist:** Vhils **Photo:** Vhils **Location:** 149 Rue de Sèvres, Paris

↑ **Artist:** Invader (PA_1112)
Location: Staircase, Place Louis Blanc, Courbevoie, Paris

→ **Artist:** C215 **Photo:** C215
Location: Various yellow La Poste boxes

61

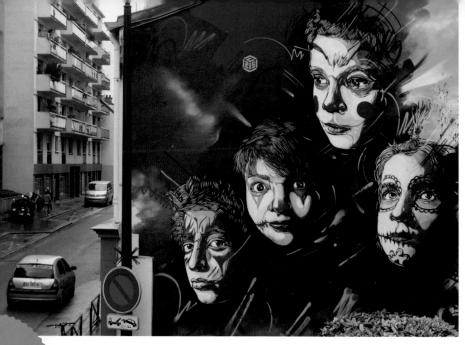

← **Artist:** C215 **Photo:** C215 **Location:** 188 Rue Pelleport, Paris

↓ **Artist:** INTI **Photo:** INTI **Location:** 81 Boulevard Vincent Auriol, Paris (there are many other murals in the immediate area, including C215, ROA, Shepard Fairey and David de la Mano)

→ **Artist:** Seth **Photo:** Seth **Location:** Rue Emile Deslandres, Paris

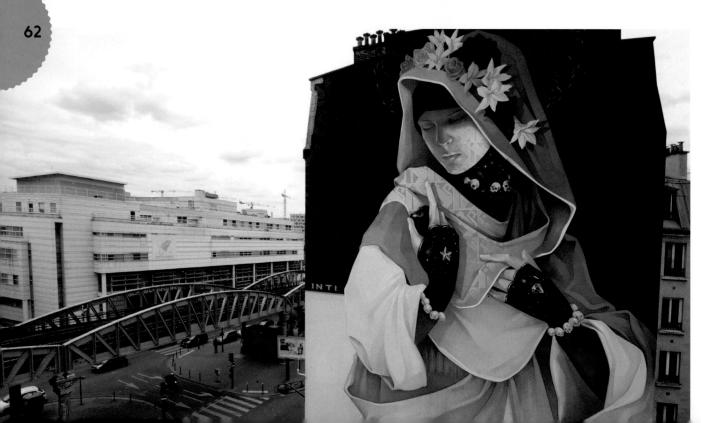

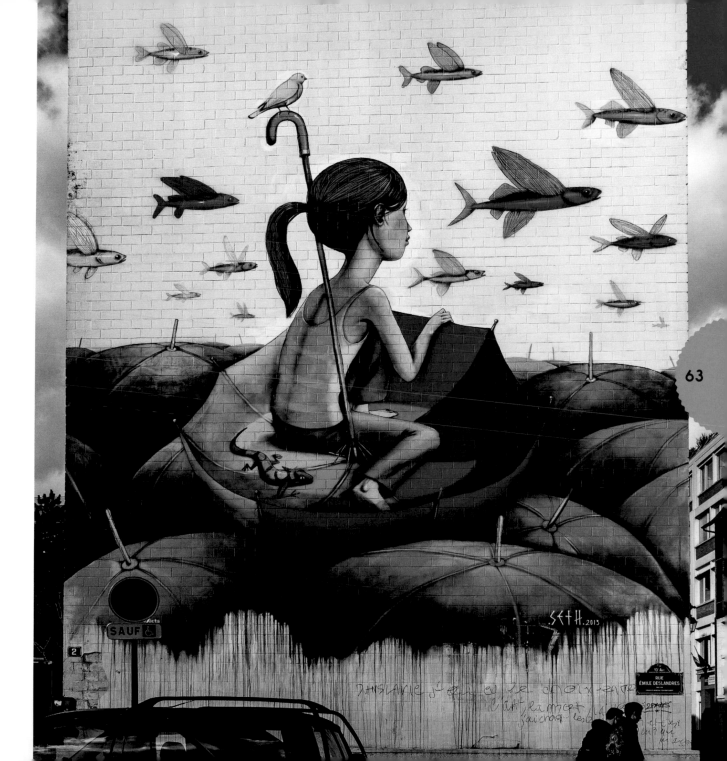

Interview
Blek le Rat

Blek le Rat was one of the first graffiti artists in Paris, and is widely credited with being the first to evolve stencilling from basic lettering into pictorial art. He began in 1981 by painting rats on the walls of Paris, describing them as 'the only free animal in the city'. Although initially influenced by the early graffiti art of New York City, he later developed a unique style that he felt better suited the architecture of the Parisian streets. Often referred to as 'the father of stencil graffiti', Blek is influential not only for his innovative use of the medium, but also for his socially conscious choice of subject matter.

What was behind your original inspiration to create art on the streets?
The first time I saw graffiti was in 1971 in New York. I was profoundly intrigued and knew immediately that I wanted to be involved, but I also knew that I didn't want to do it in the same way as the American artists.

How did you come to use stencils?
I had seen a striking stencil portrait of Mussolini in Italy when travelling with my parents as a child, and when looking for my personal means of expression I remembered this old technique. I found that the stencil better suited the architecture of Paris than the big graffiti pieces I had seen in America.

You are famous for your rats – the ultimate survivor in the metropolis. Why did you choose it as your motif?
In 1980 I lived near the Montmartre cemetery in Paris, which might be the reason that there were so many well-fed rats! I found this very anachronic compared with the image people have of Paris. Later on I learned that the whole city was full of rats – that there were even more rats than inhabitants.
Amusingly the word rat is also an anagram of art, which established an even stronger link between myself and the rats. The society of rats works in a way that would make them survivors of an apocalypse, and I have survived 35 years in the art world, just like a rat.

How important is the placement and context of street art? What makes an interesting location for your work?
When I paint in the streets I intend to give a present to the people of the city. For these reasons I try to impregnate myself with the different *parfums* (scents) of the city in which I am working, in order to paint something that corresponds to the identity of the city and that its people can therefore identify with.

What's your opinion on the current global street art scene, and particularly the proliferation of street art festivals around the world?
Simply that it's proof of the fact that street art is the biggest artistic movement of all time.

Street art has a strong history of socio-political messaging, yet the trend seems to be increasingly driven by aesthetics. Is there a risk of over-sanitisation?

Of course, but that was foreseeable. When an artform becomes very popular it is always likely to lose some of its originality and become sanitised. We have seen the same phenomenon with music. But one can still like street art for its aesthetics just as one can like French pop music for its *légèrté* (lightness).

What is your favourite place you've painted in your career and why?
Travelling the USA in 2007.
We were on a road trip through California and pasted posters of the Space Cowboy and a family of pioneers. That was one of those moments when the images, the environment and the history became one thing.
bleklerat.free.fr

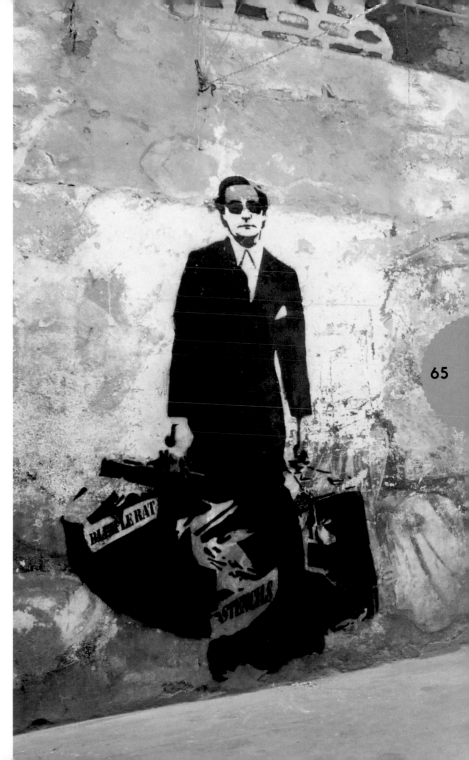

65

Reykjavík
Iceland

Despite being the world's northernmost capital, Reykjavík's small size and clean, colourful streets make it a joy to explore on foot. Which is good news, considering how much art there is to discover. Despite a zero-tolerance crackdown against graffiti in the 2000s, as well as the recent loss of one of the city's most beloved street art parks – the Hjartagarðurinn (Heart Garden) – the public art scene inReykjavík is currently experiencing something of a golden age.

One highlight is the work of local artist Sara Riel, whose murals are dotted across the city. Look out for her mushroom-scape on Hverfisgata, where the legacy of the Heart Garden is still visible, as well as the other-worldly flowers created with Davíð Örn Halldórsson for a kindergarten on Seljavegur. While you're wandering, keep an eye out for Örn Tönsberg's characterful animals and Guido van Helten's distinctive works inspired by old photographs. Graffiti fans can head south out of central

Reykjavík to Hafnarfjörður, where artists can paint legally in a series of underpasses.

Iceland's remarkable musical output has also made its mark on the city's streets, resulting in Wall Poetry (icelandairwaves.is/wall-poetry/) – an annual collaboration between the Iceland Airwaves music festival and Berlin's Urban Nation. Artists and musicians are paired together and the resulting lyric-inspired artworks are installed throughout the city – a trail worth following in its own right.

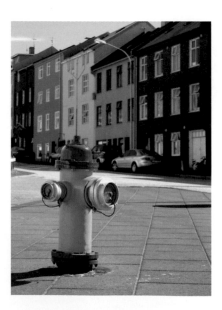

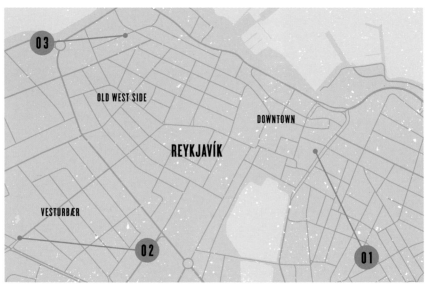

01 The Old Town

Reykjavík's downtown is a bright mishmash of colourful roofs and boldly painted shops, cafes, bars and galleries. Laugavegur, the main shopping street, and Hverfisgata, which runs parallel, are ablaze with vibrant street art commissioned as part of the annual Wall Poetry festival. Don't miss the sweeping work by Caratoes on the corner of Klapparstígur and Laugavegur.

02 Vesturbær

West of downtown, the mainly residential area of Vesturbær hosts some arresting urban art, particularly around Vesturgata, Nýlendugata and Ægisgata. It's also worth walking out along Grandagarður and Hólmaslóð to see large-scale works on the industrial warehouses of the harbourfront. Take bus 14 along Mýrargata from Laugavegur.

03 Seljavegur

A cluster of works around Seljavegur make this street one of the most impressive in Vesturbær. Here you'll find work by Sara Riel, one of Iceland's most prolific street artists, and Guido van Helten, whose pieces cover three sides of the Loftkastalinn building. To get here, take bus 14 west from Laugavegur.

Additional locations

- **Artist:** Evocal **Location:** Skúlagata 4, Reykjavík
- **Artist:** Telmo Miel **Location:** Hólmaslóð 2, Reykjavík
- **Artist:** The London Police & Above **Location:** Grettisgata, Reykjavík
- **Artist:** DabsMyla **Location:** Óðinsgata 2, Reykjavík
- **Artist:** Caratoes **Location:** Laugavegur 23, Reykjavík
- **Artist:** Ernest Zacharevic **Location:** Hverfisgata 42, Reykjavík
- **Artist:** Li-Hill **Location:** Ingólfsstræti 2a, Reykjavík

67

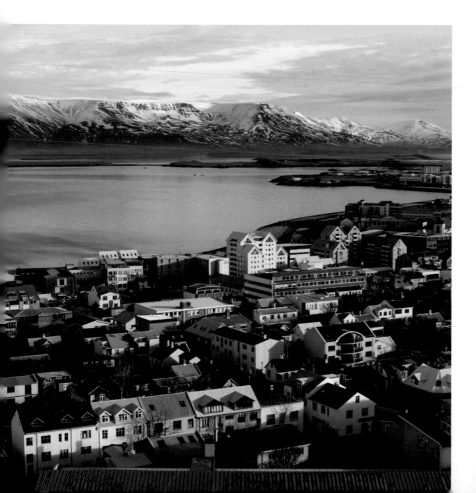

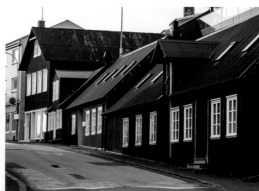

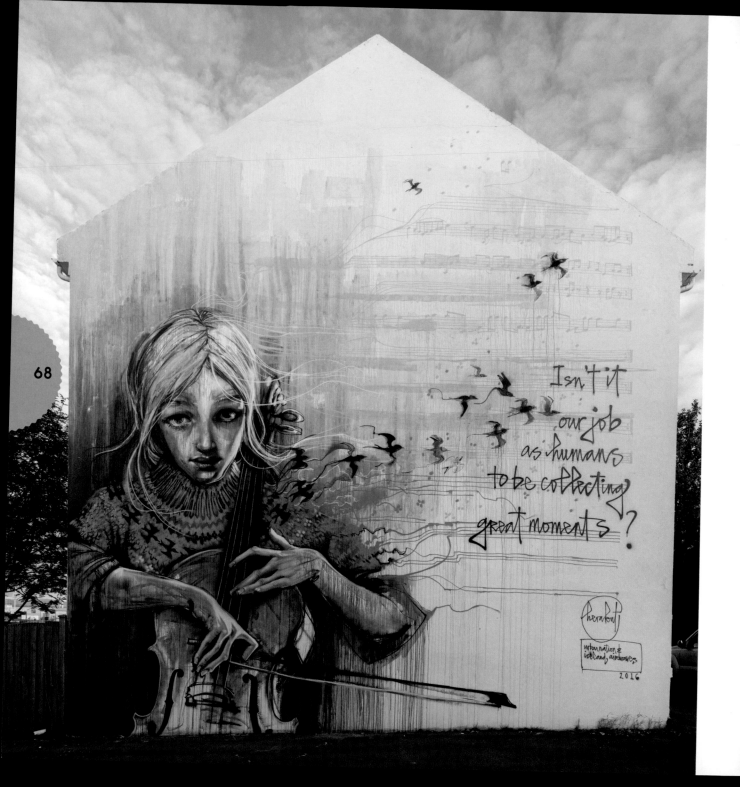

Isn't it
our job
as humans
to be collecting
great moments?

← **Artist:** Herakut **Photo:** Herakut **Location:** Nylendugata 29, 101 Reykjavík

→ **Artist:** D*Face **Photo:** @rebelsalliance **Location:** Laugavegur 66, Reykjavík

↓ **Artist:** Deih **Photo:** Chrixcel **Location:** Junction of Vesturgata/Norðurstígur, Reykjavík

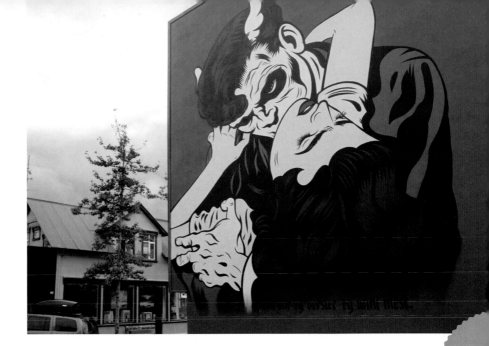

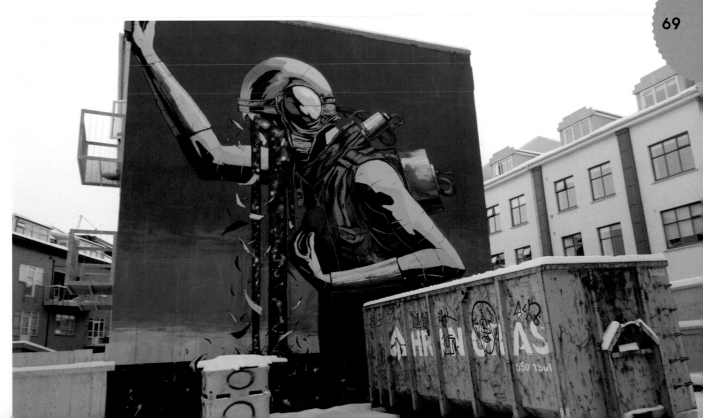

Artist: Guido van Helten **Photo:** Guido van Helten **Location:** Seljavegur 2, Reykjavík

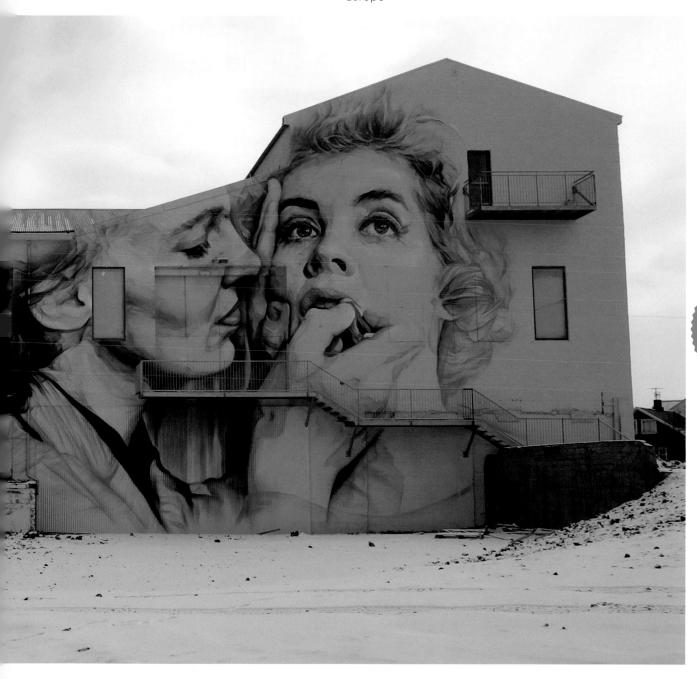

Rome
Italy

Rome's rich history – full of politics, religion, science, art and revolution – can't help but inform the present day, and nowhere is this more visible than on its beautiful, chaotic, dishevelled streets. It's a big city and there's a lot to see, even if you're only visiting for the street art. Graffiti has a long history in Rome, and there are several organisations and galleries – most notably 999Contemporary – dedicated to enhancing suburbs and uniting neighbourhoods through art.

The city has over 300 commissioned murals, a good start, though be sure not to miss out on less 'official' pieces.

Starting centrally, the metro station at Piazza di Spagna was recently painted as part of the *Urban Legends* exhibition at MACRO Testaccio. From here, take your pick from the student-filled and playful San Lorenzo district (look out for

Alice Pasquini's block-long mural on Via dei Sabelli), the historic but contemporary Ostiense, and the brash, thoroughly likeable Pigneto. Further south, Tor Marancia has some incredible murals, as does nearby Quadraro. To the north, San Basilio's Giulietto Minna square is a treat, featuring large-scale works from the likes of Liqen and Hitnes.

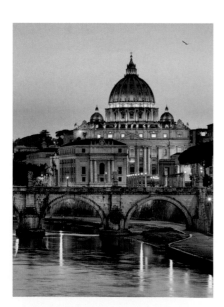

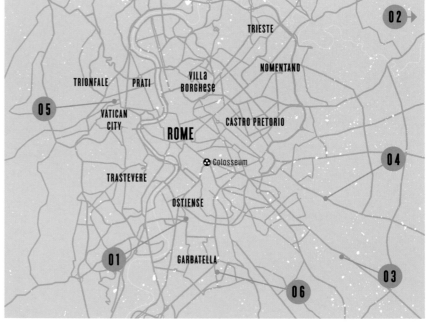

TRIESTE

NOMENTANO

TRIONFALE PRATI VILLA BORGHESE

VATICAN CITY

CASTRO PRETORIO

ROME

☢ Colosseum

TRASTEVERE

OSTIENSE

GARBATELLA

02
05
04
01
06
03

01 Ostiense

This once-industrial cityscape, close to Pyramid metro stop, has counter-culture running in its veins. Street artist Blu has coated the former airforce barracks, now a squat, in stacks of technicolour aliens, with the windows as eyes. At one end, a sailing ship morphs into a construction site, as surreal as a Monty Python cartoon.

02 San Basilio

With a shady reputation, the scrubby suburb of San Basilio (closest to metro station Rebbibia) has an air of shabby decadence. Among the best artworks are those by the natural history specialist Hitnes, facing on to a forgotten-feeling Giulietto Minna Park. Peacocks, parrots and flowers bring the buildings to life, as if nature itself is reclaiming the streets.

03 Quadraro

Quadraro has been notorious for its rebellious spirit ever since World War II, when it was a centre for the antifascist resistance. Street art punctuates the tenement blocks, including Bruno Panieri's painting of a face yawning over an underpass, the tunnel topped by a row of teeth and a pierced pink nose. Head for metro Porta Quadraro.

04 Tor Pignattara

Multi-ethnic Tor Pignattara, best reached by tram, has movie-related, local-hero portraits on its long-closed Cinema Impero. The expressive faces of Pier Paolo Pasolini, Anna Magnani, Mario Monicelli and the Citti brothers stare searchingly outwards, while a nearby building on Via Alessi has been turned almost Lego-ish by Aakash Nihalani.

05 Mercato Trionfale

North of the Vatican, a black-and-white screen goddess bears a Mona Lisa smile across a wide flight of steps that belong to the local food market. Painted by admirer Diavù, the Roman actress Anna Magnani, star of *Rome, Open City* and *Mother Rome*, seems almost to flicker across the concertina folds of the steps. Get there from metro Ottaviano.

06 Tor Marancia

A short walk from the boho southern neighbourhood of Garbetella, once-boring Tor Marancia has morphed into Rome's most colour-rich street art 'hood, courtesy of the Big City Life project. Building-sized murals include French artist Seth's poignant depiction of a young boy balanced on a colourful ladder, the glorious turquoise tendrils of Portuguese artist Pantónio, and Mr Klevra's *Madonna and Child*.

Additional locations

- **Artist:** 2501 **Location:** Via Fortebraccio 10, Rome
- **Artist:** Blu **Location:** Via del Porto Fluviale/ Via delle Conce, Rome
- **Artist:** Pixel Pancho **Location:** Via Pietro Bembo 35, Rome
- **Artist:** Alice Pasquini **Location:** Via Degli Ausoni, Rome
- **Artist:** Faith47 **Location:** 147 Via dei Volsci, Rome
- **Artist:** Hitnes **Location:** Verde tra via Arcevia, Rome
- **Artist:** Momo **Location:** Via del Commercio 36, Rome
- **Artist:** Nicola Verlato **Location:** Via Galeazzo Alessi 215, Rome
- **Artist:** ROA **Location:** Via Sabotino 4, Rome
- **Artist:** Agostino Iacurci **Location:** Via Aquilonia 92, Rome

73

← **Artist:** 2501 **Photo:** 2501 **Location:** Via Fortebraccio 10, Rome

↓ **Artist:** Agostino Iacurci **Photo:** Agostino Iacurci **Location:** Via del Porto Fluviale, 67/B, Rome

→ **Artist:** Herakut **Photo:** Herakut **Location:** Via Capua 14, 00177 Rome

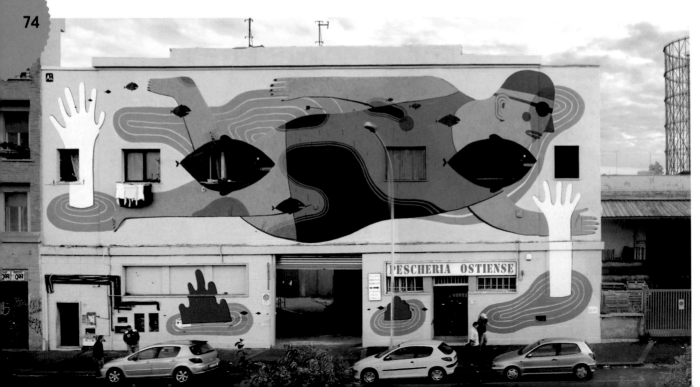

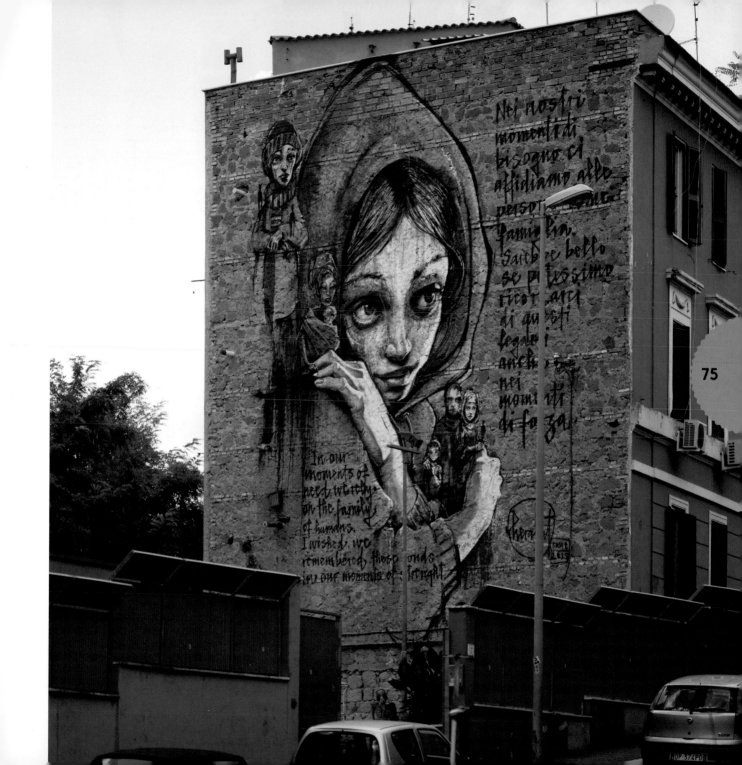

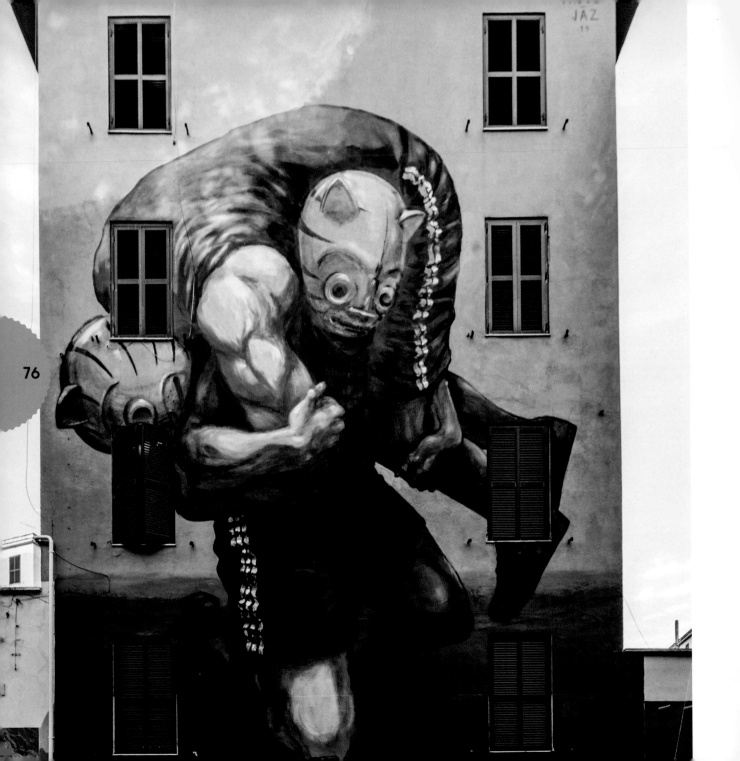

← **Artist:** Jaz/Franco Fasoli **Photo:** Jaz/ Franco Fasoli **Location:** Viale Tor Marancia 63, Rome

→ **Artist:** Seth **Photo:** Seth **Location:** Tor Marancia, Rome

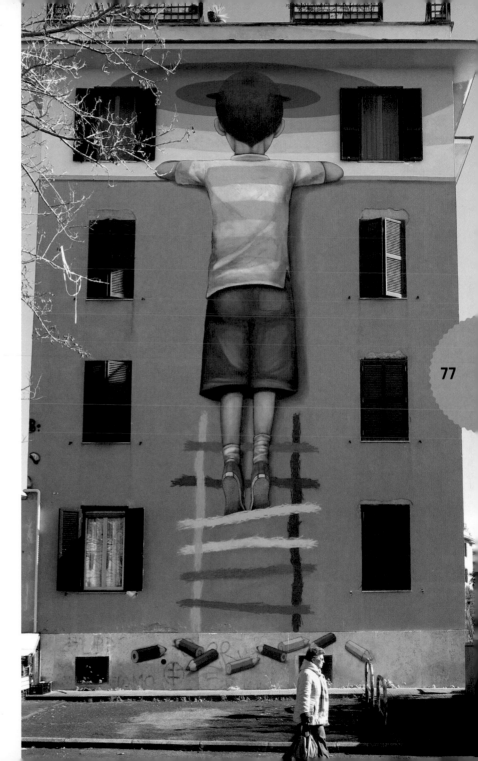

Chicago

USA

Chicago is no stranger to public art – Anish Kapoor's *Cloud Gate* sculpture is one of the most photographed aspects of the city. Historically, however, street art has been the target of hefty fines and millions of dollars spent on buffing and sanitising. More recently, thanks to institutions such as Columbia College, street art has become an important part of the cityscape. In particular, the Wabash Arts Corridor (WAC), established by the college in 2003, is helping to revitalise the South Loop business district by creating an ever-changing artistic urban landscape.

Annual street art events now include the WAC Crawl in October and the Big Walls mural festival in May – the latter attracts major international artists and an increasing array of partners and sponsors, not to mention creating a legacy of murals to rival any in the world. While the selective buffing by the Department of Streets and Sanitation continues, the WAC is helping to educate people about the positive creative and social aspects of street art. For those who prefer things a little more raw and unplanned, there is still plenty of unsolicited art in the West Side.

78

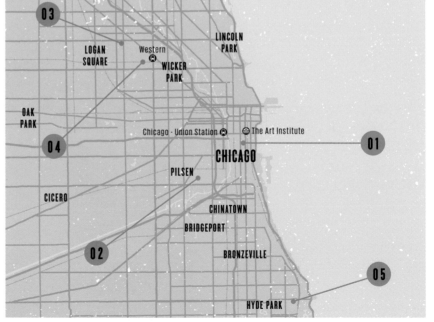

01 Wabash Arts Corridor

Downtown's southern edge has become an urban canvas, with several large-scale murals popping up around a mile-long strip of Wabash Avenue. Thank Columbia College's artsy students for the vivid eyeballs, superheroes, deer and 'Harmony' message beaming from the office buildings. The Red Line to Harrison puts you in the thick of it.

02 Pilsen

Murals splash across churches, schools and cafes in the Mexican enclave of Pilsen, a few miles southwest of downtown. The 16th Street railroad embankment unfurls a rich vein, with 50 elaborate works by local and international artists adorning a two-mile stretch. The Pink Line to 18th Street gets you there.

03 Logan Square

This hipster neighbourhood has the hottest tiki lounges and Michelin-starred taverns, and the sweetest graffiti, too. Ride the Blue Line between Logan Square and Damen stations, and gape as clowns, monsters, leprechauns, monkeys and cartoon characters flash by on rooftops and walls. Street art-focused Galerie F organises the scene.

04 The 606 Trail

This elevated hiking/biking path runs along a repurposed train track for 2.7 miles through the northwest districts of Wicker Park and Logan Square. Community groups have painted murals along the way, some depicting local history, others giving neighbourhood youth a safe space to let loose. Take the Blue Line to Damen.

05 Hyde Park

The University of Chicago's bookish neighbourhood sports heady art under the train tracks on Lake Park Avenue. James Agee poetry, civil rights images and immigrant stories mix together in a whirl of colour. Some of the murals have been there for almost 50 years. Take the Metra Electric Line south to 55th-56th-57th Street station.

Additional locations

- **Artist:** EINE **Location:** University Center, 33 E Congress, Chicago
- **Artist:** Don't Fret **Location:** Corner of Wabash and Roosevelt, Chicago
- **Artist:** Hebru Brantley **Location:** 4642 N Lincoln Avenue, Chicago
- **Artist:** Retna **Location:** 33 E Congress, Chicago
- **Artist:** Pose **Location:** 175 N Racine Avenue, Chicago
- **Artist:** Cleon Peterson **Location:** 634 S Wabash Avenue, Chicago
- **Artist:** Hebru Brantley **Location:** 1640 N Damen Avenue, Chicago
- **Artist:** Icy & Sot **Location:** 1446 W Kinzie Street, Chicago
- **Artist:** Various **Location:** W 16th Street, between S Halsted Street and S Miller Street, Chicago
- **Artist:** ROA **Location:** Corner of Kinzie Street and N Sangamon Street, Chicago

79

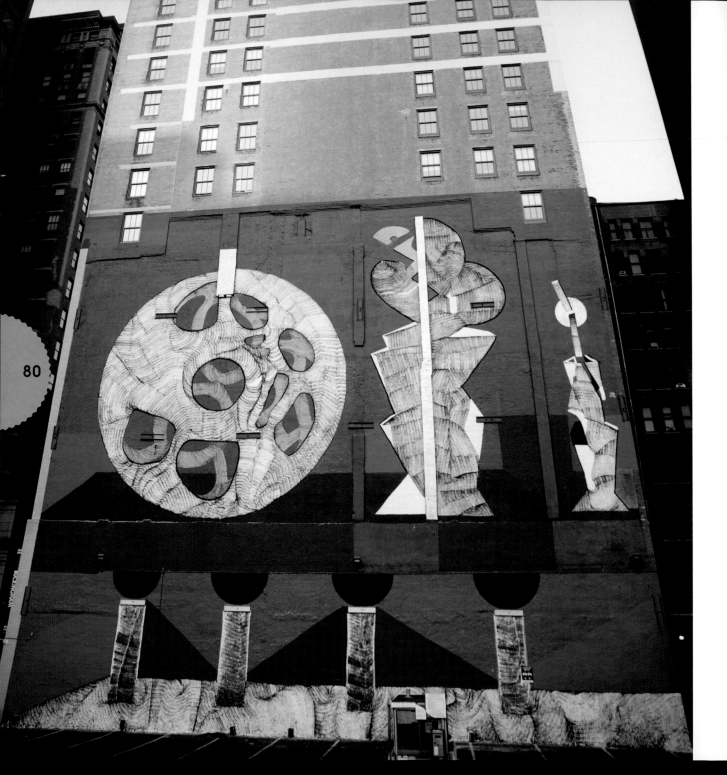

← **Artist:** 2501 **Photo:** 2501 **Location:** 422 South Wabash Avenue, Chicago

→ **Artist:** Ella & Pitr **Photo:** Ella & Pitr **Location:** Corner of Wells & Congress, Chicago

↓ **Artist:** Ricky Lee Gordon **Photo:** Ricky Lee Gordon **Location:** 634 S Wabash Avenue, Chicago

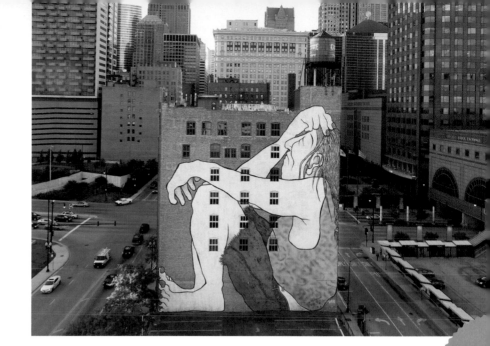

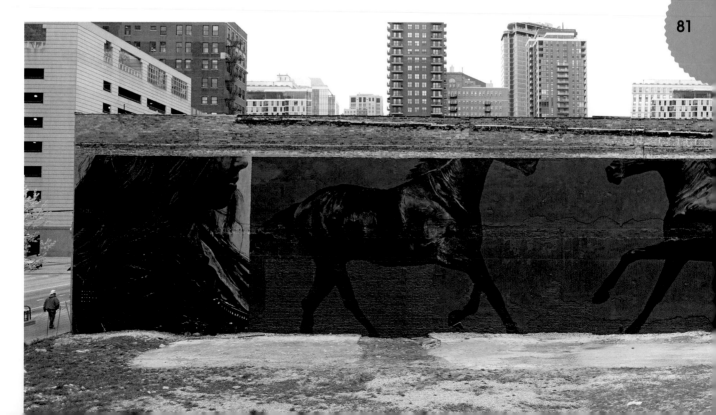

Los Angeles
USA

Famed for its calligraphic 'cholo' graffiti style, which evolved from Latino gang graffiti, the Los Angeles street art scene developed in a noticeably different way to other places in North America, helped by the fact that artists could sometimes take days to paint one piece thanks to the gigantic spread of the city.

LA has a typically laid-back attitude to the crossover between traditional graffiti and street art, with many artists blurring the boundaries. Most notably, Retna – a member of the renowned MSK crew along with the likes of Saber, Revok and Risk – is now just as likely to be found on the cover of a Justin Bieber album or Louis Vuitton storefront as on the streets. His unique script, developed from a combination of gothic, Egyptian, Hebrew and Arabic calligraphy, can be seen in several high-profile locations across the city.

The urban sprawl makes defining 'hotspots' for street art difficult, but fans should make a beeline for the warehouses of the Arts District. Grab a coffee at Stumptown and head north towards The Container Store via Imperial Street, where Belgian artist ROA has installed his giant animals across several blocks. When you inevitably head to the beach, Venice still has active graffiti walls adjacent to the famous skate park.

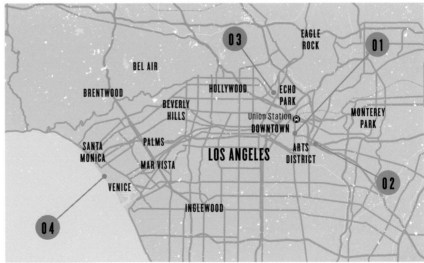

01 Arts District

Set just east of Downtown, LA's Arts District is now fully gentrified but the street art scene remains strong thanks to Shepard Fairey's *Peace Goddess*, some wonderful Tristan Eaton work, and countless subversive sidewalk stencils, psychedelic signatures and even a blown tyre sculpture installation. The best stuff is found around Angel City Brewery. Head for the Little Tokyo/Arts District metro station.

02 Boyle Heights

Street art culture first sprouted in some of America's toughest neighbourhoods, and Boyle Heights, in East Los Angeles, qualifies. Some murals around the Mariachi Plaza metro station have been painted over, but further east on First Street towards St Louis Avenue you'll find more than one illuminated mother Mary, a deadhead mariachi, and an inspired spaceman octopus from Jaime Zacarias (aka Germs) across from an Eben-Ezer Dollar Store.

03 Echo Park & Silver Lake

Street art in and around Echo Park and Silver Lake, two of LA's trendiest 'hoods, still dazzles in places. Club Bahia has a stunning mural that makes for great Instagram fodder, and the glorious Bodhisattva behind Stories bookstore is worth a peek. Further west on Sunset Boulevard are rabid coyotes, a big-eyed girl eating ice cream, green apples with wings and an invitation to 'stand here and think about someone you love'.

04 Venice Beach

A long time stronghold of street art, Venice Beach is at its best on and around Market Street, east of the beach, where buildings are emblazoned with a bulldog chasing butterflies, the Om sign, the Pink Panther, Jim Morrison and a diapered baby fingering the business end of a spray can. The Venice Boardwalk is likewise lined with muraled buildings, and the Public Art Wall on the beach features lettering swollen like blowfish and jagged like talons.

Additional locations

• **Artist:** Nychos **Location:** The Container Yard, 800 E 4th Street, Los Angeles
• **Artist:** Faith47 **Location:** The Last Bookstore, 453 S Spring Street, Los Angeles
• **Artist:** Faith47 **Location:** LAPD HQ, Corner of S Main Street & W 1st Street, Los Angeles
• **Artist:** ROA **Location:** 655 Imperial Street, Los Angeles
• **Artist:** Retna/Kenny Scharf/Shepard Fairey **Location:** 625 N San Vicente Boulevard, Los Angeles
• **Artist:** DabsMyla **Location:** 733 E 3rd Street, Los Angeles
• **Artist:** Low Bros **Location:** 625 North Alvarado Street, Los Angeles
• **Artist:** Fin DAC/various **Location:** Corner of Winston Street and South Los Angeles Street, Los Angeles

83

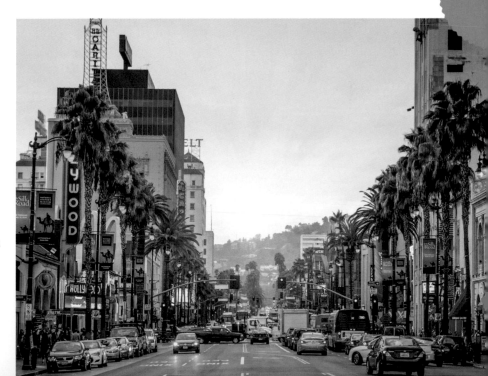

← **Artist:** Jen Stark **Photo:** Jen Stark
Location: 8850 Washington Boulevard,
Los Angeles

↓ **Artist:** D*Face **Photo:** @birdmanphotos
Location: W 3rd Street & Robertson
Boulevard, Los Angeles

→ **Artist:** Cyrcle **Photo:** Cyrcle
Location: Robert F Kennedy Community
Schools, 701 S Catalina Street,
Los Angeles

84

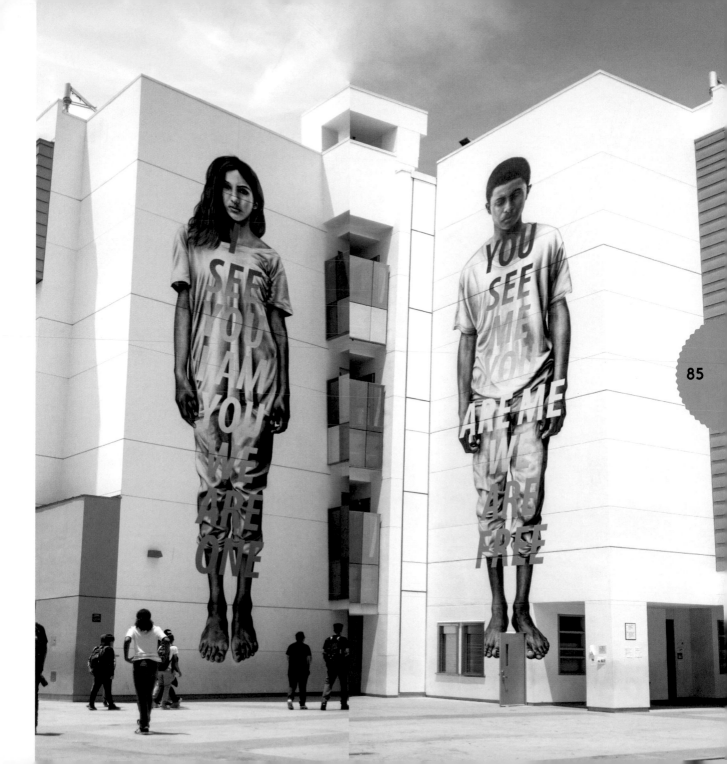

Artist: Herakut **Photo:** Herakut
Location: 12959 Coral Tree Place,
Playa Vista, Los Angeles

86

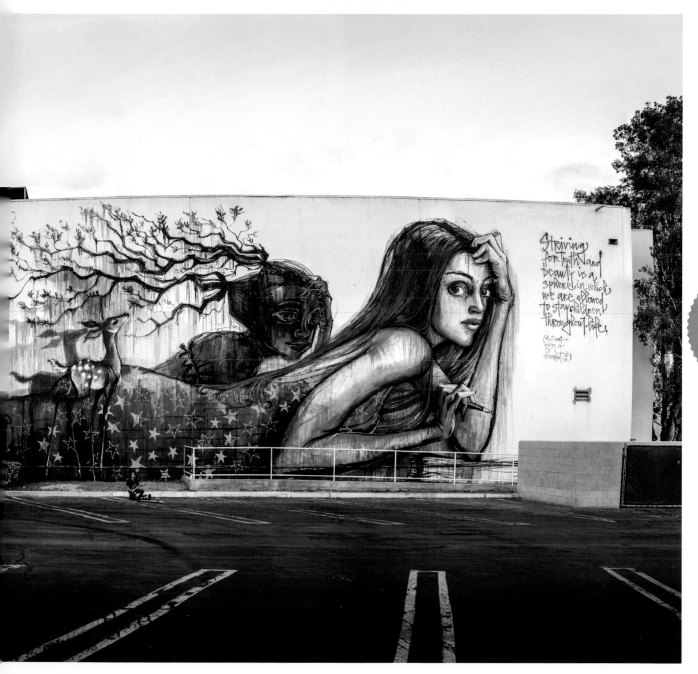

Miami

USA

Fast-paced, stylish and wealthy, Miami has earned itself a high-profile spot on the international street art scene. When leading contemporary art fair Art Basel first arrived in the city in 2002, street art was pretty difficult to find. Today, though, the Miami art scene is as much about what's on the streets as it is about what's on sale in the galleries.

The city offers rich pickings for art lovers: it's home to more than 70 galleries, 12 art studios, five different art fairs and – last but not least – the Wynwood Walls. This ex-industrial area hosts what must be one of the world's largest permanent outdoor art exhibits, featuring big, colourful murals from artists such as Ron English, Shepard Fairey and Kenny Scharf, and attracting 150,000 visitors every month.

The Walls were founded in the late 2000s, when a developer bought property in the area, drawn by its low prices, unique architecture and desirable location. He then invited artists to paint the walls to make the area more attractive to potential renters. The rest is history.

Miami isn't the easiest city to navigate – it's spread out and public transport isn't quite up to the task. However, the Walls are easy to find and an absolute delight to wander around once you're there.

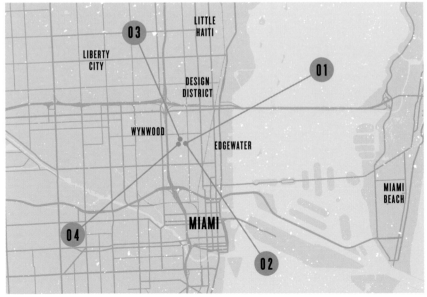

01 Wynwood Walls
The epicentre of industrial Wynwood's revival is this philanthropist-backed initiative that gives some of the world's best street artists a huge wall each. See work by Futura, Miss Van and more – on annual rotation. Every taxi driver in town knows this place, and the number 2 bus stops a block away.

02 Wynwood Doors
Adjacent to the big hitter murals is a smaller public garden where roller-shutter doors are used as canvases for up-and-coming street artists. From Aztec patterns by Cryptik to psychedelic swirls from Daze, see where the art form is headed next. It's a great place to sit on a warm day and just chill.

03 Northwest 27th Street, Wynwood
The streets of Wynwood are covered in street art but a huge Shepard Fairey and Cleon Peterson collaboration is a standout on the colourfully painted NW27th Street. Poking fun at those who are pursuing power and glory, it has a Masonic/Egyptian vibe rendered in modern monochrome.

04 Street Art Tours
Get the inside track on Wynwood's street art and contemporary developments on a street art tour. There are plenty on offer, including a free cycle tour by 'Miami's Best Graffiti Guide' every Sunday at 4pm (www.miamisbestgraffitiguide.com/byobike/). There's also a good 'art walk' every second Saturday of the month.

89

Additional locations
• **Artist:** Herakut **Location:** 1334 N Miami Avenue, Miami
• **Artist:** INTI **Location:** 2520 NW 2nd Avenue, Miami
• **Artist:** Various **Location:** Wynwood Walls, 2520 NW 2nd Avenue, Miami

← **Artist:** Jen Stark **Photo:** Peter Vahan
Location: Miami Airport North Terminal, between terminals D&E, 3rd floor

→ **Artist:** D*Face **Photo:** @rebelsalliance
Location: Jose De Diego Middle School, 3100 NW 5 Avenue, Miami

↓ **Artist:** Nychos **Photo:** Diana Larrea
Location: Wynwood Café, 450 NW 27th Street, Miami

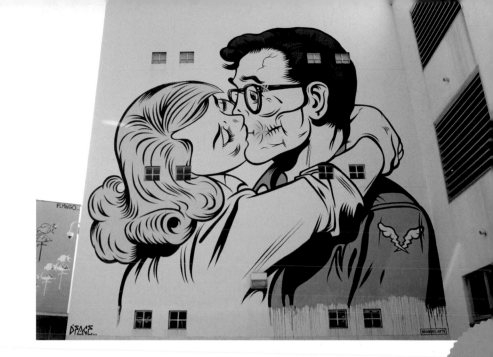

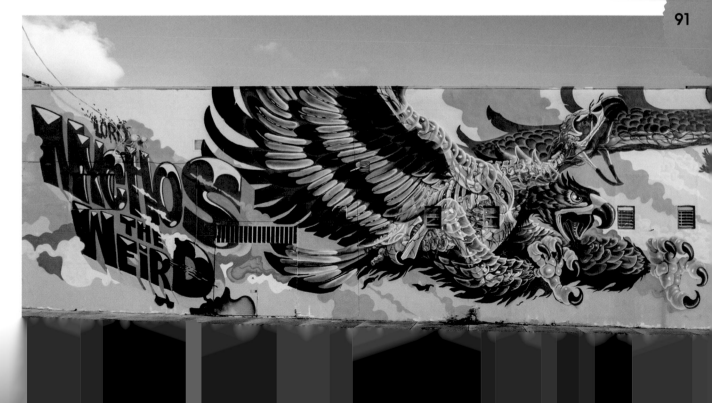

New York

USA

As the birthplace of modern graffiti, it's no surprise that New York and its artists played a starring role in the global growth of street art. Despite the increasingly frequent appearance of commissioned murals, New York's scene retains a rawness. Each area has a distinct vibe, despite sometimes being separated by only a few blocks.

Visitors should gravitate to Williamsburg and Bushwick in Brooklyn – home to many of the city's best-known artists – as well as the Lower East Side, SoHo, NoLita and Harlem. Away from the streets, the new One World Trade Center lobby houses a 27m mural from Brooklyn-based artist José Parlá, who has successfully blurred the line between street and gallery.

If you want to see some traditional graffiti, visit the Hall of Fame at 106th Street & Park Avenue. Sadly, the iconic 5 Pointz in Queens and the Bronx Wall of Fame have been lost to development projects, although the former has been digitally immortalised as part of the Google Street Art Project. Further afield, Coney Art Walls in Coney Island has developed a strong reputation, thanks in part to the involvement of renowned curator Jeffrey Deitch.

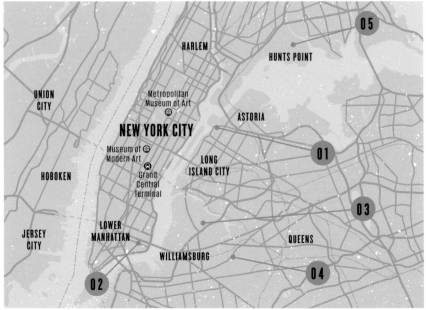

01 Welling Court, Astoria

There's more to Astoria than excellent Greek food; Welling Court is the best spot in Queens for graffiti peeping, promising more than 130 murals that bring together a host of talent from legendary taggers to new-found artists. Take the N/Q trains to 30 Avenue to check out the latest collabs between Ad Hoc Art and local resident Jonathan Ellis.

02 Lower East Side, Manhattan

Start with the Houston Bowery wall, first tagged by Keith Haring in the '70s, then dip further into the SoHo-adjacent neighbourhood where strands of murals (like Freeman's Alley) connect the area's rich tenement history with mainstay urban hangouts like the eponymous Freemans Restaurant. Take the B/D/F/M trains to Broadway-Lafayette Street and snoop in a southeastwardly direction, especially in the evenings when store shutters become art, brought to you by the 100 Gates Project.

03 Greenpoint, Brooklyn

With the world's trendiest borough reaching new levels of popularity, much of Brooklyn – including its street art – has been sanitised as rents continue to rise. But Greenpoint, tucked into the area's northern edges along the G train, still feels refreshingly intact, with un-gentrified warehouses providing the brick canvases needed to execute some of the best street art in the city.

04 The Bushwick Collective

Start your east-of-Williamsburg adventure along St Nicholas Avenue, where more than 50 murals (and counting) add a much-needed splash of colour to the gritty Bushwick vibe. Local businesses offer up their walls, and artists of every stripe lend their creativity to the project, which started in 2011 when Joe Ficalora first had the idea of reimagining the landscape of his neighbourhood.

05 Hunts Point, Bronx

It's well worth the trek to NYC's least visited borough to see over 60m of wall art in the playground of Tats Cru, a coterie of noted taggers. You can also tie in a look at some of the work of the Los Muros Hablan initiative – you'll see their murals peppered along the 6 train as you ride it north to the Bronx.

Additional locations

- **Artist:** Crash **Location:** Bowery Wall, corner of E Houston Street & Bowery, New York
- **Artist:** Buff Monster **Location:** Corner of Chrystie Street & Broome, New York
- **Artist:** Welling Court Mural Project **Location:** 11-98 Welling Court, Queens, NY
- **Artist:** Bushwick Collective **Location:** 19 St Nicholas Avenue, Brooklyn, NY
- **Artist:** 100 Gates Project **Location:** 118 Orchard Street, New York
- **Artist:** OSGEMEOS x Futura **Location:** West-facing wall, PS 11, 320 W 21st Street, New York
- **Artist:** OSGEMEOS **Location:** 26 2nd Avenue, New York
- **Artist:** Tristan Eaton **Location:** Broome Street between Centre Street & Mulberry Street, New York
- **Artist:** Faith47 **Location:** Corner of N 6th Street & Berry Street, Brooklyn, NY

93

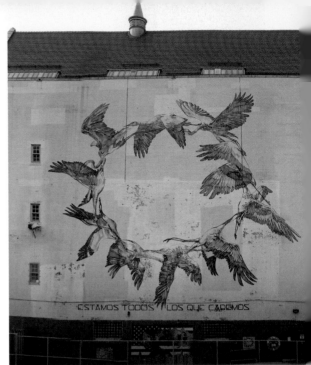

← **Artist:** Faile **Photo:** Scott G Morris D/B/A SGM Photography **Location:** 321 West 44th Street, New York

↑ **Artist:** Faith47 **Photo:** Faith47 **Location:** Madison Avenue side of PS 171, between 103rd and 104th Street, Harlem, New York

→ **Artist:** Invader (NYC_176) **Photo:** Invader **Location:** 322 West 14th Street, New York

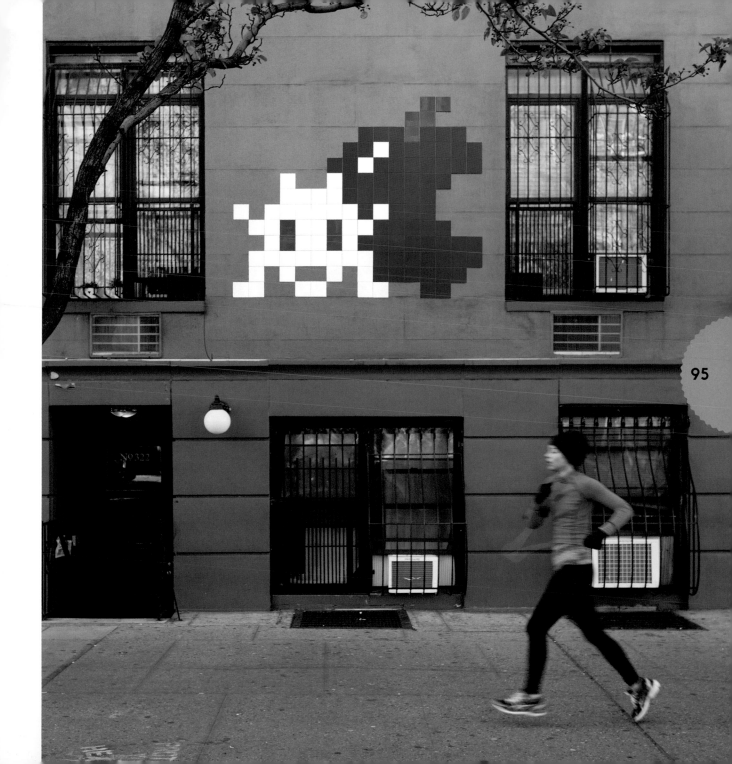

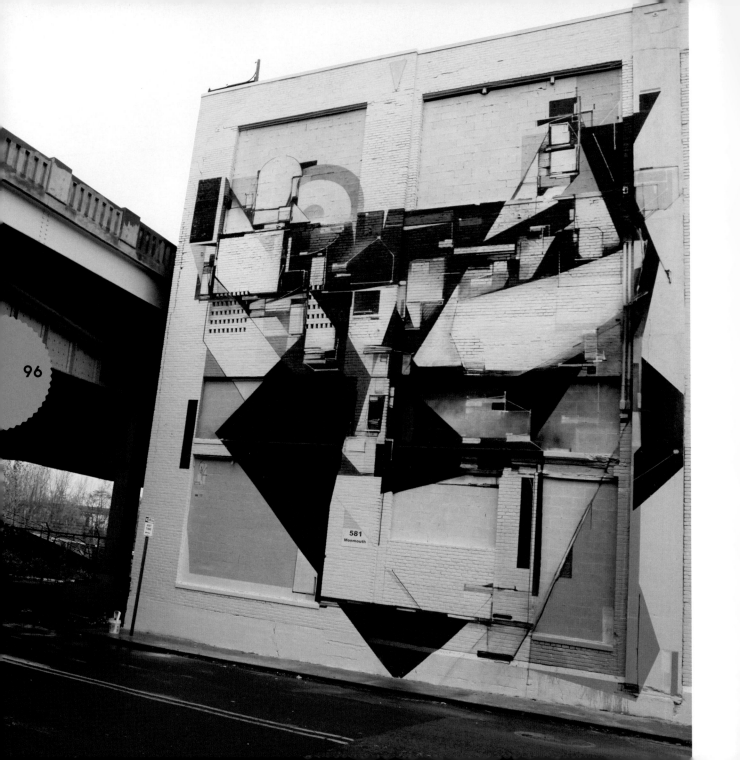

← **Artist:** Augustine Kofie **Photo:** Jaime Rojo **Location:** 581 Monmouth Street, Jersey City, New Jersey

→ **Artist:** Nick Walker **Photo:** Matthew A Eller **Location:** Parking lot, 6th Avenue & W 17th Street, New York

↓ **Artist:** D*Face **Photo:** Bob Gibson **Location:** Coney Island Art Walls, 3050 Stillwell Avenue, Brooklyn, NY

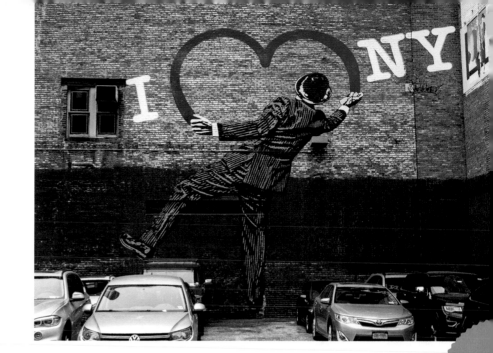

Interview
FAILE

FAILE is a collaboration between Brooklyn-based artists Patrick McNeil and Patrick Miller. The name is an anagram of their first project together, 'A life'. Since 1999, FAILE have become known for their creative explorations of duality through a fragmented style of appropriation and collage. Although painting and printmaking are central to their approach, FAILE have adapted their signature iconography to a vast array of materials and techniques, from wooden boxes and window pallets to more traditional mediums such as canvas, print, sculpture, stencils, installations and even prayer wheels. Their work has been exhibited on the streets and in galleries and museums worldwide.

What was behind your original inspiration to create art on the streets?
Simply to be a part of a small group of people making and sharing art in a public forum, without the need for permission.

How did you come to use stencils and paste-ups?
Stencils were the first method that we used. We were exposed to the idea in Brighton in the UK in the mid '90s, where they were being used to advertise punk bands. We used them initially in our sketchbooks and for making personal work, and then transitioned to the street from there. Meanwhile, in college we started taking silkscreen classes, which gave us the ability to make pasters quickly. As we continued travelling and putting up work internationally, we ran low on pasters and found stencils to last longer and have a wider variety of uses. Stencils also let us incorporate more of the detail of the surface we were working on, and to spontaneously create original hand-painted artworks on-site.

What's your opinion on the current street art scene? Do you miss anything about the early days?
Speaking for ourselves, sometimes we miss the small stuff – the works tucked away in a corner on a quiet street. We miss the spontaneity that came from having to work quickly and in secret. A lot came out of that process. All the energy in the scene has gone to murals now – but murals are also amazing. There is certainly an issue with their links to development and gentrification. But for the most part, as cities grow, they realise that culture, spirit and lasting meaning comes from art. To have original artwork on a large scale incorporated into your city is a beautiful and positive thing.

You've had some very successful exhibitions with major museums and institutions. Do you have to change your way of thinking or working for these kinds of shows?
We always created work for the street and for the studio – the two have a symbiotic relationship that informs each other. We never set out to be 'street artists' per se; we just wanted to be artists. The street

offered a great canvas and dialogue with an audience, but that in itself was never the end goal.

Successful long-term partnerships are rare in art. What's your secret?
I guess we never thought they were that rare. It starts with a strong friendship – that precedes anything. We've known each other since we were 14. There also needs to be a similar hunger for quality in the work. The space to listen to what your partner wants in the creative process. Admitting when you're wrong. Appreciating each other's strengths and weaknesses without limiting each other. And ultimately, knowing that two minds are stronger than one.

What is your favourite place you've painted in your career?
New York between 1998 and 2002. We've been fortunate to paint in many cities around the world, but NYC at that time was so fresh to us. It was much less developed and there was space to work. The surfaces of the streets were constantly evolving – those early experiences inform a lot of the way we see things today.
www.faile.net

San Francisco
USA

San Francisco has been a street art launch pad for over 85 years, thanks to one legendary art power couple, a president, and a motley crew of Mission skate punks. Mural maestro Diego Rivera and surrealist painter Frida Kahlo were newly-weds in 1930, when they were invited to San Francisco for a working honeymoon. Frida painted the couple's portrait, now in SFMOMA's collection, while Rivera completed *The Making of a Fresco Showing the Building of a City* for San Francisco Art Institute.

Inspired by Rivera, muralist George Biddle wrote to President Roosevelt proposing that the government hire muralists to represent social ideals. Roosevelt agreed, funding murals at the Beach Chalet, Aquatic Park Bathhouse, Rincon Post Office and Coit Tower. These proved controversial, and dozens of muralists were branded communists during the turbulent '40s and '50s. But locals embraced the murals as landmarks, and street art bloomed during the Flower Power years of the '60s . In the '70s and '80s, artists opposing US intervention in Latin America took to the Mission's streets, covering Balmy Alley with bold political statements.

Schooled by Mission muralistas, a generation of skateboarding graffiti punks made their marks across San Francisco in the '90s, catapulting from Clarion Alley to the Venice Biennale. Graffiti stars Rigo 23, Barry McGee and Margaret Kilgallen were trained at SFAI and Stanford, and their urban folklore 'Mission School' style is both streetwise and meticulously crafted. Today you'll spot next-generation 'Beautiful Losers' aiming spray cans citywide, carving up Potrero del Sol skatepark and launching museum careers at local galleries.

100

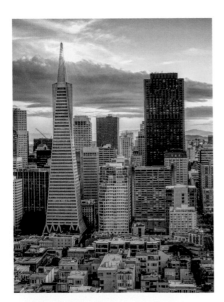

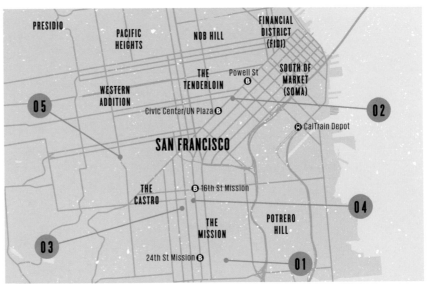

01 Balmy Alley

San Francisco's most vivid memories are captured in this mural-covered alleyway, from Mission pioneer days through to the AIDS crisis. Mural advocacy non-profit Precita Eyes preserves Balmy's decades-old murals and commissions new ones with funds raised from muralist-led walking tours. Take BART to 24th Street and walk/skate here – Potero del Sol skatepark is three blocks away.

02 Luggage Store Gallery

The soft spot in SF's tough Tenderloin district is non-profit Luggage Store Gallery, which has been lifting graffiti artists above the fray since 1989. Urban legends Barry McGee, Tauba Auerbach and Clare Rojas launched careers at this upstairs space at Market and 6th – enter the tag-covered door below the rooftop mural by OSGEMEOS. Luggage Store also rehabbed syringe-strewn Cohen Alley into the Tenderloin National Forest creative commons, featuring Rigo's *Cultural Geometry* walkway and murals by Andrew Schoultz, Nome and Johanna Poethig.

03 Women's Building

Street art doesn't get more epic than *MaestraPeace*, the resplendent mural wrapped around the Mission District's pioneering Women's Building, home to local women's non-profits since 1971. Painted by 26 women muralistas in 1994 and restored in 2012, this four-storey mural celebrates powerful women worldwide, from ancient goddesses to Nobel laureates.

04 Clarion Alley

To see what's on San Francisco's mind lately, take a shortcut through this outdoor gallery between Valencia and Mission Streets near 16th Street BART. CAMP artists' collective curates Clarion's coveted garage-door spaces, where artists address hot topics like transgender identity, gentrification and police brutality. Debate is encouraged, but one point of consensus stands: tagging Clarion is seriously uncool.

05 Haight Street

Inspiration is a downhill slide past Haight's mural-covered storefronts, from Ashbury's historic hippie crossroads to Fillmore's skate-punk hangouts. Start at Cole St with 1967's *Evolutionary Rainbow* mural spanning the Big Bang to Flower Power, test alt-history knowledge with the restored 1994 *Anarchists of the Americas* mural at Bound Together Book Collective, then roll down to Jeremy Fish murals and graffiti-art hoodies at Fifty24SF.

Additional locations

- **Artist:** Various **Location:** Linden Street, San Francisco (also home to the original Blue Bottle Coffee store)
- **Artist:** OSGEMEOS x Mark Bode **Location:** Warfield Theatre, 60-88 Taylor Street, San Francisco
- **Artist:** Banksy **Location:** 539 Broadway, San Francisco
- **Artist:** OSGEMEOS **Location:** 1007 Market Street, San Francisco
- **Artist:** Nychos **Location:** Geary Street and Shannon Street, San Francisco
- **Artist:** How & Nosm **Location:** 200 Hyde Street, San Francisco
- **Artist:** BiP **Location:** 666 Larkin Street, San Francisco
- **Artist:** EINE **Location:** 222 Octavia Street, San Francisco
- **Artist:** Augustine Kofie **Location:** Corner of Larkin Street and Post Street, San Francisco

101

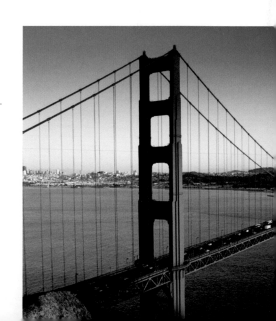

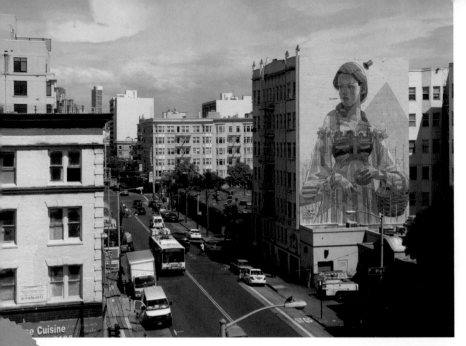

← **Artist:** Aryz **Photo:** Aryz **Location:** 691 Eddy Street, San Francisco

↓ **Artist:** Nychos **Photo:** Brock Brake **Location:** 540 Howard Street, San Francisco

→ **Artist:** Barry McGee **Photo:** Stash Maleski/ICU Art, Courtesy Sites Unseen **Location:** Moscone Contemporary Art Center & Garage, 255 3rd Street, San Francisco

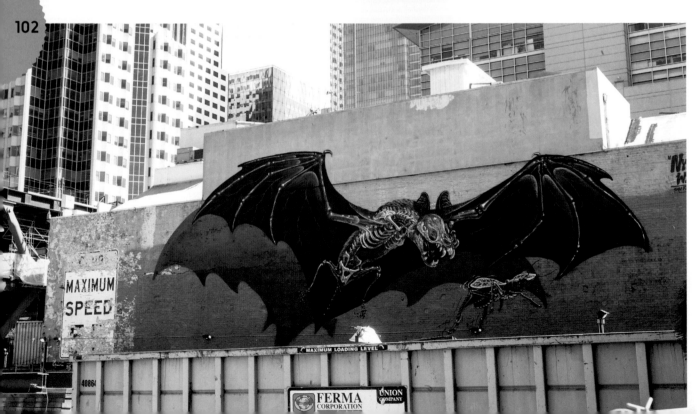

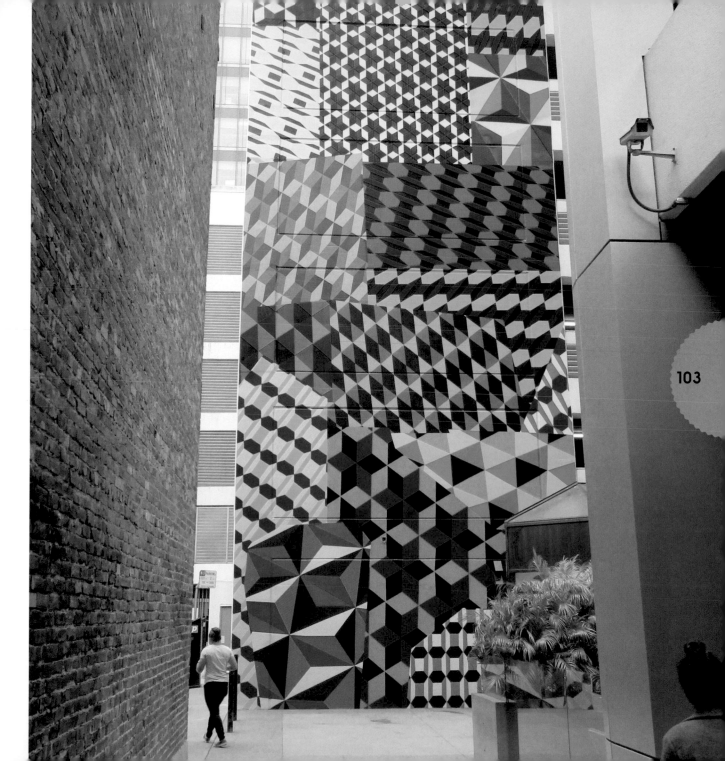

103

Toronto
Canada

It may come as a surprise – especially if you're from a major multicultural metropolis like London or Los Angeles – but Toronto is one of the most culturally diverse cities in the world. More than half its population was born outside Canada, and its residents are made up of 230 different nationalities. As is often the case, cultural diversity brings creative inspiration, and this is certainly true in Toronto. Possibly the most famous street art hotspot in Canada is here: the aptly named 'Graffiti Alley', which runs the length of half-a-dozen blocks in Chinatown. Heading north brings you to the boho Kensington Market, where you'll find plenty more works to enjoy.

There are large-scale murals across the city too, with projects such as Spectrum Art Projects and StreetARToronto (StART) working with local artists and major international names to bring colour to the streets. StART is a council-backed initiative that aims to develop creative outlets for graffiti and street artists, in the hope that the more vandalistic aspects of the art form can be avoided. The abundance of street art in the city is proof that such progressive thinking can be effective.

104

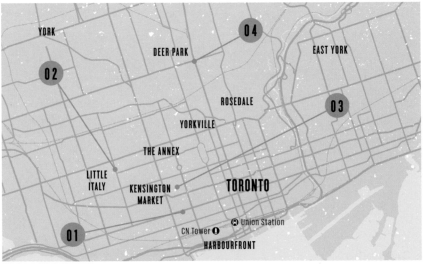

01 Graffiti Alley

Canadian comedian Rick Mercer made this alleyway Toronto's most popular street art destination after he began filming his 'rants' – commentary on whatever irks him – while walking between its colourfully tagged walls. Officially known as Rush Lane, the alley is south of Queen Street West, between Portland Street and Spadina Avenue.

02 Ossington Avenue

Poke around the alleys off Ossington Avenue, north of Queen Street West, for an eclectic range of art. In one lane between Queen Street and Humbert Street, artists have used garage doors as canvases. Another mural series, *A Love Letter to the Great Lakes*, incorporates fish, ships, and other aquatic images.

03 Kensington Market

In this funky Toronto district just west of downtown, where a Latino market sits opposite an Indian spice shop and you can eat everything from Chilean *empanadas* to Chinese dumplings, brick walls are tagged with a changing array of murals. Catch the streetcar to Carlton or Spadina.

04 Padulo Building

The exterior of this north-of-downtown office building (on St Clair Avenue West at Yonge Street) is covered by one massive mural. The eight-storey black-and-white work by British street artist Phlegm resembles a human figure, but up close it's detailed with Toronto landmarks, from the CN Tower to the St Lawrence Market.

Additional locations

- **Artist:** Herakut **Location:** 1135 Dundas Street E, Toronto
- **Artist:** Various **Location:** Graffiti Alley, Toronto
- **Artist:** Faile **Location:** Bathurst Street just north of Davenport Rd, Toronto
- **Artist:** Maya Hayuk **Location:** 227 Lansdowne Avenue, under flyover, Toronto
- **Artist:** Shepard Fairey **Location:** 567 Queen Street W, Toronto
- **Artist:** El Mac **Location:** 4 Bestobell Road, Toronto
- **Artist:** Faith47 **Location:** 100 Queen Street W, Toronto
- **Artist:** Jimmy Chiale **Location:** Studio 835, 835 Bloor Street W, Toronto
- **Artist:** Various **Location:** Underpass Park, Lower River Street beneath the Eastern Avenue overpass, Toronto

105

© Zun Lin Zheng / EyeEm, bobloblaw / Getty Images

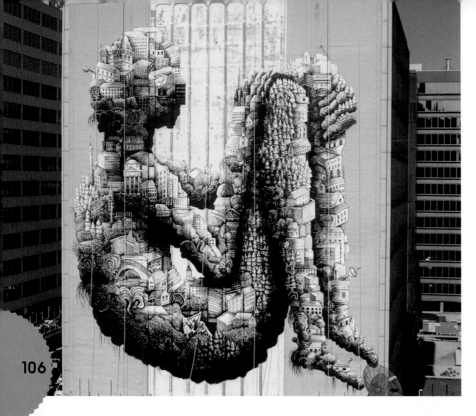

← **Artist:** Phlegm **Photo:** Yen Chung
Location: Yonge Street and St Clair
Avenue, Toronto

↓ **Artist:** Various **Photo:** Amber Dawn
Pullin **Location:** Graffiti Alley, Toronto

→ **Artist:** Jesse Harris **Photo:** Jesse Harris
and Cooper Cole **Location:** 1059 Queen
Street W, Toronto

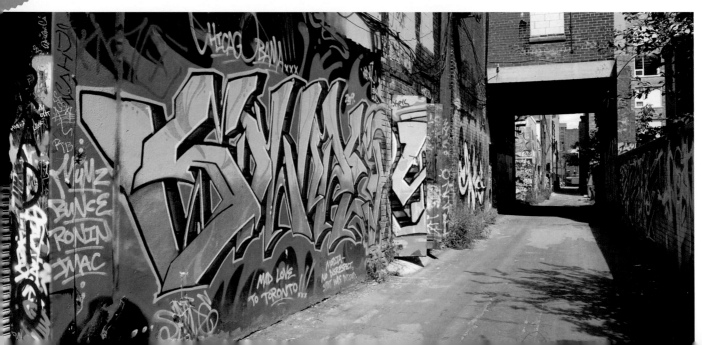

Artist: Nunca **Photo:** Jan Normandele
Location: South side of 52 McCaul Street,
Toronto

Buenos Aires

Argentina

The fourth most populous city in the Americas, Buenos Aires shares a very active contemporary street art scene with its table-topping cousins. The European-influenced architecture of the city provides creates a great backdrop for street art, reminiscent of cities such as Valencia, Barcelona and Lisbon. Unlike in those cities, however, there is no need to obtain permission from local authorities to create new murals in Buenos Aires – you simply need permission from the property owner. This legal and logistical freedom has led to an active and innovative street art scene, built on the city's historical legacy of stencil-based political protest art.

Street art flourishes throughout the city, but areas particularly worthy of attention include Coghlan and Villa Urquiza. Here, a now-abandoned plan for a new motorway led to the demolition of many buildings and the creation of scores of giant murals, including one by famed local artist Martin Ron. The city is also a magnet for international artists; check out the Italian Blu's incredible stop-motion video *Muto*, which was primarily filmed here. Several of the paintings from the video are still visible on the streets today.

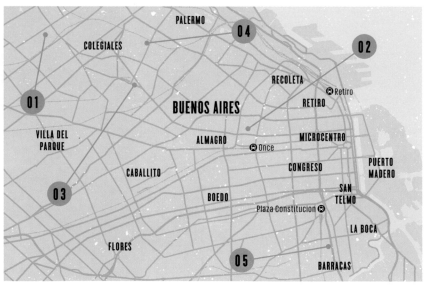

01 Villa Urquiza

Jump off the train at Drago to explore the multiple murals of the leafy, bohemian neighbourhood of Villa Urquiza in the affluent northern suburbs. The jaw-dropping, 412 sq m surrealist work *The Parrots' Tale* by Martin Ron is just the beginning; the residential streets that surround it are home to a patchwork of exquisite pieces.

02 Abasto

A series of murals depicting iconic tango-crooner Carlos Gardel can be seen close to the singer's former Abasto home on the street Jean Juares. The adjacent houses are painted in the local *fileteado* style, while the cobbled, pedestrianised street Zelaya is a veritable gallery of painted and mosaic-tiled Gardel portraits interspaced with tango lyrics.

03 Federico Lacroze

Buenos Aires' street artists, including Primo, Jiant and Ice have gone underground, collaborating to brighten the platforms of several of the city's metro stations. Take the B-line to Federico Lacroze in Chacarita to see two exotic murals: a 90m jungle scene with Amazonian tribesmen facing a rainforest montage of caterpillars, iguanas, piranhas and birds.

04 Colegiales

Hop across Avenida Dorrego and just steps away from the swanky bars and media professionals of Palermo Hollywood you'll find the street artists' playground of Colegiales. Start by checking out the mishmash of murals at the *mercado de las pulgas* (flea market), before exploring the many works on the streets surrounding Plaza Mafalda.

05 Barracas

Abandoned warehouses are the canvas for some stunning street art in the working-class neighbourhood of Barracas on the city's southern edge (it's best not to walk around here alone). The eeriness and melancholy of the empty, industrial buildings contrasts with the colourful murals, including the magnificent *Pedro Lujan and his Dog* by Martin Ron.

Additional locations

- **Artist:** Aryz **Location:** Avenue Independencia 688, Buenos Aires
- **Artist:** Ever **Location:** 9 de Julio 1135, Luján, Buenos Aires
- **Artist:** Various **Location:** Adjacent to Roberto Goyenech between Av García del Río and Av Congreso, Buenos Aires
- **Artist:** Various **Location:** Post St. Bar, Thames 1885, Buenos Aires
- **Artist:** Martin Ron **Location:** Holmberg 2664, Buenos Aires
- **Artist:** ROA **Location:** Corner of Araoz and Castillo, Buenos Aires
- **Artist:** Gaia **Location:** Ghelko Factory, Vieytes 1601, Buenos Aires
- **Artist:** Alice Pasquini **Location:** 4021 Valderrama, Buenos Aires
- **Artist:** Jorge Rodriguez Gerada **Location:** Corner of Venezuela and Tacuari, Buenos Aires

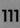

111

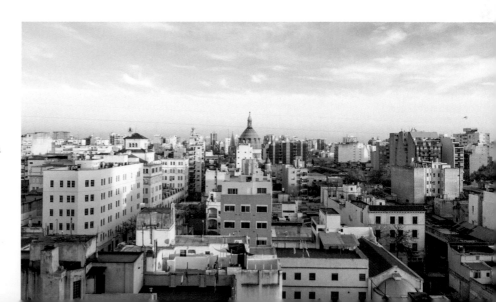

← **Artist:** Telmo Miel **Photo:** Telmo Miel
Location: Agustín R. Caffarena 110,
Buenos Aires

→ **Artist:** Elian **Photo:** Elian **Location:**
Villarino 2299, Barraccas, Buenos Aires

↓ **Artist:** David de la Mano **Photo:** David
de la Mano **Location:** Carlos Calvo 816,
Buenos Aires

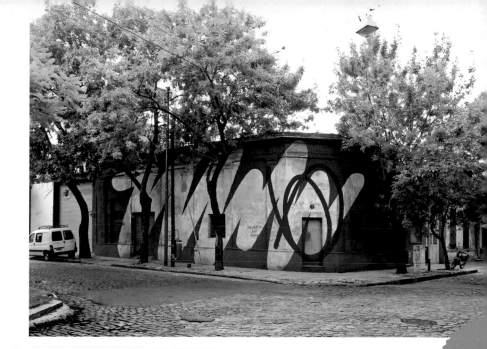

Mexico City
Mexico

Crowded, cosmopolitan and with a lot to say for itself. Mexico City has a long tradition of muralism, first made famous by Mexican artist Diego Rivera in the 1920s. Much like those who followed in his footsteps, Rivera wasn't afraid to use his art to tackle contentious issues. Today, street artists use the city's vast amount of wall-space (as well as buses, phone booths and construction boards) as a canvas to explore Mexico's social and political issues, from the cult of the drug lords to the plight of Central American migrants.

Although street art can be found throughout the city, an exploratory wander will be most rewarding in the Colonia Condesa, Colonia Doctore and Colonia Roma Norte districts. The birthplace of Mexican street art is Xochimilco, an area famous for its canals that is best experienced on board a colourful 'Trajineras' raft.

In 2007, Foro Cultural MUJAM brought together more than 2000 artists for its first International Graffiti Festival, with a second festival in 2012 giving birth to the ongoing operation All City Canvas. Much of the work from this festival is still on the streets, including a unique portrait by Portuguese artist Vhils at Juarez 26, Colonia Centra. Street Art Chilango (www.streetartchilango. com) is a great resource for visitors.

114

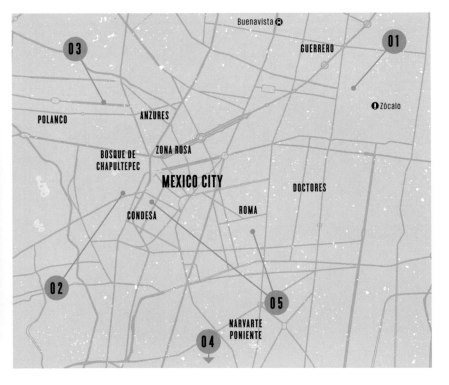

01 Centro Histórico

Centring around the Zócalo – once the heart of Aztec civilisation, now a bustling Spanish-style square – Mexico City's oldest neighbourhood is rich with ancient ruins and architectural landmarks. Wandering these streets you'll stumble on many large-scale murals and colourful stencils, some referencing the city's tumultuous history, on the walls of colonial buildings.

02 Chapultepec Park

The largest city park in the Americas might not seem like an obvious venue for urban art, but it contains one key draw for art aficionados: a notable work by Diego Rivera. He may be famed for his murals, but in Chapultepec Park Rivera turned to urban infrastructure, creating the *Fuente de Tláloc* – a giant tiled fountain, complete with painted water tanks.

03 Polanco

North of Chapultepec Park, posh Polanco is home to several museums, including one, the Sala de Arte Público Siqueiros, that's dedicated to the Mexican muralist David Alfaro Siqueiros. The building itself doubles as a canvas: as part of an ongoing project, the organisation continually invites artists to paint the exterior.

04 Coyoacán

Metro Line 3 takes you into the colonial suburb of Coyoacán, Frida Kahlo's old stomping ground, where you'll find a small showcase of public art devoted to the beloved Mexican artist. The area is also the gateway to Ciudad Universitaria, UNAM's main campus, with works by Siqueiros, Rivera and Juan O'Gorman adorning the rectory, stadium and library.

05 Roma & Condesa

Where the cool *chilango* kids go, the street art scene is sure to follow. The streets of Roma and Condesa, twin barrios of hip, conveniently wedged between the historic centre and Chapultepec Park, stage an eclectic and ever-changing mix of murals by Mexican and international artists.

Additional locations

- **Artist:** Saner **Location:** Hotel Reforma Avenue, Donato Guerra 24, Cuauhtémoc, Mexico City
- **Artist:** Vhils **Location:** Avenida Juárez 26, Colonia Centro, Centro, Mexico City
- **Artist:** ROA **Location:** MUJAM, Calle Dr Olvera 15, Cuauhtémoc, Doctores, Mexico City
- **Artist:** Saner x Aryz **Location:** 19 de Fray Servando T de Mier Jardín Balbuena, Mexico City
- **Artist:** Escif **Location:** Chihuahua building, Almacenes 74, Tlatelolco, Mexico City

115

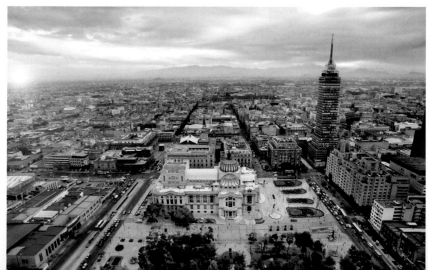

← **Artist:** Augustine Kofie
Photo: Augustine Kofie **Location:** Calle Tonalá 91, Delegación Cuauhtémoc, Col Roma Norte, Mexico City

↓ **Artist:** D*Face **Photo:** @rebelsalliance **Location:** Rear, Av Cuauhtémoc 273, Roma Norte, Mexico City

→ **Artist:** Guido van Helten
Photo: Guido van Helten **Location:** Estación 6 Deportivo, San Andres de la Cañada, Ecatepec, Mexico City

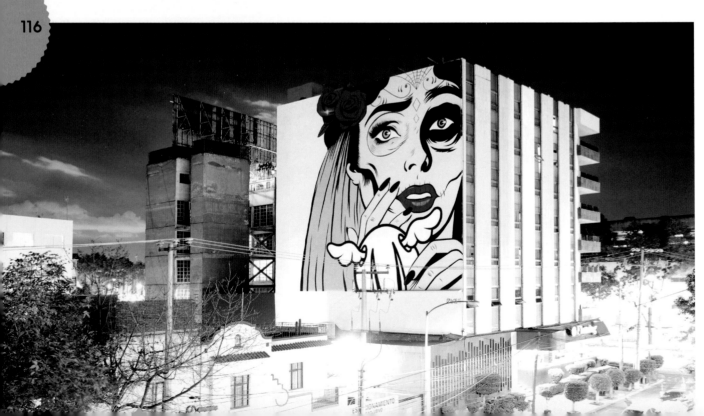

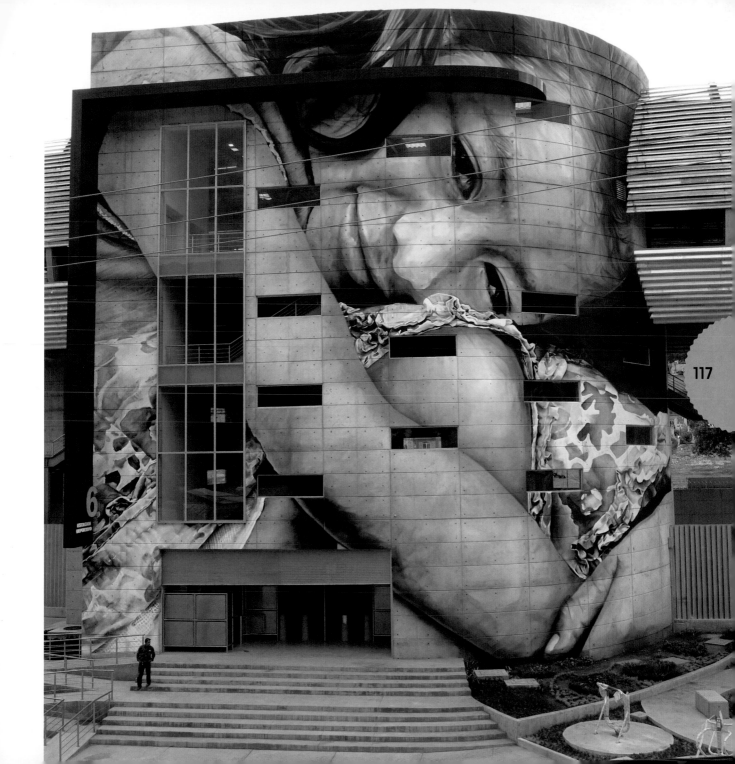

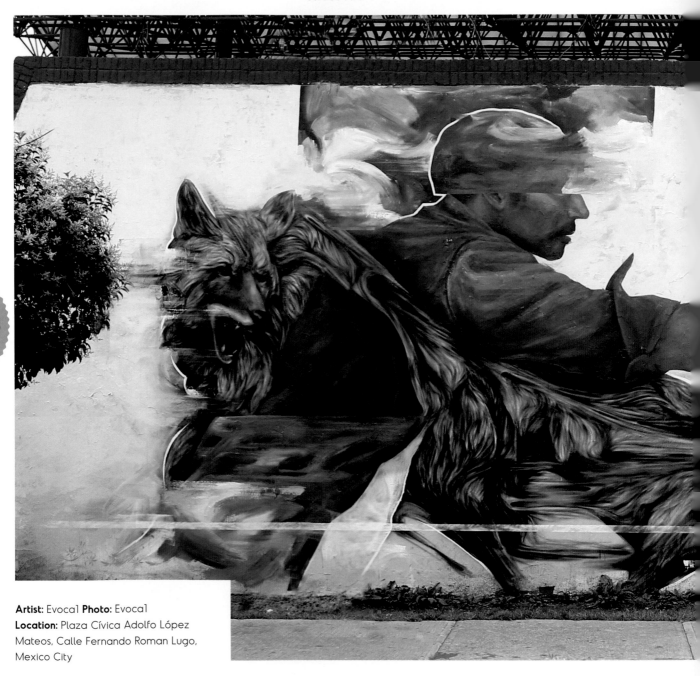

Artist: Evocal **Photo:** Evocal
Location: Plaza Cívica Adolfo López
Mateos, Calle Fernando Roman Lugo,
Mexico City

São Paulo
Brazil

Prior to experiencing the São Paulo street art scene for the first time, it's worth educating yourself about the history behind the visual onslaught of tagging that seemingly adorns every surface in this sprawling urban metropolis. *Pichação* ('writing in tar') began as political graffiti during the Brazilian dictatorship, with its distinct calligraphic font inspired by the heavy metal album covers that dominated the São Paulo airwaves during the 1980s. Today, however, the 'Pichadores' are mostly interested in extreme tagging, with success measured in volume and height – the latter gained through use of modified fire extinguishers, roller extensions and life-or-death free climbing.

It's impossible to speak about São Paulo without mentioning the pioneering street art twins, OSGEMEOS. Their iconic yellow characters are prominent in cities across the world, and the duo now have major gallery representation. Alongside Brazilian peers such as Nunca (see interview p124), Cranio, Nina and Eduardo Kobra, their distinctive visual styles help to define contemporary Latin American art. The must-see street art hotspots in the city include Beco do Batman (Batman's Alley) and the streets surrounding the Centro Cultural Rio Verde on Rua Belmiro Braga.

120

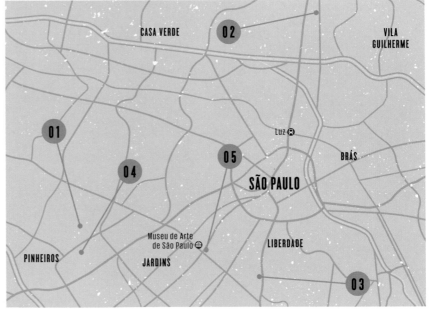

01 Beco do Batman

São Paulo's most famous street art hotspot, this narrow, curving alley in the bohemian neighbourhood of Vila Madalena is covered head-to-toe in eye-popping murals, including some from internationally known graffiti artists such as Speto and Paulo Ito. This is the domain of photo shoots, video shoots, films and TV shows – even Jamie Oliver has broadcast from here! – and is easily accessible from Vila Madalena metro station.

02 MAAU (Museu Aberta de Arte Urbana)

This open-air urban art museum features 33 murals – from the likes of well-known local artists Binho Ribeiro, Magrela, Enivo, Crânio, Caps, Feik, Sliks, Inea, Chivitz and Minhau – tagged across underpass support walls of the metro's blue line. The deal to create the space was struck between the city and urban artists after a few went to jail for illegal tagging in 2011. It's 200m north of the metro station Carandiru in a grittier area.

03 Av 23 de Maio

São Paulo comes alive along Avenida 23 de Maio between Ibirapuera Park and the city's historic centre – it's the largest open-air art gallery in Latin America. At the invitation of São Paulo Mayor Fernando Haddad in 2014, local urban artists such as Ozi, Mauro Neri, Mundane, Nick Alive, Tikka Meszaros, Toddy, Barbara Goy and Rui Amaral reimagined 70 walls (a 15,000 sq m canvas) across nearly six kilometres – best seen by car or taxi.

04 Pinheiros

The hip neighbourhood of Pinheiros, easily reached by metro, is ideal for checking out some of the best known murals by Eduardo Kobra, one of Brazil's most celebrated graffiti artists. At Club 27 on Rua Sumidouro there's an homage to musicians and artists who died at the age of 27 (Janis Joplin, Amy Winehouse, Jimi Hendrix, Jean-Michel Basquiat, Jim Morrison and Kurt Cobain), while at the FNAC on Praça dos Omaguás, it took 300 spray cans for Kobra to pay tribute to musician Chico Buarque and playwright/author Ariano Suassuna.

05 Av Paulista

Unmissable both literally and figuratively, Eduardo Kobra's most striking mural pays tribute to legendary Brazilian architect Oscar Niemeyer. Clocking in at 52m high and 16m wide, it took the artist and his team a year to splash the colourful portrait on the Ragi Building at Praça Oswaldo Cruz in front of Shopping Pátio Paulista. It's a ritzy neighbourhood – the financial beating heart of São Paulo – located 400m southeast of the metro station Brigadeiro.

Additional locations

- **Artist:** Interesni Kazki **Location:** Rua Rêgo Freitas 285, São Paulo
- **Artist:** Cranio **Location:** Rua Domingos de Morais 2023, São Paulo
- **Artist:** Jaz/Franco Fasoli x Conor Harrington **Location:** Rua Vitória 872, Jardim Ataliba Leonel, São Paulo
- **Artist:** INTI x Alexis Diaz **Location:** Vale do Anhangabau, São Paulo
- **Artist:** Eduardo Kobra **Location:** 46 Avenida Paulista, São Paulo
- **Artist:** 2501 x Speto **Location:** Largo do Arouche 370, São Paulo
- **Artist:** Cranio **Location:** Rua Turiassu 2113, São Paulo
- **Artist:** Various **Location:** Rua Padre João Gonçalves, São Paulo
- **Artist:** Arlin Graff **Location:** 133 Rua Rodrigo Lobato, São Paulo
- **Artist:** Vhils **Location:** Rua Minas Gerais 350, São Paulo
- **Artist:** Nunca/Nina **Location:** 731 Avenida Vinte e Três de Maio, São Paulo

121

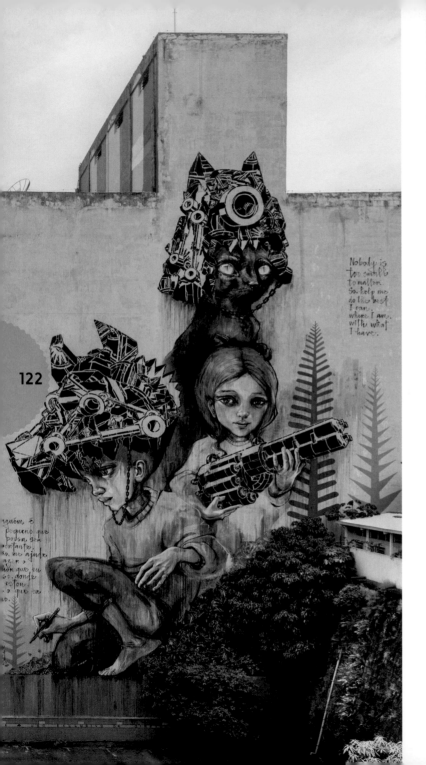

122

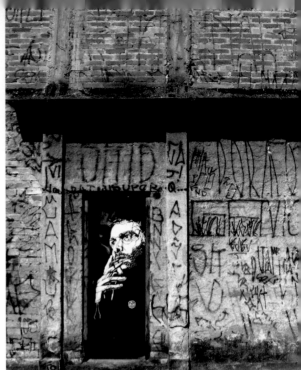

← **Artist:** Herakut **Photo:** Herakut
Location: Avenida Prestes Maia 316,
Centro, São Paulo

↑ **Artist:** C215 **Photo:** C215
Location: Rua Simpatia 127, Jardim das
Bandeiras, São Paulo

→ **Artist:** Invader (123: SP_45)
Photo: Invader **Location:** Avenida 9 de
Julho 1135, São Paulo

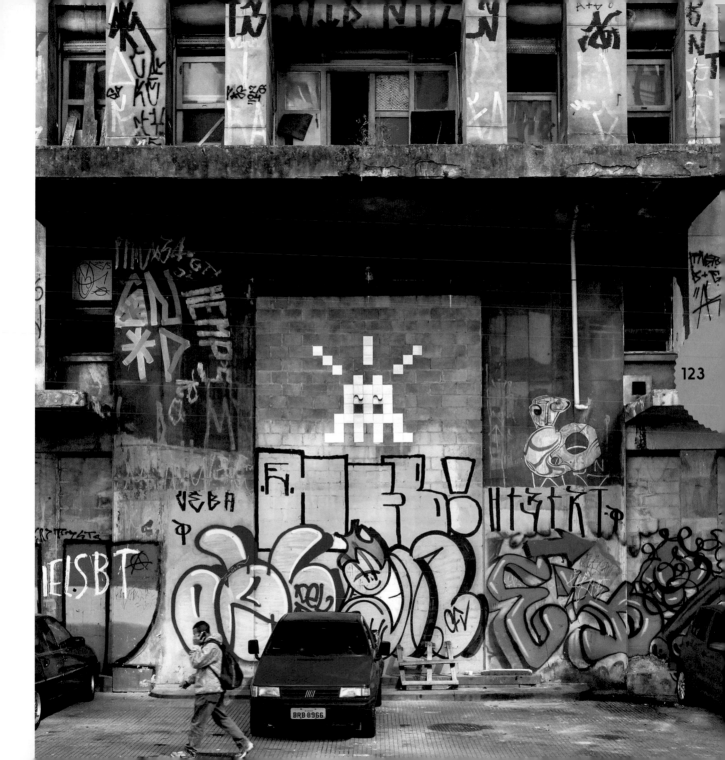

Interview

Nunca

Nunca ('never' in Portuguese) is the artistic pseudonym of Francisco Rodrigues da Silva, a Brazilian artist known across the world for his unique style. Having initially made his mark growing up as a *pichador* in São Paulo, his style gradually evolved to incorporate more colourful and figurative forms, depicting images that combined the historic indigenous culture of Brazil with modern social, political and environmental messages. In 2008, Nunca was among a handful of artists commissioned to install giant murals on the facade of the

Tate Modern in London as part of its groundbreaking street art exhibition, bringing further international attention to his work.

What originally inspired you to create art on the streets?
The same as today: to be free to create what I want, with the materials I have. And to find different ways of using the street as a medium, with no need for the credibility of any art institution or gallery.

Your contemporaries all share a very unique, recognisable visual style. What do you think it is about Brazil and São Paulo in particular that feeds into this?
For me it was both to break and yet still somehow retain the visual tradition of painting in the street with graffiti, while trying to bring something about living in a violent and crowded city like São Paulo. I live in a country with such a cultural richness, and with so many different people living together and yet separated at the same time by cultural or social barriers.

You made history by painting a mural on the front of the Tate Modern in London in 2008. Almost a decade later, do you think the art establishment has done enough to support street art?
A lot of solo and group shows of artists that came from a graffiti background happened as a result of the Tate Modern show, but it's true that there are few critics or curators looking at 'street art' with a deeper intent. It seems like the art establishment still doesn't see it as serious creative expression, or as something that has a strong conceptual body. As an artist, it seems to me more like something

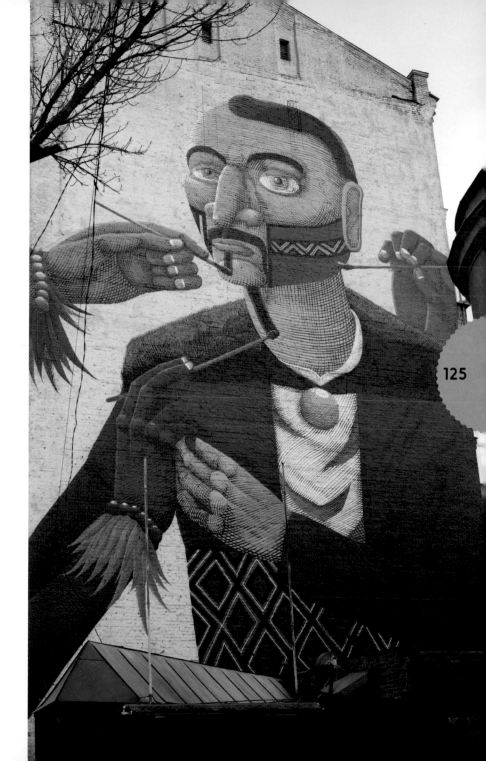

that has to be done individually than as a movement, to bring this kind of attention and understanding.

Your work tends to carry strong social, political and environmental messages. Why is street art such a good vehicle for this?
Street art is a 'young blood' thing, but I hate this term. The act of painting in the street – doing graffiti, street art or any other kind of expression – is such a powerful tool that's closer to the public than any other kind of art. It doesn't need the credibility of any third party for thousands of people to see it every day. All you need is paint and the balls to break some property laws.

What is your favourite place you've painted in your career and where would you most like to paint if you had the choice?
Every piece and every place is a different and unique experience, so I prefer not to say one in particular is my favourite. For me my best piece is always my next one.
www.facebook.com/nunca.art

125

Adelaide
Australia

There is a good reason for Adelaide's nickname 'Radelaide' – South Australia's compact capital has a vibrant street art scene, which is focused on the inner city and supported by both local and state government. There is also an active and technically adept traditional graffiti scene. Morphett Street Bridge is the only 'free wall' in the city, and sits just round the corner from the Jive car park – itself a real treasure trove of urban art.

Adelaide is also home to arguably Australia's most dynamic, multi-disciplinary arts festival, the Adelaide Fringe, which includes a dedicated street art element in its programming. It's based not far from the city, on Little King William Street. There's always plenty to see in Adelaide: the city plays host to a dynamic cultural scene, including live music, exhibitions and festivals. Proactive Australasian street art organiser Oi YOU! has also held high profile events in town, with pieces still on show on Trades Hall Lane and Central Market. Further out, the Wonderwalls festival has left a legacy of large-scale murals around Port Adelaide, which are well worth a wander.

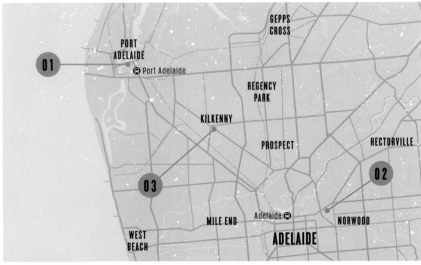

Additional locations

- **Artist:** Various **Location:** McLaren Parade, Port Adelaide
- **Artist:** Various **Location:** 320 Morphett Street, Adelaide
- **Artist:** Anthony Lister **Location:** Her Majesty's Theatre, Pitt Street & Zhivago's Laneway (off Currie Street) Adelaide
- **Artist:** Lisa King **Location:** 181 Hindley Street, Adelaide
- **Artist:** Vans the Omega **Location:** 135 Waymouth Street, Adelaide
- **Artist:** Etam Cru **Location:** 293 St Vincent Street, Port Adelaide
- **Artist:** Smug **Location:** Rear lane, 17 Robe Street, Port Adelaide

127

01 Port Adelaide
The city-sponsored Wonderwalls project kicked off in Adelaide in January 2015 to rejuvenate the industrial area of Port Adelaide, transforming it into a gallery of large-scale murals. These epic works include a collaboration by Kiwi artists Askew One and Elliot Francis Stewart, commenting on Indigenous affairs in Australia, plus pieces by Polish duo Etam Cru, and Scottish portraitist Smug. Local artists include the lyrical geometric works of Beastman, and Guido van Helten, now famous for his rural silo projects. Catch the metro to Port Adelaide.

02 Little Rundle Street
Parallel to Adelaide's main shopping strip in Kent Town, Little Rundle Street is home to murals of such high quality that wedding parties head here for photo shoots. Internationally recognised artists include Irish-born Fin DAC, whose work has a noir graphic-novel feel; and local Adelaide boy Jimmy C, whose colourful pointillist portraits, painted entirely from dots and dashes of spray paint, are instantly recognisable and displayed in cities throughout the world.

03 Kilkenny
While many Australian cities are curating and commissioning street art spaces and festivals, there are still some spots where illegal works are being painted, and painted over. In Adelaide, the old Bianco factory site behind Kilkenny railway station is the poster child of post-manufacturing urban decay. The huge dilapidated interior is home to many graffiti works and looks like the set for a 1980s music video clip. Access is illegal, but you can see some of the art from the street. The outer harbour train line is also a good place to spot new pieces along the railway siding. Get out and explore.

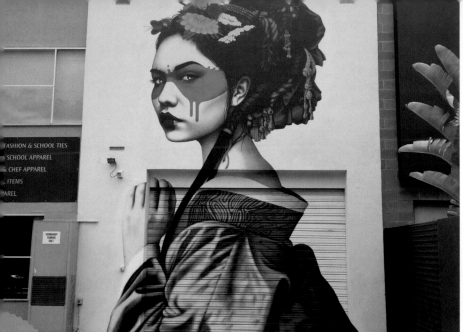

← **Artist:** Fin DAC **Photo:** Colourourcity
Location: Little Rundle Street, Kent Town, Adelaide

↓ **Artist:** Rone **Photo:** Colourourcity
Location: 28 Bank Street, Adelaide

→ **Artist:** Adnate **Photo:** Adnate **Location:** Leigh Street, Adelaide

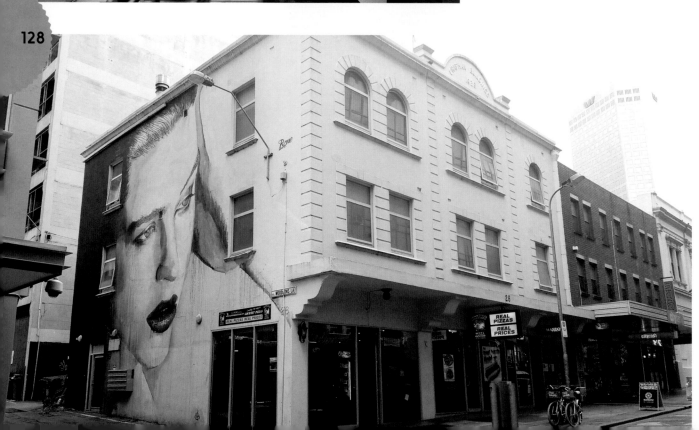

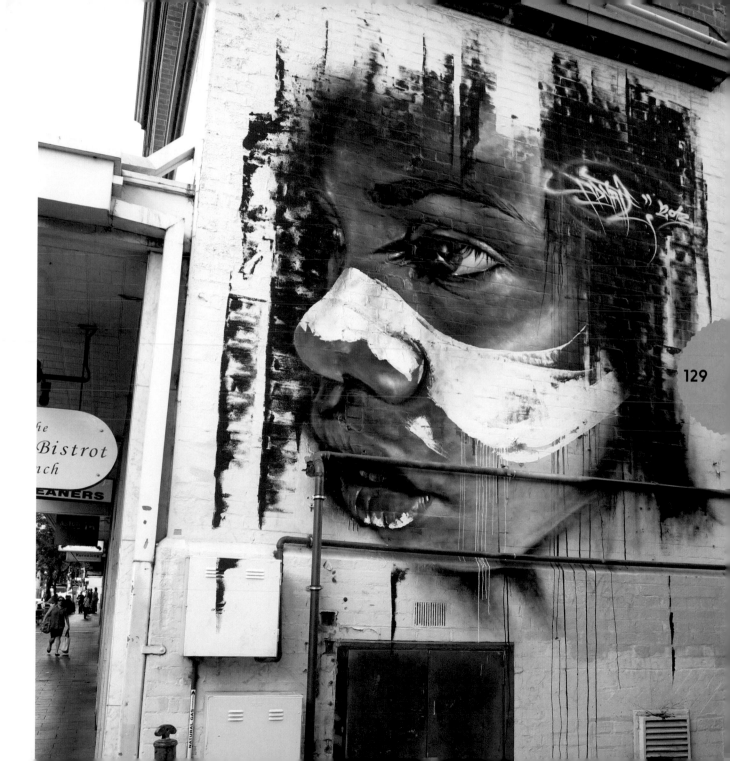

129

Christchurch

New Zealand

Extreme geology and stunning landscapes often go hand in hand with the uncontrollable and unpredictable forces of plate tectonics. For Christchurch – the largest city in New Zealand's South Island – the contemporary street art scene was born out of tragedy. The 6.3 magnitude earthquake that struck almost directly beneath the city in February 2011 claimed the lives of 185 people, causing huge structural damage across the city, with an estimated 80 percent of the centre needing to be rebuilt.

As so often happens, creativity played a key role in rejuvenating the region. Within two years of the quake – during which time most of the city was under army cordon – George Shaw and Shannon Webster's Oi YOU! had developed and delivered a groundbreaking project, in partnership with Canterbury Museum, called RISE, which drew a quarter of a million visitors and won NZ Museum Show of the Year in the process. As a result of that event – and subsequent 'Oi YOU!' projects in the city – more than 40 murals have since been produced, and street art has become a vital part of the energy of the rejuvenated city.

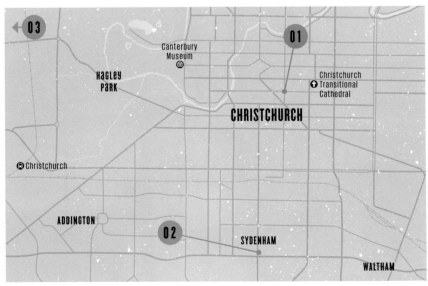

Additional locations

- **Artist:** Askew One **Location:** 160 Gloucester Street, Christchurch
- **Artist:** ROA **Location:** Side of Canterbury Museum, Rolleston Avenue, Christchurch
- **Artist:** Tilt **Location:** Christchurch Casino parking lot, 30 Victoria Street, Christchurch
- **Artist:** Sofles **Location:** Car Park, 163 Saint Asaph Street, Christchurch
- **Artist:** Telmo Miel **Location:** 12 Hereford Street, Christchurch Central, Christchurch
- **Artist:** Owen Dippie **Location:** Corner of Manchester Street & St Asaph Street, Christchurch
- **Artist:** Jorge Rodriguez-Gerada **Location:** 92 Cashel Street, Christchurch

01 City Centre

On the blocks fanning out from Christchurch Cathedral and the Container Mall (see above) are a host of murals, some dating from the RISE and SPECTRUM festivals, established in 2012. In the years since, blank city-centre walls have been transformed by such internationally recognised artists as Cuban-American portraitist Jorge Rodriguez-Gerada; Dutch duo Telmo Miel with their large-scale playfully surrealist works; plus ROA (Belgium), Rone (Australia), Askew One (NZ), Buff Monster (USA), Owen Dippie (NZ), and Vexta (Australia).

02 Sydenham

Colombo Street's retail and commercial zones are dotted with works by local and international artists such as the geometric pieces by Australian collaborative artists Beastman and Vans The Omega, or a colourful and environmentally- and culturally-conscious mural of native birdlife such as *Tui* (2013) by celebrated Maori artists Charles and Janine Williams. Look out for pieces by Askew One (NZ), Misery (NZ), the TMD crew, and Captain Kris (UK) too.

03 City fringes

On Fitzgerald Avenue an ever-evolving array of graffiti art productions fill vacant lots. The trainline through Riccarton is also popular with emerging urban artists. Check out *bon voyage* by Rachael Dewhirst, the longest mural in New Zealand, produced for the public art biennial SCAPE. The DTR Crew in Christchurch are pushing new works and encouraging emerging artists with 'Style Wall' battles each summer. Competitors are invited to face off in a battle of style and skill. Check out http://uturn.co.nz/.

← **Artist:** Anthony Lister **Photo:** Luke Shirlaw **Location:** Parking side of Les Mills, 203 Cashel Street, Christchurch

↓ **Artist:** Seth **Photo:** Luke Shirlaw **Location:** Car Park, 90 Falsgrave Street, Waltham, Christchurch

→ **Artist:** Rone **Photo:** Luke Shirlaw **Location:** Quest Serviced Apartments, 113 Worcester Street, Christchurch

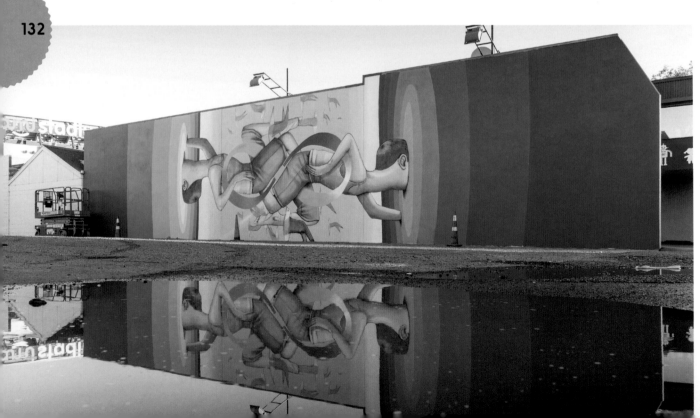

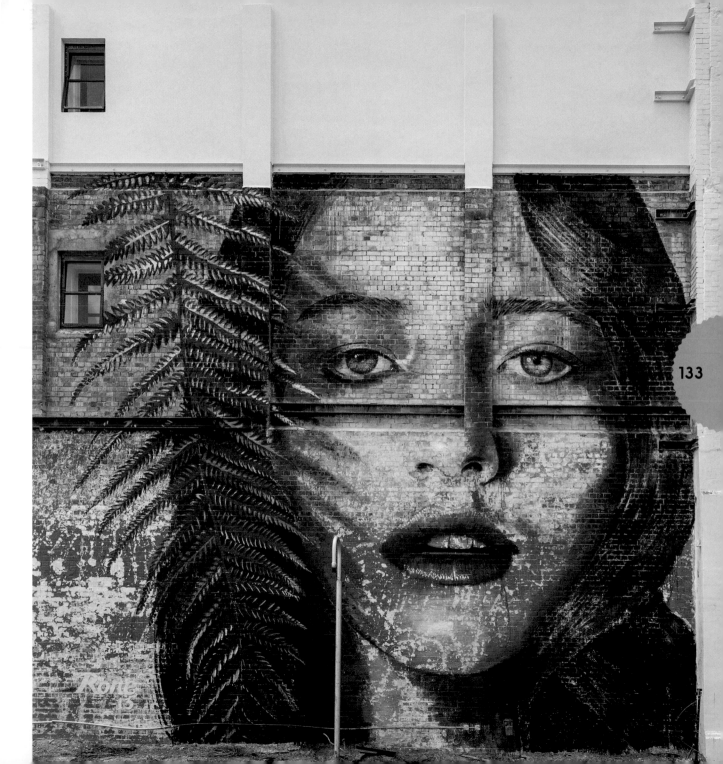

Artist: Buff Monster **Photo:** Luke Shirlaw
Location: Underground Coffee
Roasters, 190 Durham Street South,
Christchurch

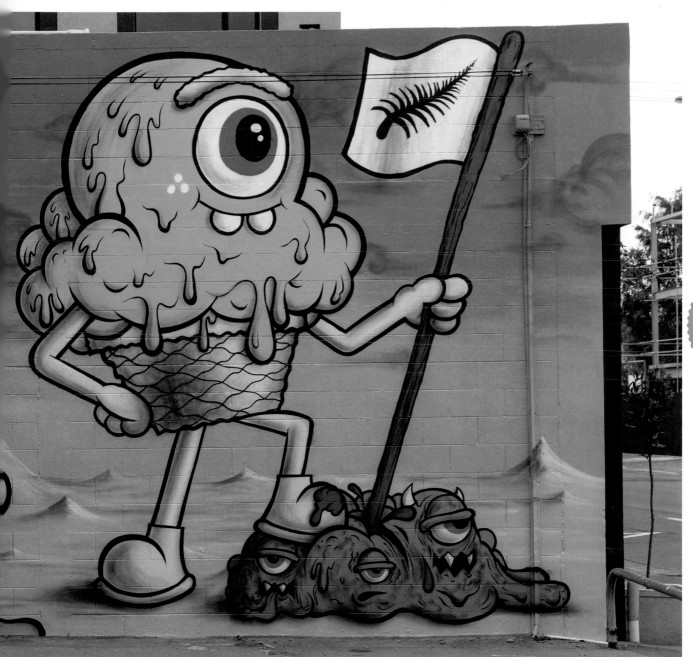

George Town
Malaysia

George Town, the capital of Penang, is responsible for kick-starting a craze for street art that has spread across Malaysia. In 2010, the state government commissioned the studio Sculpture At Work (www.sculptureatwork.com) to create a series of cartoons made from iron rods. As a result, there are now some 50 of these quirky and humorous artworks attached to walls in the city's Unesco World Heritage protected zone. Since then, street art has exploded across George Town, with many local and international artists coming to the party and a dedicated hub for the scene being created at Hin Bus Depot Art Centre. Look out for works by Russia's Julia Volchkova, England's Thomas Powell, Germany's Addison Karl and Malaysia's own Fuazan Fuad.

For the 2012 George Town Festival, Lithuanian artist Ernest Zacharevic was commissioned for a series of murals in the city centre, some of which he chose to combine with objects and architectural features. Zacharevic's pieces were a smash hit, leading to the commissioning of another series of murals the following years, known as '101 Lost Kittens'. Street art lovers can download a map of mural locations in the city from Penang Global Tourism (www.tourismpenang.net.my).

136

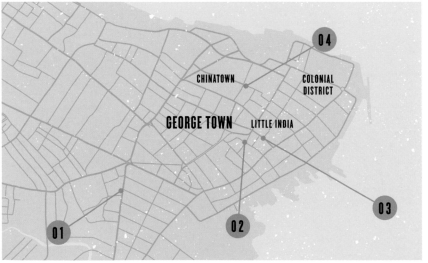

01 Hin Bus Depot Art Centre

A short walk from George Town's landmark KOMTAR tower is this former bus depot, turned into a gallery, cafe and bar. To the rear is a mural garden that's a canvas for a wide range of street art. The owner was one of Ernest Zacharevic's first sponsors in Penang, and this is where the Lithuanian street artist had his first solo show, *Art is Rubbish/Rubbish is Art*, in 2014.

02 Lebuh Armenian

This quiet street of antique shophouses, clan houses and temples inside the Unesco World Heritage zone is the location of Ernest Zacharevic's most famous local work, *Kids on a Bicycle*. Zacharevic captures two children laughing while riding a real bicycle that has been fixed to the wall – no matter that neither of the kids' feet reach the pedals! There's always a crowd of people lining up to have their photo taken here.

03 Lebuh Ah Quee

You'll find a couple more of Zacharevic's works on Lebuh Ah Quee: *Old Motorcycle*, featuring a boy riding a real motorbike, and the *Little Boy with Pet Dinosaur*. Nearby, in the grounds of Cheah Kongsi, is *Cats & Humans Happily Living Together*, a mural of a group of kitties in a Taoist deity procession created by Artists for Stray Animals.

04 Lorong Stewart & Lebuh Muntri

These adjoining streets, among the heritage zone's most attractive, are peppered with boutique hotels, hostels, bars, cafes – and street art. On the corner of Lebuh Klang is Julia Volchkova's proud *Indian Boatman*, while further along Lebuh Muntri at Penang Ta Kam Hong, look up to find Zacharevic's *Kungfu Girl* balancing over two window awnings.

Additional locations

- **Artist:** Ernest Zacharevic **Location:** Lebuh Armenian, George Town, Penang
- **Artist:** ASA (Artists for Stray Animals) **Location:** Cheah Kongsi, Lebuh Pantai, George Town, Penang
- **Artist:** ASA (Artists for Stray Animals) **Location:** Lebuh Armenian, George Town, Penang
- **Artist:** Various, including Ernest Zacharevic, Julia Volchkova and Thomas Powell **Location:** Hin Bus Depot, 31A Jln Gurdwara, George Town, Penang
- **Artist:** Ernest Zacharevic & Martin Ron **Location:** Lebuh Chulia, George Town, Penang

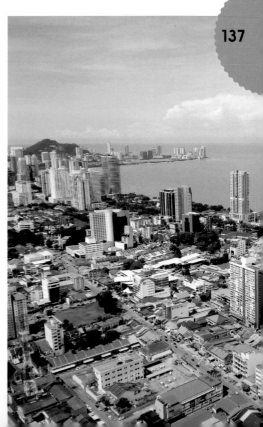

137

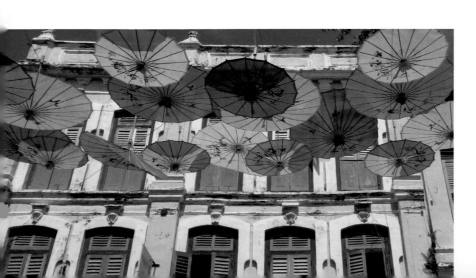

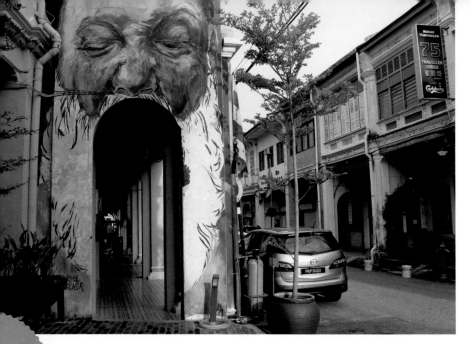

← **Artist:** Gabriel Pitchet **Photo:** Simon Richmond **Location:** 62 Lebuh Muntri, George Town, Penang

↓ **Artist:** Ernest Zacharevic **Photo:** Simon Richmond **Location:** Lebuh Muntri, George Town, Penang

→ **Artist:** Julia Volchkova **Photo:** Simon Richmond **Location:** Lorong Stewart, George Town, Penang

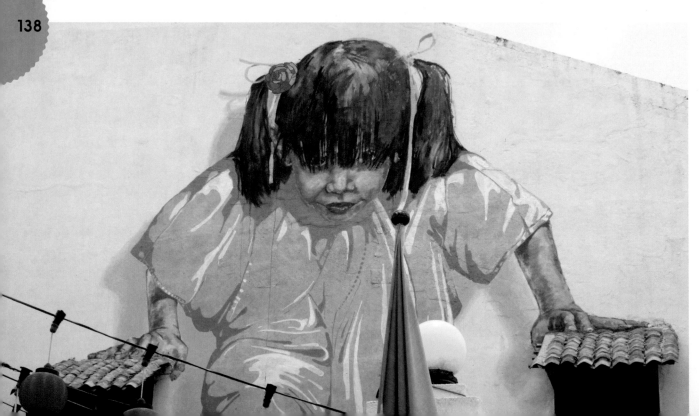

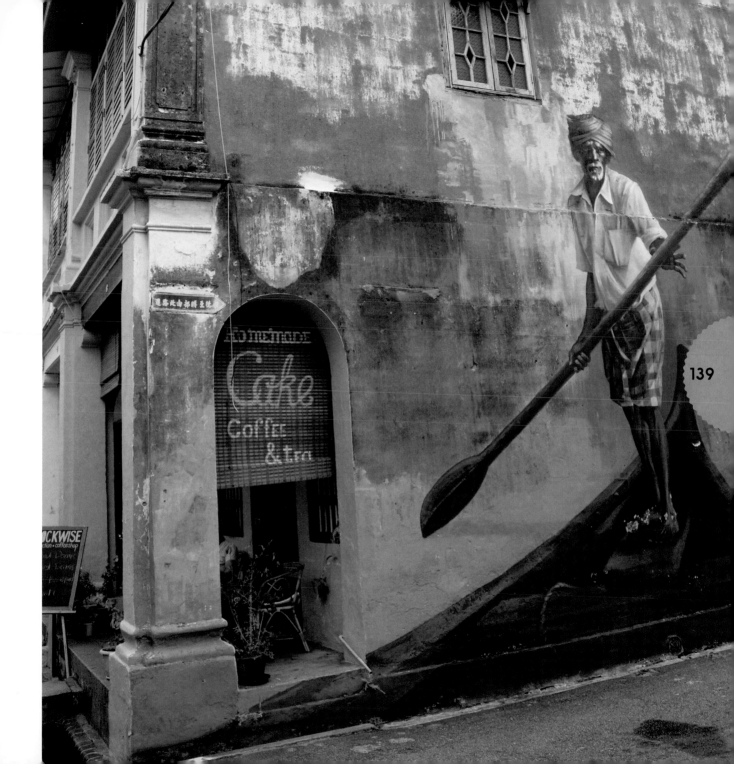

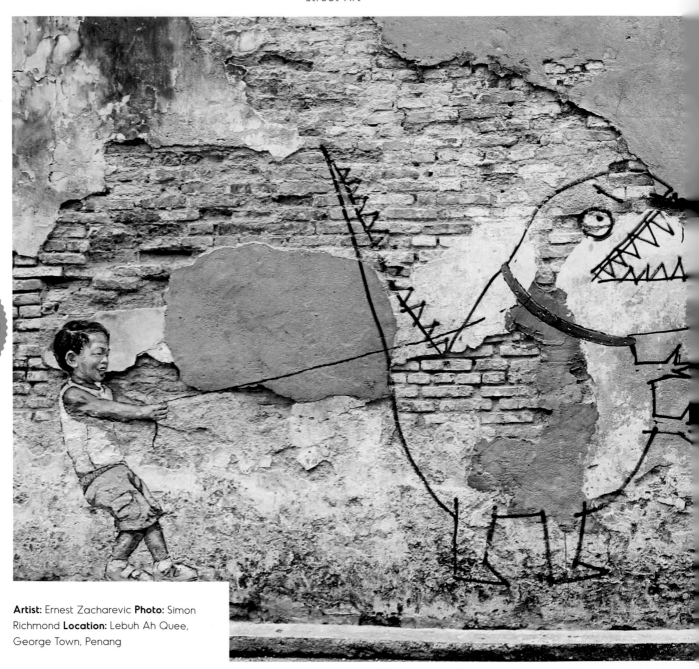

Artist: Ernest Zacharevic **Photo:** Simon
Richmond **Location:** Lebuh Ah Quee,
George Town, Penang

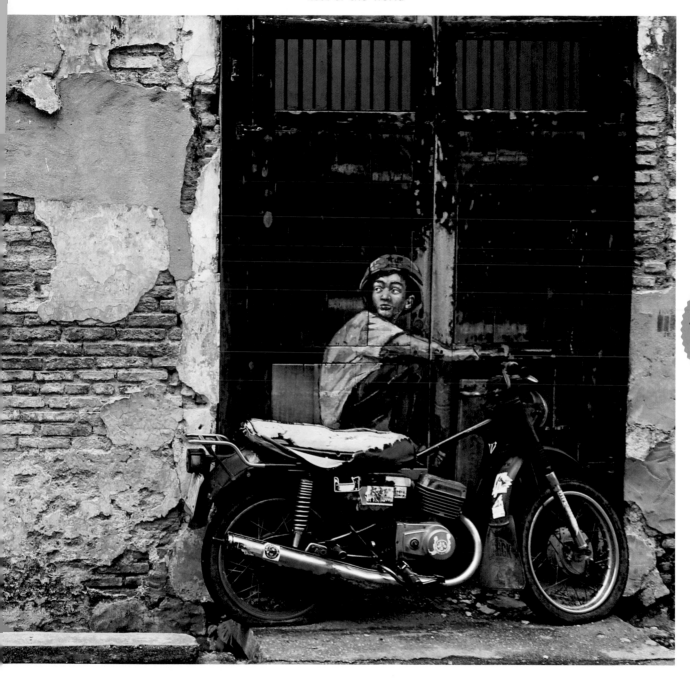

Istanbul

Turkey

Istanbul is perhaps one of the least obvious street art destinations. However, this vibrant historical city has almost as many murals as it does minarets. The combination of rich art and dazzling architecture makes for a truly unique experience. Istanbul is a large and complex city with dozens of disparate districts, each with something different to offer.

The most popular way to travel between the two continents of the east-meets-west metropolis

is by ferry, and one of the most atmospheric ferry routes links Karaköy on the European shore with Kadıköy in Asia. If you're interested in street culture and art, these two neighbourhoods are well worth exploring, particularly during the annual Mural Istanbul Festival in Kadıköy, which has survived recent political upheavals albeit as a smaller event. And the ferry across offers fantastic panoramic views of the city to boot.

For those seeking smaller and more unexpected discoveries, head back across the Bosphorus to the area surrounding Tünel tram stop, where a maze of streets are lined with painted shutters, stencils and galleries. Walking southeast from here towards the coast through Shishane and Karaköy offers several surprises for the eagle-eyed visitor, including several of the remaining mosaics from the 2003 visit of infamous French artist, Invader.

142

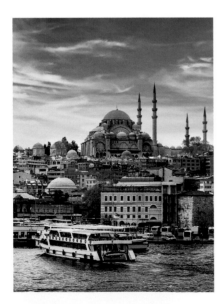

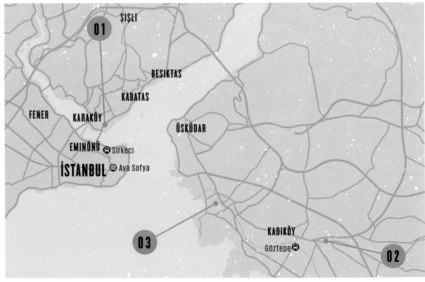

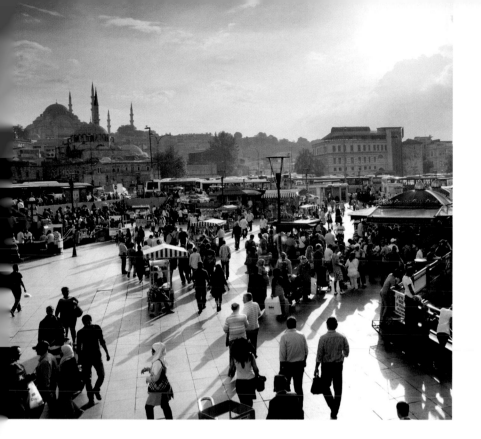

Additional locations

- **Artist:** Aryz **Location:** Kadıköy, Istanbul
- **Artist:** Jaz/Franco Fasoli **Location:** Iskele Sk 41, Kadıköy, Istanbul
- **Artist:** JR **Location:** Mektebi Café, Balat, Istanbul
- **Artist:** Pixel Pancho **Location:** Izzettin Sk, Kadıköy, Istanbul
- **Artist:** Gaia **Location:** Kargili Sk, Ümraniye, Istanbul
- **Artist:** Rustam QBic **Location:** Agabey Sk, Kadıköy, Istanbul
- **Artist:** Burak **Location:** Kır Kahvesi Sk, Kadıköy, Istanbul
- **Artist:** Ruben Sanchez **Location:** Emek Yemez Sk 6, Beyoglu, Istanbul
- **Artist:** Pixel Pancho **Location:** Nüzhet Efendi Sk 53, Osmanaga, Kadıköy, Istanbul

143

01 Karaköy

Cargo and passenger ships have docked near the Galata Bridge in Karaköy for centuries, and until recently its streets were home to little except shipping offices and seedy sailors' bars. These days, the narrow streets running northeast from the main passenger ferry dock are boho central, littered with artists' studios, cafes, bars and boutiques. Wander along Necatibey Caddesi, Hoca Tahsin Sokak and Kılıç Ali Pasa Sokak and you'll pass plenty of walls, doors and shop shutters doubling as canvases for vivid street art.

02 Kadıköy

Home to the city's best fresh-produce market during the day, the sprawling suburb of Kadıköy morphs into a very different place after dark, when its grunge bars and music venues lure students and hipsters from across the city. South of the ferry dock and metro station is the largely residential district of Moda, where the side streets off busy Moda Caddesi are adorned with murals by local street artists including Adekan, Canavar and Yabanci.

03 Yeldegirmeni

Head to this neighbourhood near the *iskele* (ferry dock) in Kadıköy and you'll hit the mother lode of street art in Istanbul. Home to the Mural Istanbul Festival, the streets of this arty enclave are filled with apartment blocks and abandoned factories whose huge exterior walls serve as showcases for high-profile local and international artists including Tabone, Chu, Ares, Pixel Pancho, Amose and Captain Borderline.

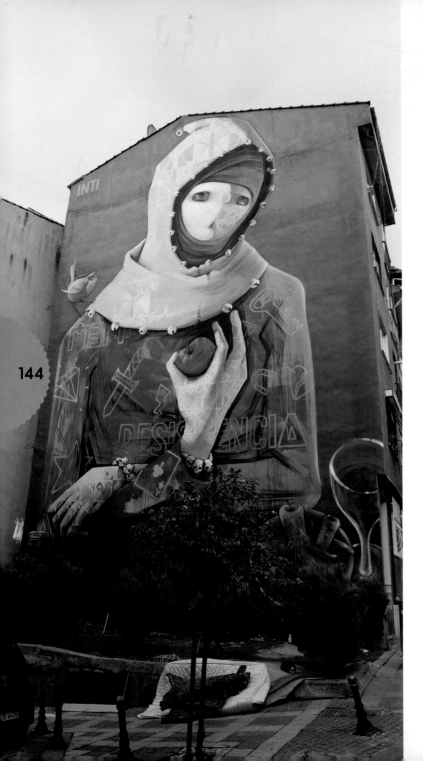

← **Artist:** INTI **Photo:** Burak
Location: Macit Erbudak Sk 37, Kadıköy, Istanbul

↑ **Artist:** C215 **Photo:** C215
Location: Unknown

→ **Artist:** M-City **Photo:** M-City
Location: Talimhane Sk 5, Osmanag, Kadıköy, Istanbul

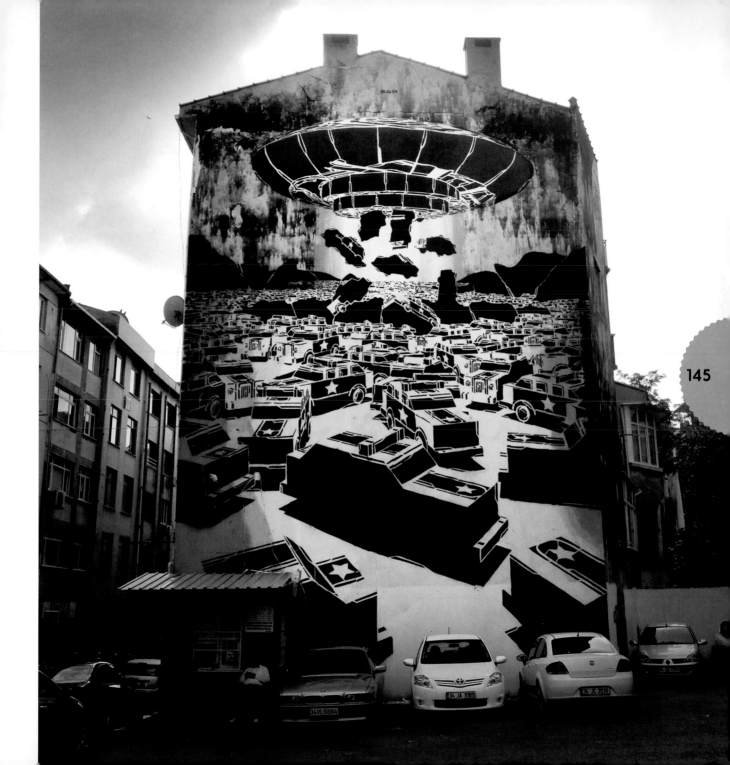

Johannesburg
South Africa

The entire African continent is dotted with inspiring street art projects, from Djerbahood in Tunisia to Wide Walls in Gambia. The most prolific and progressive street art scene on the continent, however, can be found in South Africa, split primarily between Cape Town and Johannesburg. The graffiti and street art on show often has political messages at its heart, stemming from its origins in the apartheid reforms of the 1980s. The arrival of the 2010 FIFA World Cup in Cape Town led to a major crackdown on graffiti there, leaving Johannesburg as the nation's undisputed street art capital.

Works by world-renowned South African artists such as Faith47 (see interview p150), Falko and Freddy Sam are prominent across the city. International artists are also becoming increasingly visible through projects like the City of Gold Urban Art Festival, held annually in Jeppestown. Like many former industrial areas, Jeppestown is slowly being gentrified, with street art once again playing a highly visible role.

Further west into Maboneng, street-level graffiti and building-sized murals are on almost every corner. Lovers of graffiti must also make a pilgrimage to the northern tip of Henry Nxumalo Street to see some of the best artists painting side by side.

146

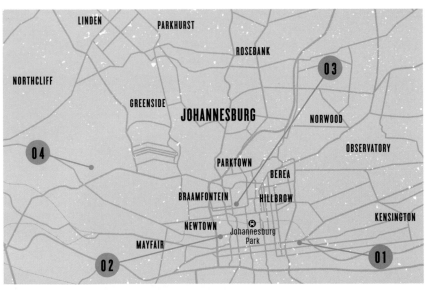

01 Maboneng Precinct

The southeastern side of the city centre was a no-go zone until property developers transformed the derelict warehouses into a hip chunk of urban revival known as the Maboneng Precinct (www.mabonengprecinct.com). Global spray-can stars are now invited to use the neighbourhood as their canvas. You can see their work around the Arts on Main complex (artsonmain.info) or on tours with Main Street Walks (www.mainstreetwalks.co.za) and Curiocity Backpackers (www.curiocitybackpackers.com).

02 Newtown

The area around Mary Fitzgerald Square is a trailblazing example of the urban regeneration transforming downtown Johannesburg, with sculptures, graffiti, theatres and music venues giving the neighbourhood a creative vibe. To track down Newtown's best street art, download a map or book a guided walking tour through Newtown Heritage Trail (www.newtown.co.za/heritage).

03 Braamfontein

Across the landmark Nelson Mandela Bridge from Newtown, Braamfontein is another creative inner-city enclave with numerous design companies and the Neighbourgoods Market (www.neighbourgoodsmarket.co.za). The Saturday market takes place in a building decorated with a 15-storey mural; street-art hunters should also call into Grayscale Gallery (grayscalestore.co.za) or join a Past Experiences walking tour (pastexperiences.co.za).

04 Westdene

While Johannesburg has a municipal goal to become the world's largest street-art city by 2040, the inhabitants of the suburb of Westdene are also embracing the medium. Homeowners in the residential neighbourhood, northwest of the centre, have donated their walls to local and international spray-can wielders. To see the latest murals of the Westdene Graffiti Project check out www.graffitisouthafrica.com.

Additional locations

- **Artist:** Cyrcle **Location:** 6 Moseley Street, Johannesburg
- **Artist:** Faith47 **Location:** Various
- **Artist:** Gaia **Location:** Albrecht Street, Maboneng, Johannesburg
- **Artist:** Various **Location:** Henry Nxumalo and Jeppe Street, Johannesburg
- **Artist:** Remed **Location:** 300 Commissioner Street, Johannesburg
- **Artist:** ROA **Location:** 63 Sivewright Avenue, Johannesburg
- **Artist:** Faith47 **Location:** Corner of Fox & Rissik Street, Johannesburg
- **Artist:** Shepard Fairey **Location:** 70 Juta Street, Johannesburg
- **Artist:** Above/Falko **Location:** 36 Madison Street, Johannesburg
- **Artist:** DALeast **Location:** Maverick Corner, 300 Commissioner Street, Johannesburg

147

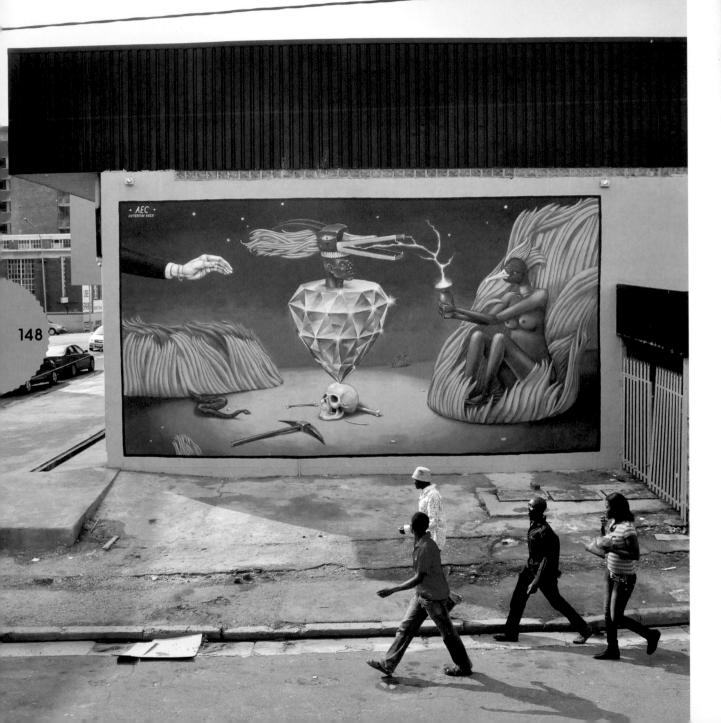

148

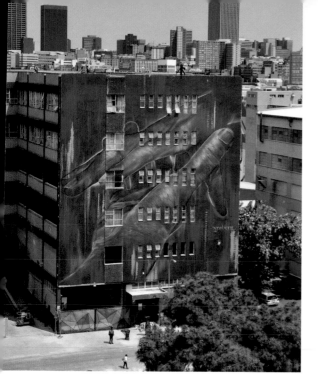

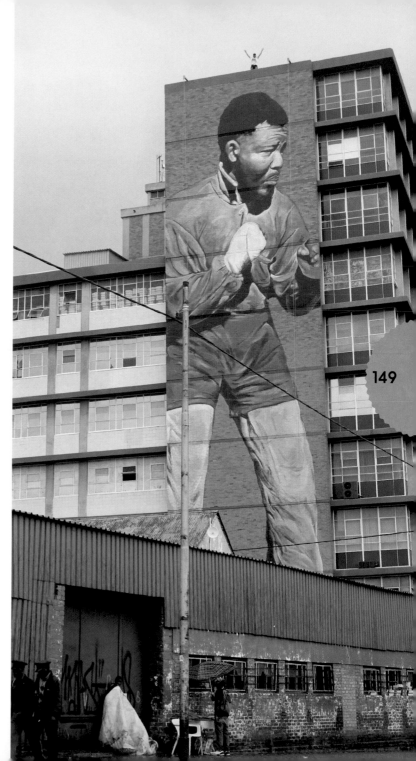

149

← **Artist:** AEC Interesni Kazki/Aleksei
Bordusov **Photo:** AEC Interesni Kazki
Location: 293 Fox Street, Johannesburg

↑ **Artist:** Adnate **Photo:** Adnate
Location: 21 Gus Street, Johannesburg

→ **Artist:** Ricky Lee Gordon **Photo:**
Chris Mitchell **Location:** 8 Staib Street,
Johannesburg

Interview

Faith47

Faith47 is an internationally acclaimed visual artist from South Africa, whose work has been lauded for its ability to resonate with people around the world. She has held solo exhibitions in New York, London and Johannnesburg, and her art appears on walls from Shanghai to Cape Town. Through her work, Faith47 attempts to disarm the strategies of global realpolitik, in order to advance the expression of personal truth. In this way, her work is both an internal and spiritual release that speaks to the complexities of the human condition, its deviant histories and existential search. Channelling the international destinations that have been imprinted on her after two decades of interacting with urban environments as one of the planet's most renowned and prolific muralists, she continues to examine our place in the world.

What was behind your original inspiration to create art on the streets?
This is something that happened organically for me. I was introduced to the graffiti scene as a teenager in 1997 and my work evolved from there. I didn't study in the traditional manner – all of my education has been through practical experience and my own independent investigation. One could say that the physical process of my life has been paralleled and reflected in my journey as an artist, with all its flaws and triumphs.

Much of your work appears to be very considered in its placement. How important is location and context to you?
The context of the environment is vital, as the work needs to communicate and co-create a story with the existing history of a place. I don't want to make works that 'take over' an area, but rather are a part of the fabric of that space, perhaps summoning unseen spirits that might otherwise remain hidden.

Do you feel that coming from South Africa has influenced your work in a particular way?
You can see this influence more directly in my earlier work, whereas my later work speaks in terms that are more applicable to the human condition as a whole, as opposed to one specific region or society. I have become increasingly introspective and consequently my work has become somewhat existential in nature.

Do you approach your gallery work in a different way from murals?
My current 7.83Hz series is manifesting itself through various substrates, from cyanotypes, screen prints, video installations, murals and photography as well as a series of works in abandoned spaces. I'm interested in how an idea can translate within different mediums, creating a wider and more explorative investigation over time.

What's your opinion on the current street art scene, and particularly the proliferation of 'legal' walls and street

art festivals around the world?

I feel it's quite oversaturated and has lost much of its soul. The impact of social media and commercial popularity has created a situation where work is made for very fast interpretation, and it is rare to find artists that are putting real time and effort into a critical investigation behind what they are doing. Although there will always be a certain labelling of genres and movements, I feel on a personal level that it is vital that artists act independently and make work that is not only for popular consumption, but also satisfies the very real need for the investigation of existence.

What is your favourite place that you've painted in your career and where would you most like to paint?

I am at my most content when painting in abandoned buildings.
www.faith47.com

↑ **Artist:** Faith47 **Photo:** Makhulu (@makhulu_) **Location:** Cape Town, South Africa

→ **Artist:** Faith47 **Photo:** Henrik Haven **Location:** Ostend, Belgium

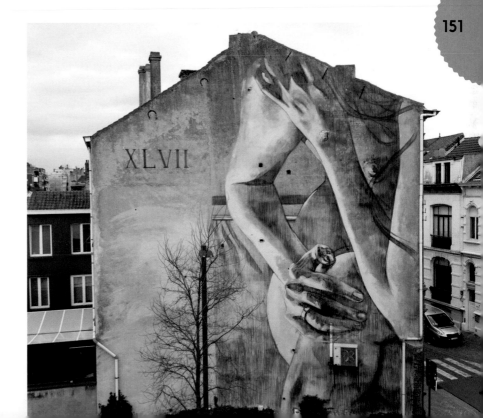

Melbourne
Australia

Melbourne is arguably Australia's cultural (and countercultural!) capital, and is regularly voted one of the world's most liveable cities. One of the reasons for its distinction can be traced to its streets. Thanks to the vision of its founders, the city centre has a uniquely navigable combination of wide, sweeping avenues and characterful, bluestone-cobbled lanes, making it something of a joy to explore. It's a safe, clean, vibrant metropolis brimming with residents who love to meet, eat, drink and create.

Although graffiti is still technically illegal in the city, the public and private response to street art is generally positive – when Banksy first painted here, the council even tried (unsuccessfully) to preserve his work behind perspex panels. Today, Melburnians tend to embrace the ephemeral nature of public art, although work has been undertaken to restore a rare Keith Haring mural in the city. The first stencil graffiti festival in the world was held in Melbourne in 2004, and the city was once dubbed the stencil capital of the world. The majority of Melbourne's street art can be found in its laneways. The scene is constantly changing, but a wander down any of the CBD laneways will be fruitful: look out for work by Rone, DabsMyla and Kaff-eine, to name but a few. Other hotspots include St Kilda, Collingwood and Fitzroy.

152

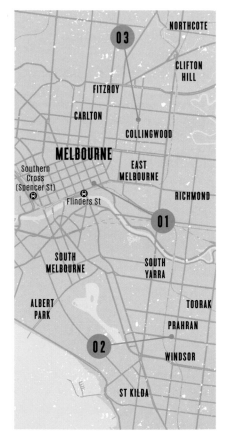

© Sharon Lapkin / Getty Images

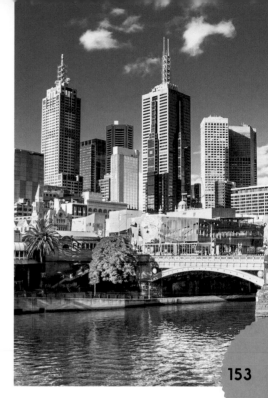

01 City laneways

The walls of Melbourne's laneways are thick with re-sprays, paste-ups and occasional mixed media installations. The most famous, Hosier Lane, runs off Flinders Street, opposite Federation Square. Sadly, poor quality graffiti has started to take over, and the promise of international names like Banksy, Shepard Fairey and Invader are only a memory, but a 23m-high Caravaggio-like portrait of an Indigenous boy by local artist Adnate looks out over Birrarung Marr. East of Hosier, AC/DC Lane and Duckboard Place have the occasional rock-inspired work, plus several large-scale murals. Drewery was already on the street art map, and now includes an evolving ANZAC Centenary Legacy mosaics project. Other lanes to visit include Sniders, Union, Blender (with a summer market), Croft, Tattersalls and Stevenson (where stencil artist Haha honours Oz icons like Ned Kelly).

02 Windsor & Prahran

South of the city, these two neighbourhoods are busy with bars, cafes, clubs and boutiques, but the less-gentrified end of Chapel Street is also home to a fairly eclectic range of street art, much of it supported by the local council. Greville Street is a good place to begin: catch the train to Prahran station then head east. Your final destination is Artists Lane, aka 'Aerosol Alley', where evolving works include pieces by Heesco, a Mongolian artist living in Melbourne, *Summer Bubbles* (2014) by Singaporean artists Ink & Clog, and work by acclaimed Parisian artist Choq, known to escape the French winter for Melbourne.

03 Collingwood & Fitzroy

With a mid-'80s Keith Haring mural at the epicentre, the backstreets of Collingwood and neighbouring Fitzroy are rich with vibrant street art (look out for the whimsical works of Be Free!). The 86 tram takes you up Smith Street, but be sure to walk the length between Gertrude Street and Alexander Parade. Every street heading east towards Brunswick and west down to Wellington is worth exploring – including Easey Street, with its monochromatic *Easey Livin'* mural by world-renowned artists Rone, Adnate, Mayo, Guido van Helten and Askew.

Additional locations

- **Artist:** Keith Haring **Location:** 35 Johnston Street, Collingwood, Melbourne
- **Artist:** Smug **Location:** Otter Street, Collingwood, Melbourne
- **Artist:** Herakut **Location:** 639 Brunswick Street, Fitzroy, Melbourne
- **Artist:** Mr Never Satisfied **Location:** 99 Rose Street, Fitzroy, Melbourne
- **Artist:** Faith47 **Location:** The Cullen Hotel, 164 Commercial Road, Prahran, Melbourne
- **Artist:** Banksy **Location:** Entry doorway, 390 Brunswick Street, Fitzroy, Melbourne
- **Artist:** Invader **Location:** Corner of Drewery Lane and Little Lonsdale Street, Melbourne
- **Artist:** Reka One **Location:** 34 Franklin Street, Melbourne

153

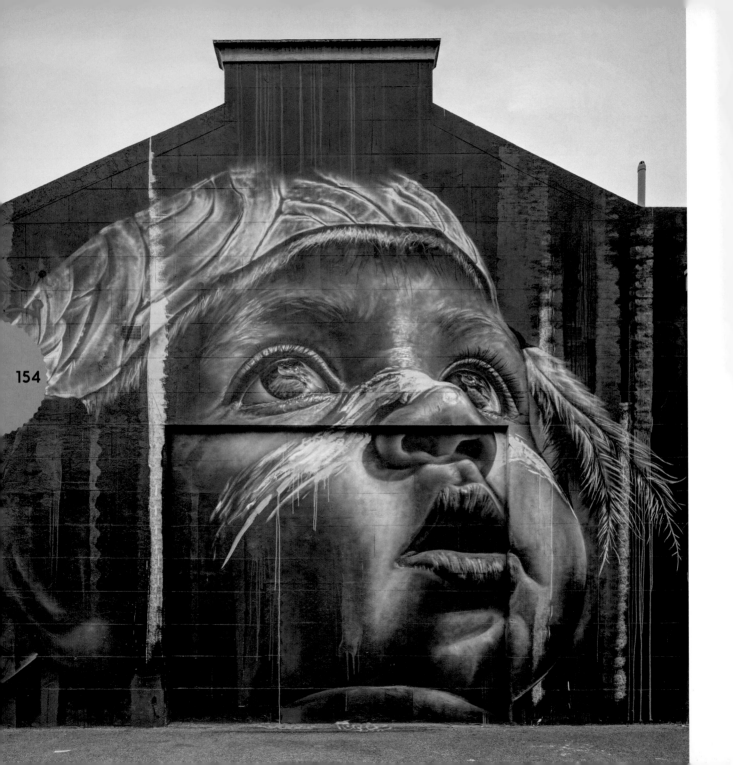

154

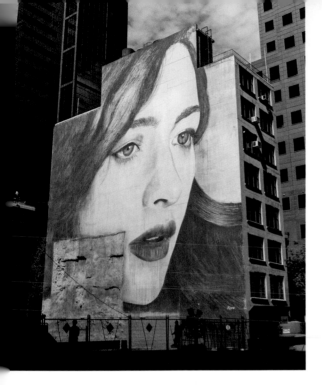

← **Artist:** Adnate **Photo:** Andrew Haysom **Location:** 22 Saxon Street, Brunswick, Melbourne

↑ **Artist:** Rone **Photo:** Rone **Location:** 80 Collins Street, Melbourne

→ **Artist:** Fintan Magee **Photo:** Dean Anthony **Location:** AC/DC Lane, Melbourne

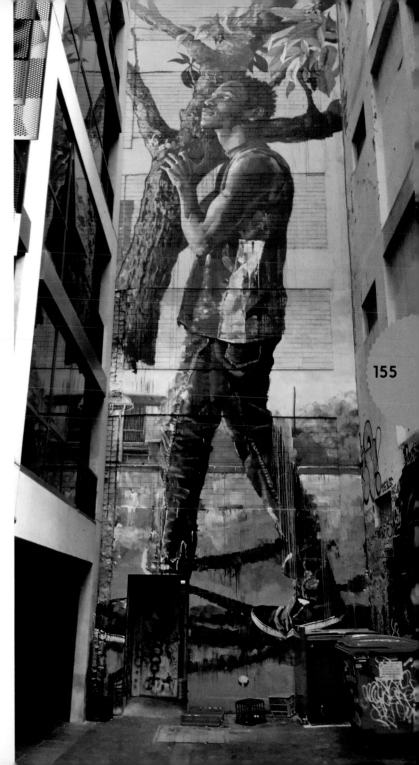

155

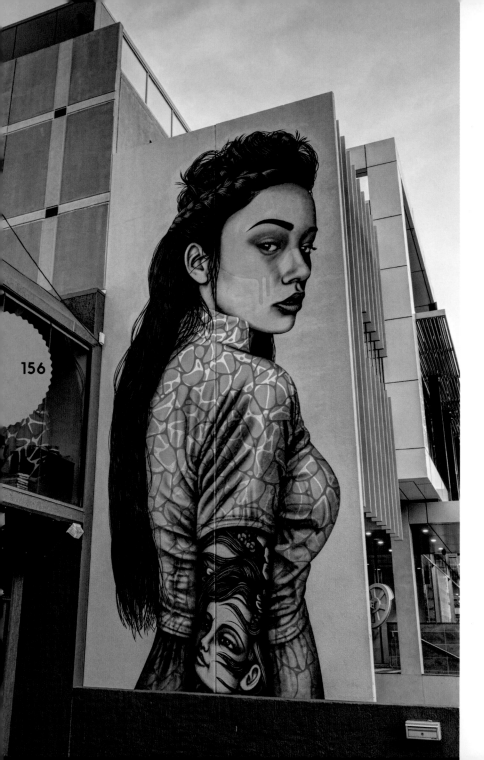

156

← **Artist:** Fin DAC **Photo:** Andrew Haysom
Location: 1 Male Street, Brighton,
Melbourne

→ **Artist:** Fintan Magee **Photo:** Fintan
Magee **Location:** 200 Argyle Street,
Fitzroy, Melbourne

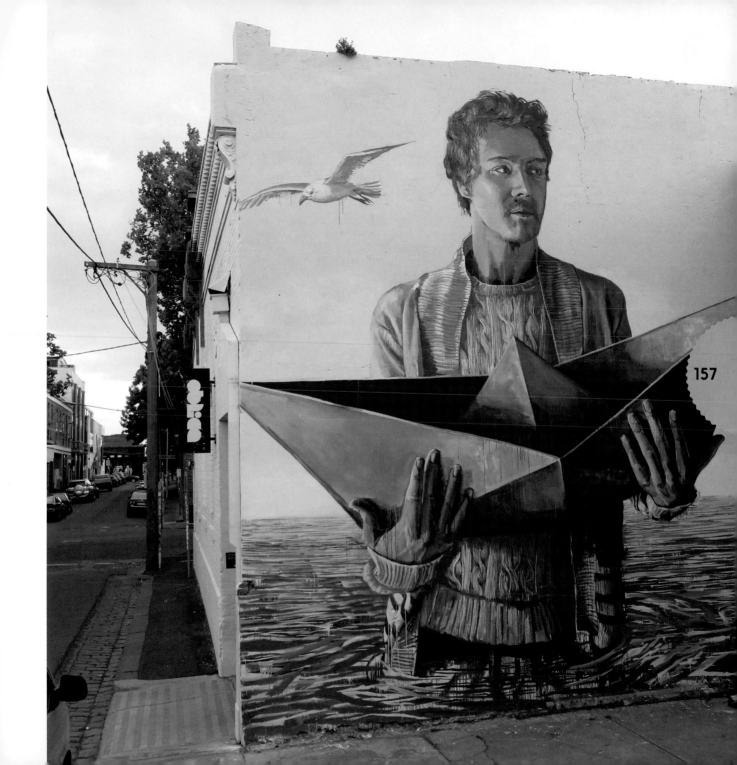

Murals in the Market

Detroit, USA

www.muralsinthemarket.com

One of the city's oldest cultural hubs, Detroit's Eastern Market has always been a hotspot for street artists. Public art is an integral part of the market's DNA, and it's this legacy that Murals in the Market draws on, by inviting more than 50 local and international artists to paint large-scale murals throughout the district each year. The festival helps to expand the market's reach, bringing visitors and customers to businesses in less-visible areas. It also features an innovative 'Adopt A Mural' programme, where local residents and businesses have the chance to sponsor an individual mural from their favourite artist.

The festival culminates in a 10-day programme encompassing the entire footprint of the market, with a series of events including discussion panels, a cultural tour with Detroit's famous 'Slow Roll' bike tour, art exhibitions, an Eastern Market block party, and night-time activities coinciding with the neighbourhood's yearly 'Eastern Market After Dark' event.

Artist: Denial **Photo:** Sal Rodriguez
Location: Rear of Sweiss Imports, 1561 Adelaide Street, Detroit →

← **Artist:** Pat Perry **Photo:** 1xRUN
Location: Wilkins & Orleans Street, Detroit

↓ **Artist:** Ouizi **Photo:** Sal Rodriguez
Location: 1326 Adelaide Street, Detroit

→ **Artist:** Kashink **Photo:** Sal Rodriguez
Location: 2515 Riopelle Street, Detroit

POW! WOW!

Hawaii, USA
www.powwowhawaii.com

The name 'POW! WOW!' was inspired by the colour-filled pages of comic books – 'POW!' being the impact of the art, and 'WOW!' being the reaction of the viewer. Together, the words pay homage to the Native American pow wow, a gathering that celebrates culture, music, art and community. The main event of the POW! WOW! calendar takes place over a week in February in the Kaka'ako district of Honolulu. The festival brings together more than a hundred international and local artists to create murals and installations in public spaces.

Since its beginnings in Hawaii, POW! WOW! has expanded across the globe, taking the festival to Taiwan, Japan, California, Washington D.C., Massachusetts and Texas. The organisation has grown into a global network responsible for art exhibitions, lectures, schools for art and music, creative community spaces, concerts and live art installations worldwide.

Artist: Andrew Hem and Ekundayo
Photo: Brandon Shigeta **Location:** 327 Lana Lane, Honolulu →

164

← **Artist:** Hauser **Photo:** Brandon Shigeta
Location: 690 Pohukaina Street, Honolulu

→ **Artist:** 1010 **Photo:** Brandon Shigeta
Location: Back of 1170 Auahi Street
building where Big Bad Wolf is located
(1140 Queen Street), Honolulu

↓ **Artist:** OG Slick, Ckaweeks and Mung
Monster **Photo:** Brandon Shigeta
Location: 770 Ala Moana Boulevard,
Honolulu

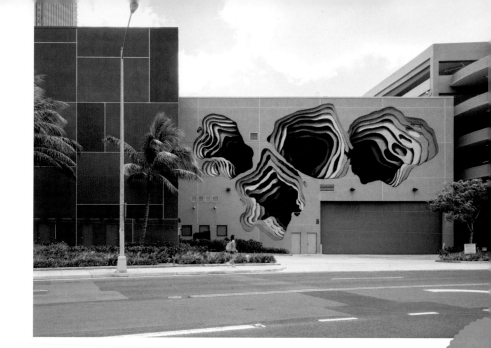

MURAL
Festival

Montreal, Canada
www.muralfestival.com

The 2016 iteration of Montreal's MURAL festival saw renowned names from eight different countries come together with local Canadian artists to create an exciting array of murals and installations along Saint-Laurent Boulevard. MURAL's bold programme offers the public the opportunity to witness the creation of murals in real time, with a large stretch of road closed to traffic during the event. Beyond the art, MURAL more than lives up to the 'festival' tag, with a wide range of events including free block parties, seminars, film screenings, guided tours and exhibitions.

Many murals still exist from previous years along the main stretch of Saint-Laurent Boulevard, and if you venture into the side streets you will find countless more works from both street artists and traditional graffiti artists alike – testament to the creative spirit of the city and of MURAL festival.

Artist: D*Face **Photo:** HALOPIGG
Location: 3547 Saint Laurent Boulevard, Montreal →

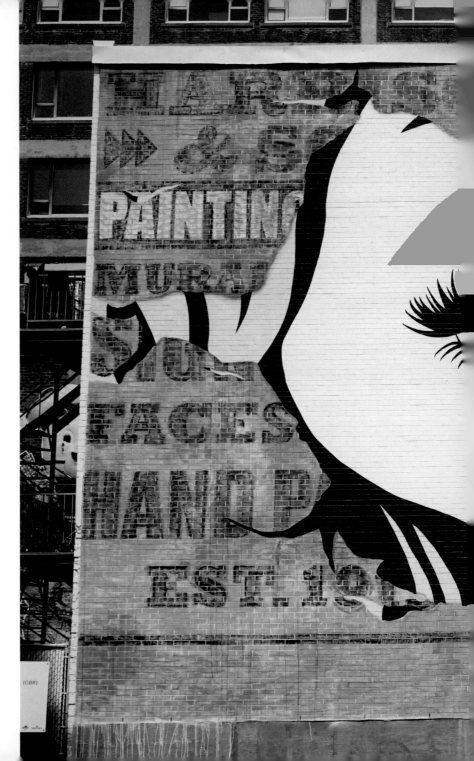

(GBR)

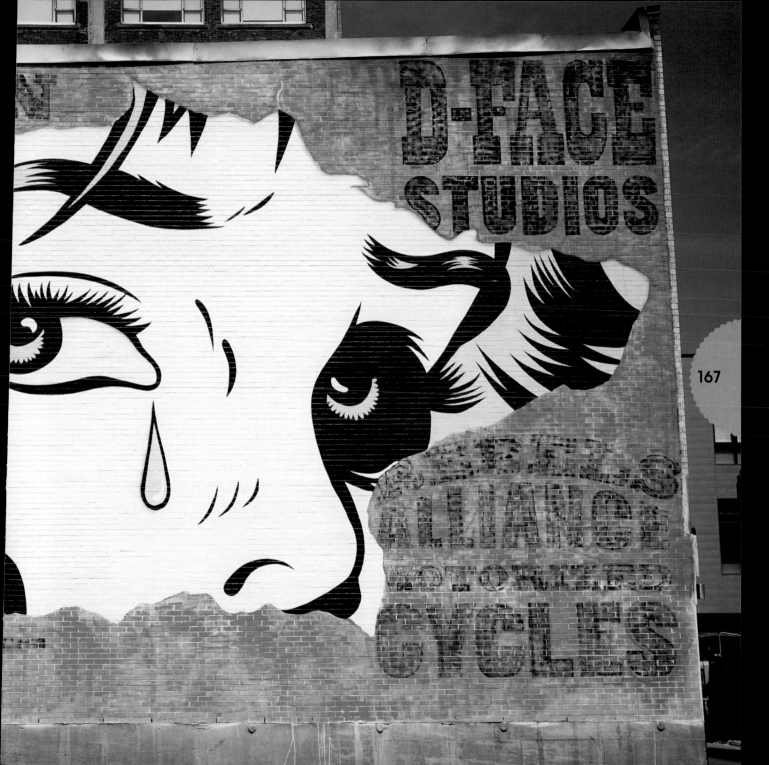

168

← **Artist:** Klone Yourself **Photo:** HALOPIGG
Location: 3492 rue Sainte Famille,
Montreal

→ **Artist:** Felipe Pantone
Photo: HALOPIGG **Location:** 3527 Saint
Laurent Boulevard, Montreal

↓ **Artist:** Matéo **Photo:** HALOPIGG
Location: 201 rue Milton, Montreal

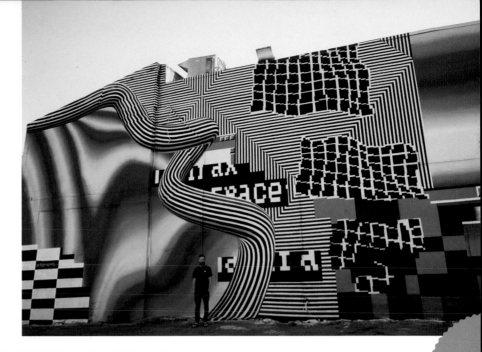

Forest for the Trees

Portland, Oregon, USA

www.forestforthetreesnw.com

Established in 2013, Forest for the Trees is dedicated to the creation of contemporary public art in Portland. The festival brings together local and international artists to work collaboratively on urban art projects in public spaces. Playing on the idea that we too often fail to see the big picture, Forest for the Trees hopes to pull Portland's residents away from their daily routines and provide them with a moment of appreciation for the creativity and beauty that surrounds them.

Since its inception, the festival has been responsible for more than 50 murals throughout Portland, many of which are still visible today. The 2016 iteration of the festival expanded to include performance art, video projections and short film screenings, alongside the creation of new public artworks.

Artist: Yoshi47 **Photo:** Anthony Taylor
Location: ADX, 417 SE 11th Avenue, Portland →

172

← **Artist:** Andrew Hem **Photo:** Anthony Taylor **Location:** 1302 SE Ankeny Street, Portland

→ **Artist:** Joram Roukes **Photo:** Anthony Taylor **Location:** 312 SE Stark Street, Portland

↓ **Artist:** Olivia Knapp **Photo:** Anthony Taylor **Location:** 7804 SE Stark Street, Portland

Upfest

Bristol, UK

www.upfest.co.uk

Hailed as the largest street and urban art festival in Europe, Upfest draws artists from all over the world to Bristol – renowned for its street art and the rumoured birthplace of Banksy – in July to paint at the festival's home in Bedminster. Using the streets, walls, boards, double-decker buses, vans, cars and even a New York subway train as their canvas, more than 300 artists bring their brushes here each year.

Upfest remains true to its roots as a platform for some of the world's most creative artists to get together and paint live in front of thousands of people, with the artwork remaining in situ until the following year. Held over one weekend, the festival also includes workshops, musical performances and other types of live entertainment. A portion of the money raised goes towards the charity NACOA, which assists children whose parents suffer from alcoholism.

Artist: Louis Masai **Photo:** Neil James
Location: Redpoint Climbing Centre, 40 Winterstoke Road, Bristol →

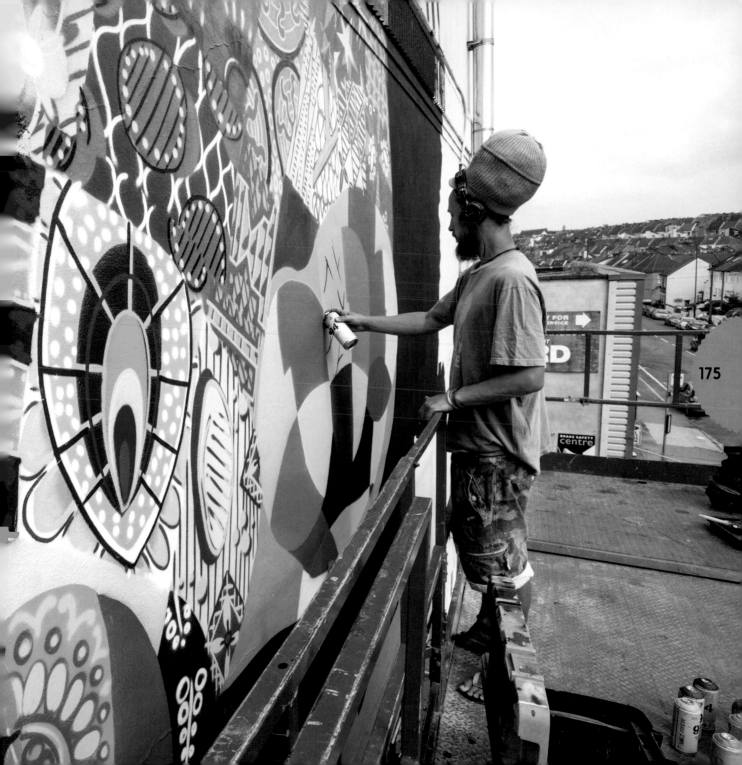

← **Artist:** Cheo **Photo:** Plaster
Location: Tobacco Factory, North Street, Bristol

↓ **Artist:** Odeith **Photo:** Colin Rayner
Location: Masonic Pub, 112 North Street, Bristol

→ **Artist:** PichiAvo **Photo:** Neil James
Location: Masonic Pub, 112 North Street, Bristol

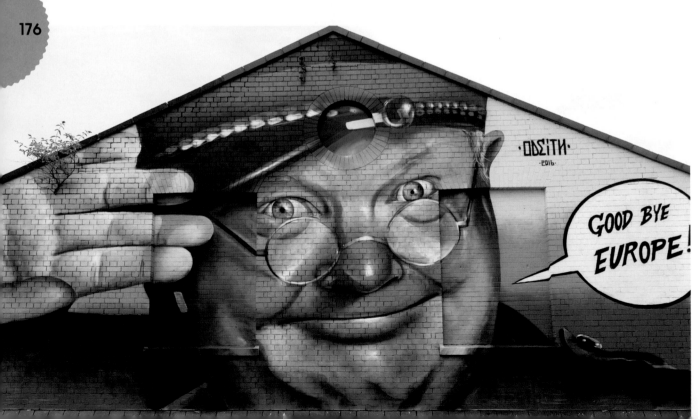

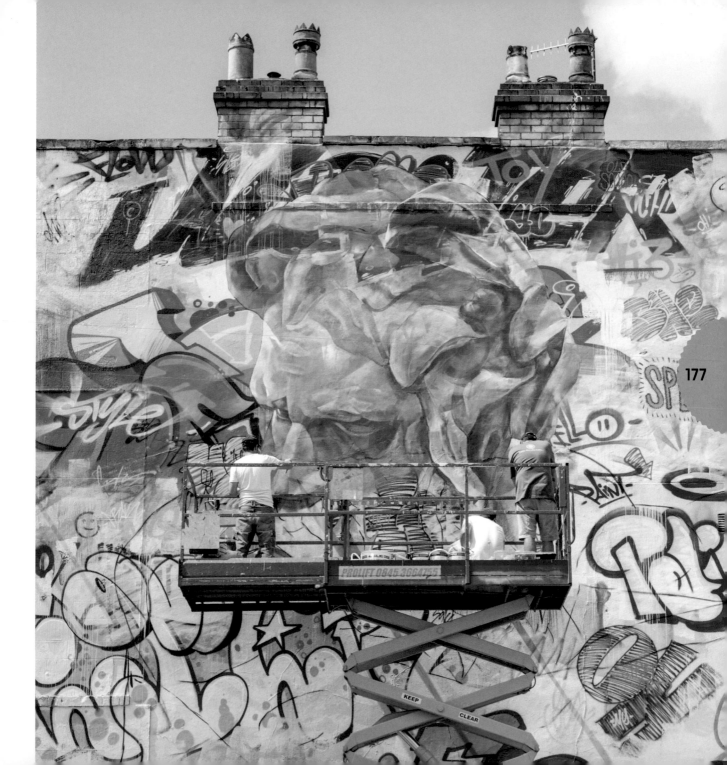

Traffic Design Festival

Gdynia, Poland

www.trafficdesign.pl

The Traffic Design Association was founded in 2012 in Gdynia, focused on promoting art in public spaces. The organisation believes that the city – its character, image, and its function – are the common responsibility of every citizen, and that the task of improving the city should not be limited to organised, municipal actions.

The organisation's flagship project is the Traffic Design Festival, which has evolved from a local street art initiative to a broader project combining art and design projects, revitalisation, community involvement and education. The 2016 festival involved the beautification of buildings throughout the city, including gateways, shopfronts and billboards, as well as the installation of new sculptures and murals.

Many of the murals from previous editions of the event are also still visible, adding a lasting cultural legacy to the landscape of Gdynia.

Artist: Tyrsa **Photo:** Rafał Kołsut
Location: Warszawska 34/36, Gdynia →

180

← **Artist:** Kislow **Photo:** Kodow
Location: Corner of Jerzego
Waszyngtona and Świętego Wojciecha,
Gdynia

↑ **Artist:** Paweł Ryżko **Photo:** Rafał Kołsut
Location: Antoniego Abrahama 57,
Gdynia

→ **Artist:** Sainer **Photo:** Kodow
Location: Opposite Hotel Neptun, Jana z
Kolna 8, Gdynia

Artscape

Gothenburg, Sweden
www.artscape.se

The 2016 Artscape festival was one of the most ambitious urban art projects ever undertaken in Scandinavia, joining other established events in the region such as Nuart in Norway. Over four weeks in July and August, 20 international, national and local artists joined forces to create large-scale art in every single borough of Sweden's second-largest city, Gothenburg. Artscape seeks to promote public art for everyone, believing that the advertising jungle of the modern cityscape needs competition, and that great art shouldn't be confined to galleries and museums.

The festival was another important step for the Swedish urban art scene. It brings into the mainstream an art form that is still very much on the outer, in a country influenced by a conservative view of the purposes of public space and a long-standing 'zero tolerance' policy towards any kind of aerosol-based art.

Artist: Ana María **Photo:** Fredrik Åkerberg **Location:** Härlanda Park 6b, Kålltorpsgatan 3, Gothenburg →

← **Artist:** YASH **Photo:** Linus Lundin **Location:** Väderilsgatan 44-56, Gothenburg

↑ **Artist:** CityzenKane **Photo:** Remington Andersson **Location:** Andra Långgatan 15, Gothenburg

→ **Artist:** Animalitoland **Photo:** Fredrik Åkerberg **Location:** Bredfjällsgatan 46, Angered, Gothenburg

Grenoble Street Art Fest

Grenoble, France

www.streetartfest.org

The Grenoble Street Art Fest was founded in 2015 by independent curator and creator of Spacejunk art centre, Jérôme Catz.

The festival takes place in the centre of Grenoble over three weeks in June, focusing on displaying the diversity of street art as an artform. Monumental frescoes by leading international artists, stencils, collages of all kinds, calligraphy, traditional graffiti, sculptures, interventions, restoration of heritage works, lectures and films keep visitors coming back each and every day as the festival evolves.

The whole shebang is also accompanied by a large exhibition of participating artists' work. The street-side murals are retained each year, building a heritage of works across town, and tours of the artworks are offered throughout the year.

Artist: NEVERCREW **Photo:** NEVERCREW
Location: 26 rue des Bergers, Grenoble →

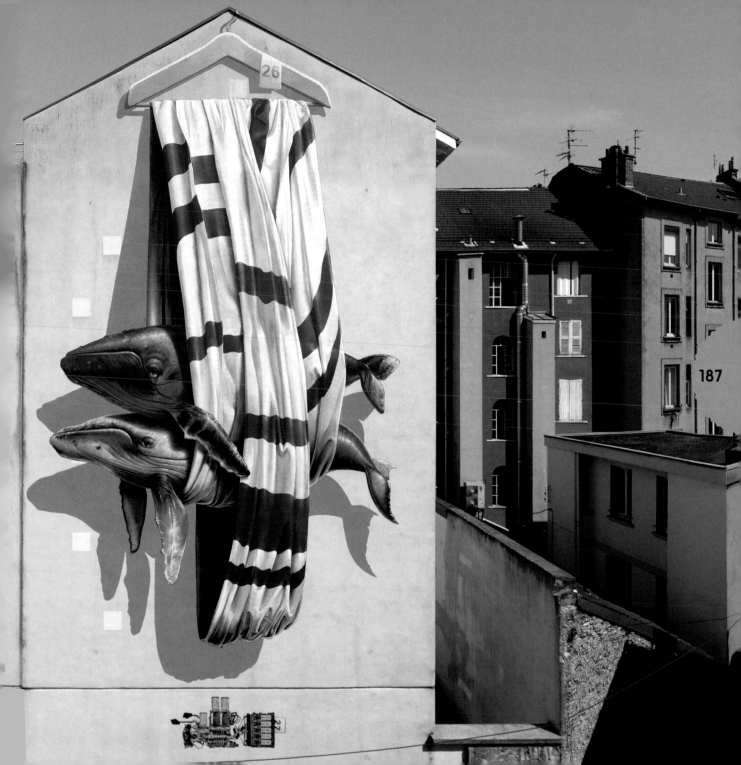

188

← **Artist:** Anthony Lister **Photo:** Andrea Berlese **Location:** Centre Sportif Hoche, 7 rue François Raoult, Grenoble

↑ **Artist:** Augustine Kofie **Photo:** Augustine Kofie **Location:** 50 Galerie de l'Arlequin, Rue de l'Arlequin, Grenoble

→ **Artist:** Snek **Photo:** Andrea Berlese **Location:** 10 rue Doudart de Lagrée, Grenoble

BLOOP

Ibiza, Spain
www.bloop-festival.com

BLOOP International Proactive Art
Festival is an independent initiative
that showcases art, technology,
music, education and gastronomy.
The month-long festival has run in
July and August every year since
2011, covering the streets of Ibiza
in murals, interactive installations,
paintings, video mappings,
sculptures, parties, workshops,
exhibitions and more.

One of the main activities within
this fiesta is OpenAir.Gallery, which
currently exhibits more than 20
murals by artists from around the
world. The gallery is open year-
round, embodying the festival's
ethos: 'art is for everybody'. After
six consecutive years, the festival is
now considered a tourist attraction
in its own right, with something for
everyone from art lovers through
to partygoers visiting Ibiza for its
renowned nightlife.

Artist: Bisser **Photo:** Bisser
Location: Carrer de Catalunya 12,
Sant Antoni de Portmany, Ibiza →

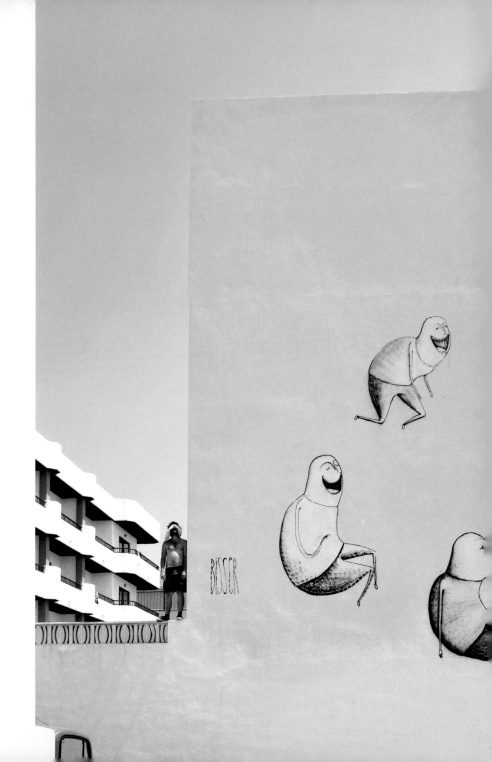

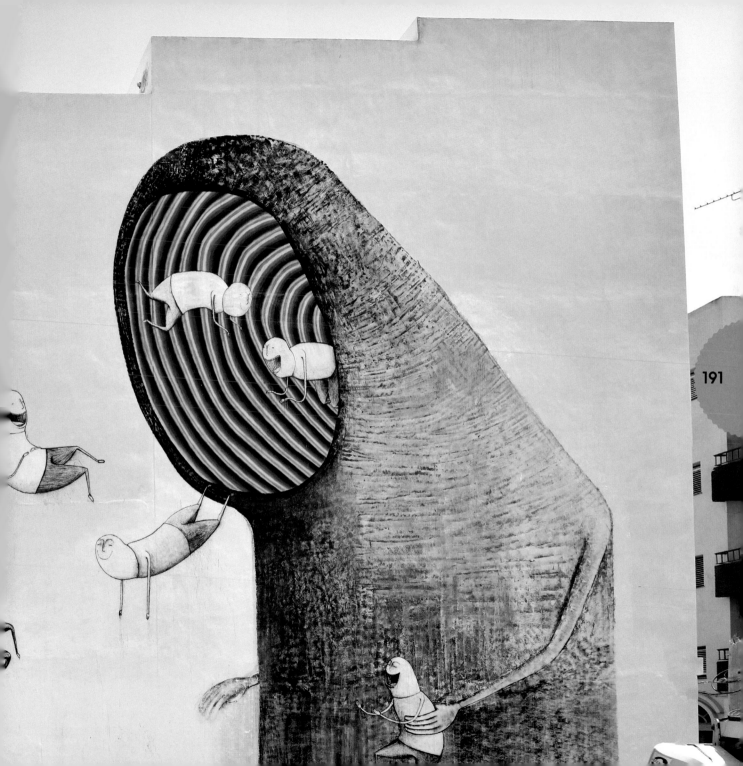

← **Artist:** Btoy **Photo:** BLOOP Festival **Location:** Plaça la Mar 1, Sant Josep de sa Talaia, Ibiza

↓ **Artist:** Phlegm (left) and AEC Interesni Kazki **Photo:** Marc Colomines **Location:** Carrer Ample 35, Sant Antoni de Portmany, Ibiza

→ **Artist:** AEC Interesni Kazki/Aleksei Bordusov **Photo:** BLOOP Festival **Location:** Carrer Ramon y Cajal 20, Sant Antoni de Portmany, Ibiza

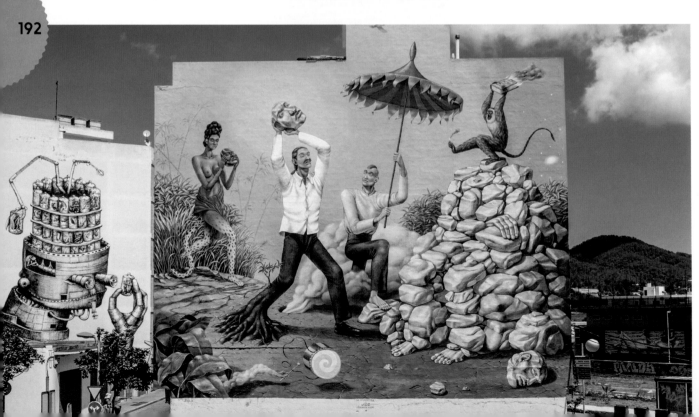

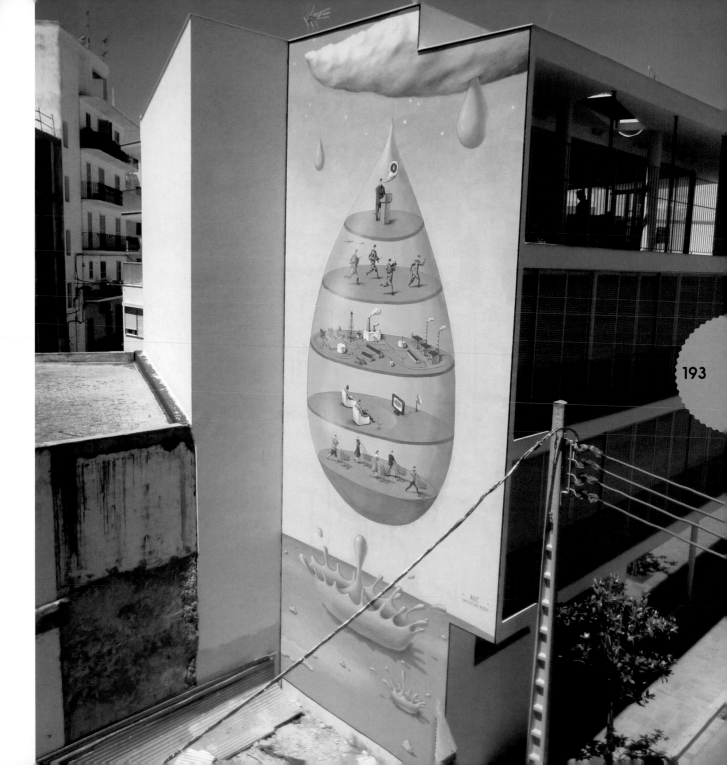

Nuart

Stavanger, Norway

www.nuartfestival.no

Norway's third-largest city probably isn't the first place you'd look for one of the world's oldest street art festivals, and yet that's exactly what you'll find in Stavanger. Since 2001, the renowned Nuart Festival has provided an annual platform for the world's best urban artists to exhibit their creativity. From the first week of September a team of local and international street artists leave their mark on the city's walls – both indoor and out – creating one of Europe's most dynamic and constantly evolving public art events.

The festival includes a series of citywide exhibitions, events, performances, debates and workshops, by some of the world's leading practitioners and emerging names in street art. In 2016, a new partnership with local bus company Kolumbus also led to the introduction of eight 'street art buses' – mobile artworks that bring street art even closer to the heart of the city.

Artist: MTO **Photo:** Ian Cox
Location: Kongsteinsgata 3, Stavanger →

← **Artist:** Jaune **Photo:** Ian Cox
Location: On the Tårngata side of the Shell station, Pedersgata 19, Stavanger

↓ **Artist:** SpY **Photo:** Brian Tallman
Location: Waterside of Rogaland Maritime Senter AS, Breivikveien 22, Stavanger

→ **Artist:** Fintan Magee **Photo:** Ian Cox
Location: Industrial silos, best viewed from Breivikveien 31, Stavanger

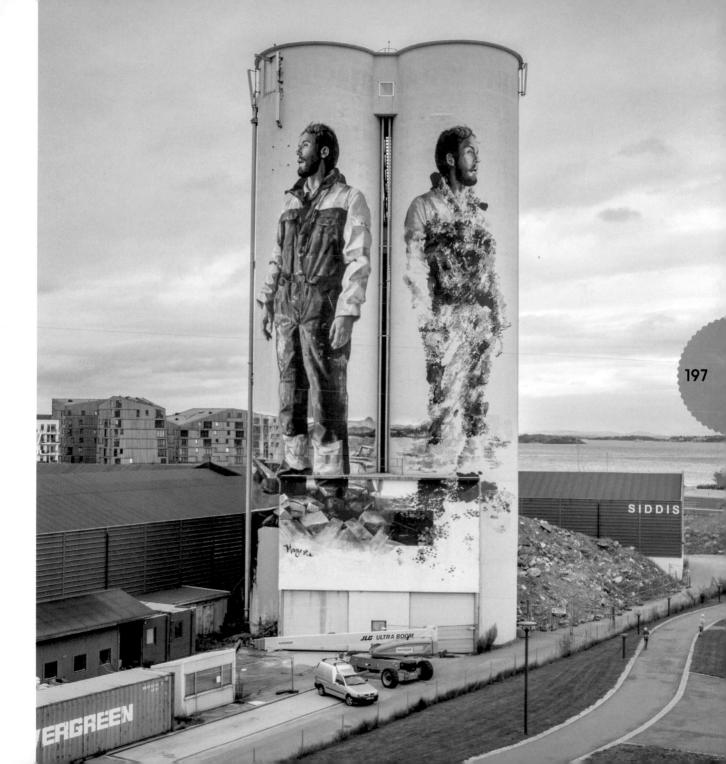

Interview

Martyn Reed, Nuart festival

Nuart is an international contemporary street and urban art festival held annually in Stavanger, Norway. Launched originally in 2001, it is widely considered the world's premier celebration of street art. Nuart aims to stimulate debate by challenging entrenched notions of what art is and, more importantly, what it can be, pioneering a new breed of art exhibition that is neither institutionalised nor commercial. Without the usual restraints of curatorial and corporate preferences, the event consistently brings out the best in its invited guests, who are typically among the most acclaimed and progressive public art practitioners in the world. Martyn Reed is the festival's founder and director.

What was the original inspiration behind Nuart?
Nuart was established in 2001 as a new media festival – a platform that emphasised the democratic nature of digital culture and affordable technology in art making. It presented work that fluctuated between art and activism. New media art slowly grew into a bloated beast, with the focus shifting to a fetishisation of the technology rather than anything interesting to say about society.

In 2005, having a keen interest in all aspects of art and activism and seeing similarities between the early days of new media art, we transitioned to a 'street art' festival – a genre that was often saying more with a craft knife and piece of cardboard than a fully funded arts council biennale.

Stavanger was maybe not an obvious location for launching a street art festival back then. How has the city reacted – both residents and tourists – and what do the authorities think?
Stavanger is an unusual place, nestled on the coast of the fjords and surround by some of the world's most inspiring scenery. The residents have grown up with this and generally take it for granted. Bringing large-scale murals and street art into this community was met with a positivity I'd rarely – if ever – experienced before, and it was across all demographics, from kids to grandparents. It took a while to understand that they hadn't been conditioned by the decades of negative media coverage and urban neglect that American and UK cities had lived through. They simply saw it as big, bold and clever public art. We have had fantastic support from day one, from both residents and authorities alike.

What is the biggest challenge with organising an event of this kind?
The biggest challenge is always

→ **Artist:** Robert Montgomery **Photo:** Ian Cox **Location:** Midtre Suldalsgate 18, Stavanger

↓ **Artist:** Martin Whatson street art bus **Photo:** John Roger **Location:** Various, Stavanger

getting the balance between the various stakeholders right – the city, the public, the artists, partners, funding bodies, wall owners, public and private sector demands, bureaucracies, politicians – the list is endless.

What's your opinion on the current global street art scene, and particularly the proliferation of street art festivals around the world?
We're living through extraordinary times. There is a revolution in public art practice and how artists engage with cities and public space. Who has the rights to it? Where and when and how? The fact that we have events to celebrate this, and the fact that citizens are embracing it across the globe, should be celebrated. This has to be the starting point.

What does the future hold for Nuart festival and what do you think its legacy will be?
There were 134 street art 'festivals' organised in Europe alone last year. I like to think that we have inspired – and will continue to inspire –

a few of them to look beyond the giant-sized, colourful murals that are currently dominating the culture and to seek out the small, the hidden, and the human. It's important to promote meaningful engagements with the artists' work, and to get involved with the process. It's these connections – these one-on-one discoveries – that have a long-lasting effect. There's little to beat finding the poetic little paste-up down a back alley, away from the glare of the spectacle.

Cash, Cans & Candy

Vienna, Austria

www.facebook.com/
CashCansCandyNext

Vienna is typically linked with classical music, Egon Schiele, Gustav Klimt, Sissi and the Habsburg monarchy. Nowadays, however, a generational shift is taking place – Vienna is growing more cosmopolitan, embracing new forms of contemporary urban art. In the past few years, Vienna has begun to appear on the radar of street artists and street art lovers alike. Take a stroll or a cruise along the Danube and you'll see an eye-popping array of classical graffiti side-by-side with street art from both local and international artists.

Since 2013, the Cash, Cans & Candy festival has given Viennese street artists a platform to exhibit their art, providing walls and venues in public spaces, and contributing to the city's ongoing process of establishing itself as a vibrant hub for this contemporary artform.

Artist: Cyrcle and Gaia **Photo:** Oliver Juric **Location:** Westbahnhof, Wipark Garage, Vienna →

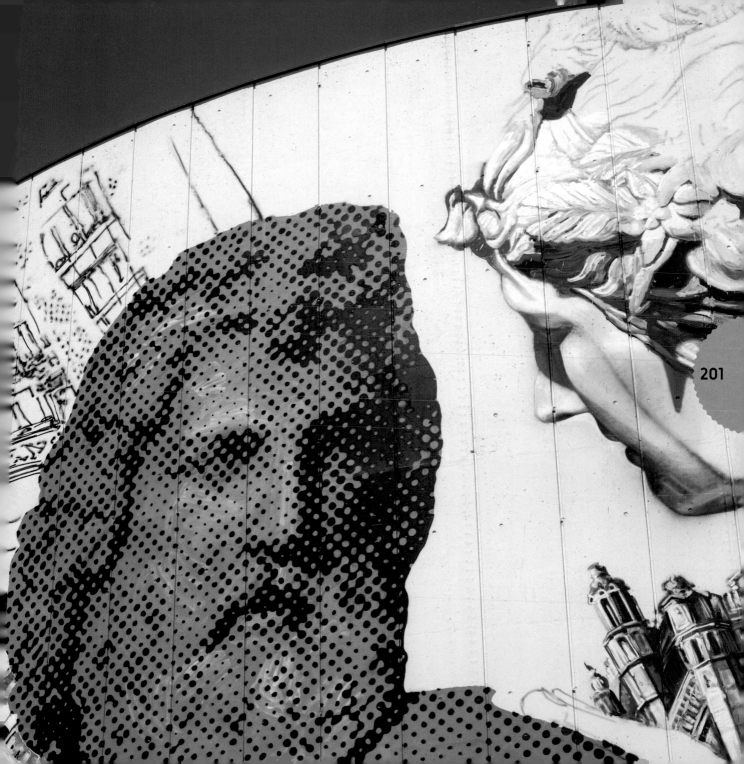

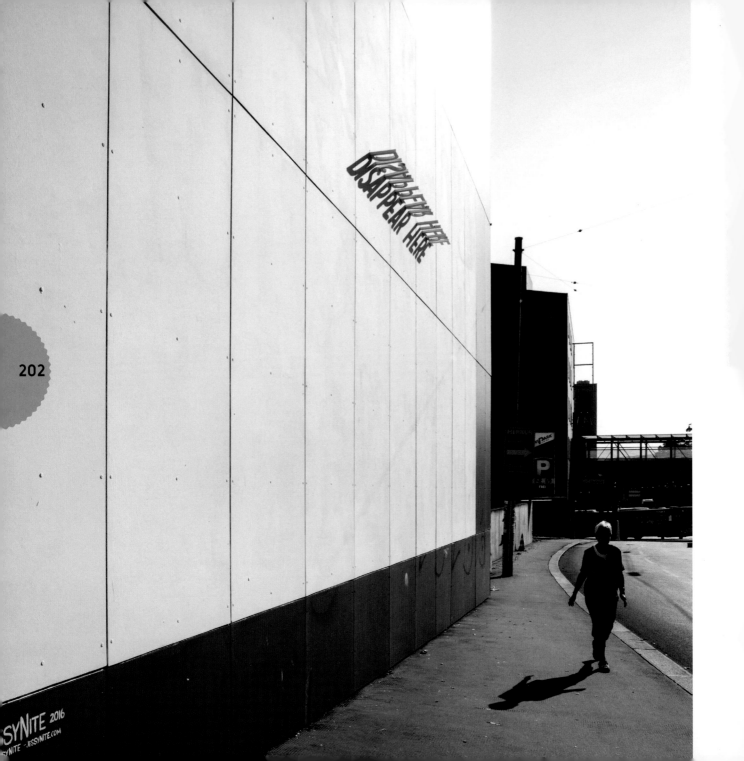

202

DISAPPEAR HERE

203

← **Artist:** Jessy Nite **Photo:** Katharina Stögmüller **Location:** WIPARK Garagen GmbH, Liesinger Platz, Vienna

↑ **Artist:** Faile **Photo:** Katharina Stoegmueller **Location:** Absberggasse 35, Vienna

→ **Artist:** Faith47 **Photo:** Katharina Stoegmueller **Location:** Absberggasse 35, Vienna

St+art Festival

New Delhi, India

www.st-artindia.org

St+art is a not-for-profit organisation bringing large-scale street art to public spaces across India. Since 2014, St+art has promoted annual festivals throughout the country, including in New Delhi, Mumbai, Hyderabad and Bangalore, with the aim of moving art from the galleries to the streets, making it accessible to a much wider audience.

The fourth iteration of the festival took place in New Delhi at the beginning of 2016, in collaboration with the Ministry of Urban Development. It featured the creation of the first open-air street-art zone in India, the Lodhi Colony Art District. This vision of a pedestrian-friendly neighbourhood transformed into an open-air art museum wowed locals and helped to reinvent the idea of public spaces in Indian cities.

The colony now exhibits 26 major new artworks by globally renowned artists running along the Meharchand Market Road and Khanna Market Road, and has become a tourist destination in its own right.

Artist: Daku **Photo:** Akshat Nauriyal
Location: Lodhi Colony, New Delhi →

205

← **Artist:** Colectivo Licuado
Photo: Akshat Nauriyal **Location:**
Lodhi Colony, New Delhi

↓ **Artist:** NEVERCREW **Photo:** Naman
Saraiya **Location:** Block 9, Lodhi Colony,
New Delhi

→ **Artist:** Lek & Sowat and Hanif Kureshi
Photo: Naman Saraiya **Location:** Block 8,
Lodhi Colony, New Delhi

207

HKwalls
Hong Kong, China
www.hkwalls.org

The HKwalls festival adds a much-needed street art element to Hong Kong Arts Month, held annually in March. HKwalls invites local and international artists to create large-scale works on the streets of the city. The festival celebrates creativity, originality and freedom of expression, actively connecting and building relationships between artists and the community through high-quality public art.

Each year, HKwalls selects one area of Hong Kong to focus on, with artists painting as many exterior walls, gates and windows as possible throughout the district. During the festival, HKwalls also hosts a number of supplementary events and activities including exhibitions, film screenings and public workshops. Works from the 2015 and 2016 iterations of the festival, which took place in the Sheung Wan, Stanley Market and Sham Shui Po neighbourhoods, are still visible to visitors.

Artist: Okuda **Photo:** Cheung Chi Wai
Location: Man Fung Building, 180 Tai Nan Street, Tong Mi, Hong Kong →

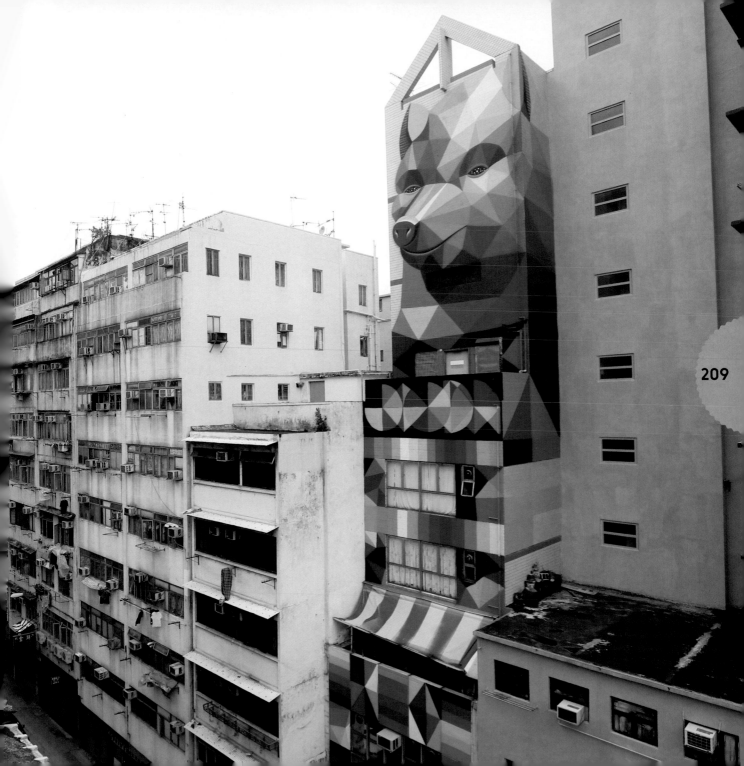

209

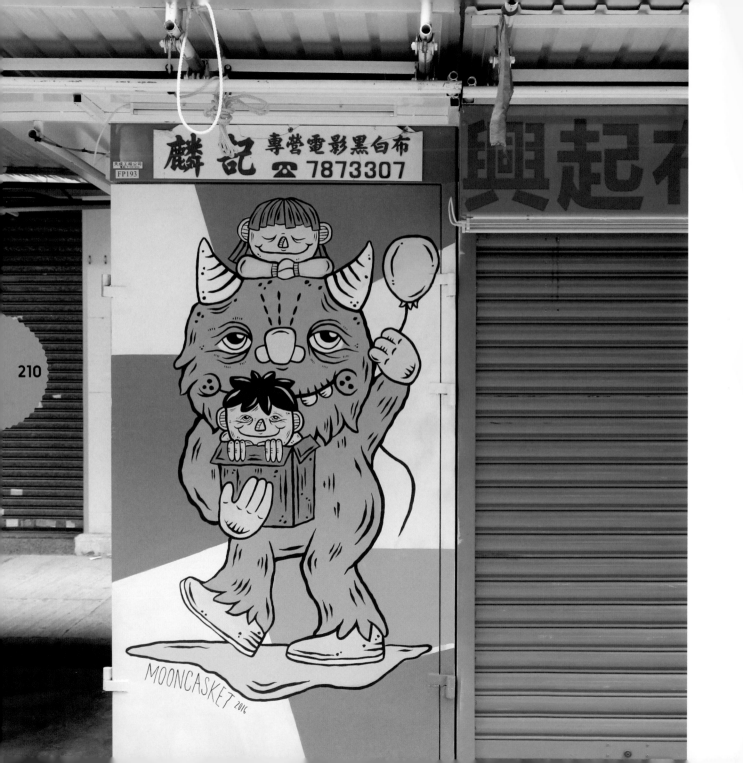

← **Artist:** Mooncasket **Photo:** Kyra Campbell **Location:** Tin House 193, 152-154 Ki Lung Street, Tong Mi, Hong Kong

→ **Artist:** Clogtwo **Photo:** Wailok **Location:** 147 Yee Kuk Street, Sham Shui Po, Hong Kong

↓ **Artist:** Colasa **Photo:** Cheung Chi Wai **Location:** 1 Wong Chuk Street, Sham Shui Po, Hong Kong

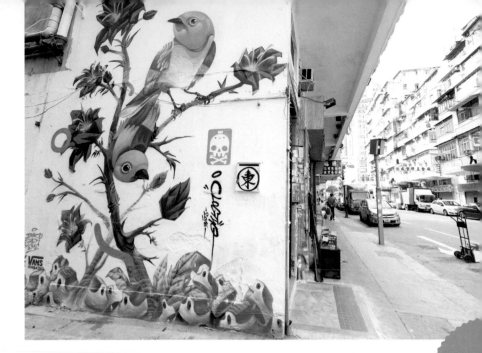

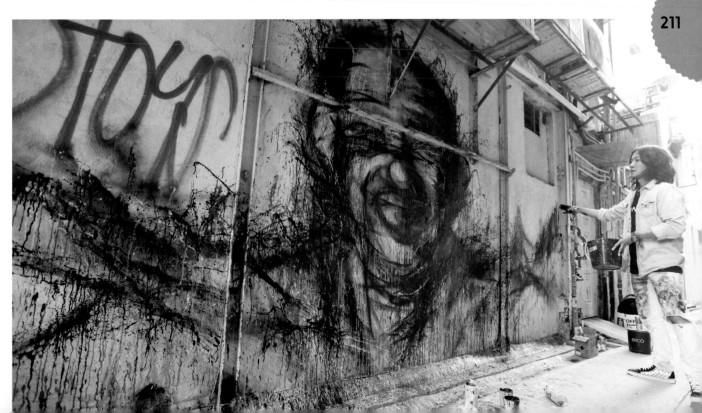

MB6: Street Art

Marrakesh, Morocco
www.mb6streetart.org

In 2016, the Marrakesh Biennale included urban art as part of its integral programming for the first time since its inauguration in 2004. Twelve leading local and international street artists were invited to Morocco to participate in the Biennale as part of the MB6: Street Art project. The focus on public art is indicative of the inclusive motivations behind the festival, allowing audiences of all backgrounds to engage with artistic works across the cityscape.

The murals are located in key public spaces, including the rooftops of the souks in the Medina, the area around the palace, and walls across the Mellah and Gueliz districts. The project also included the installation of North Africa's largest mural, a 6400 sq metre work by Italian artist Giacomo Bufarini (aka 'RUN'), painted on the ground of the Moulay Hassan Square in Essaouira. The artwork depicts two figures communicating across borders, echoing the rich musical heritage in Essaouira while also addressing the migration crisis.

Artist: Remi Rough **Photo:** urbanpresents. net **Location:** Rue Tétouan, Marrakesh →

← **Artist:** Dotmasters **Photo:** urbanpresents.net **Location:** Exterior Palais Badii, 49 rue Touareg, Marrakesh

↓ **Artist:** Alexey Luka **Photo:** urbanpresents.net **Location:** Places des épices, Derb Aârjane Rahba Lakdima, Marrakesh

→ **Artist:** MadC **Photo:** urbanpresents.net **Location:** Corner Avenue El Glaoui and Derb Tougha, Marrakesh

214

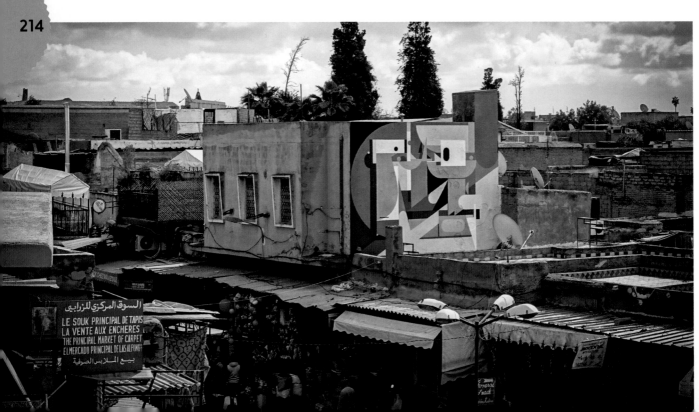

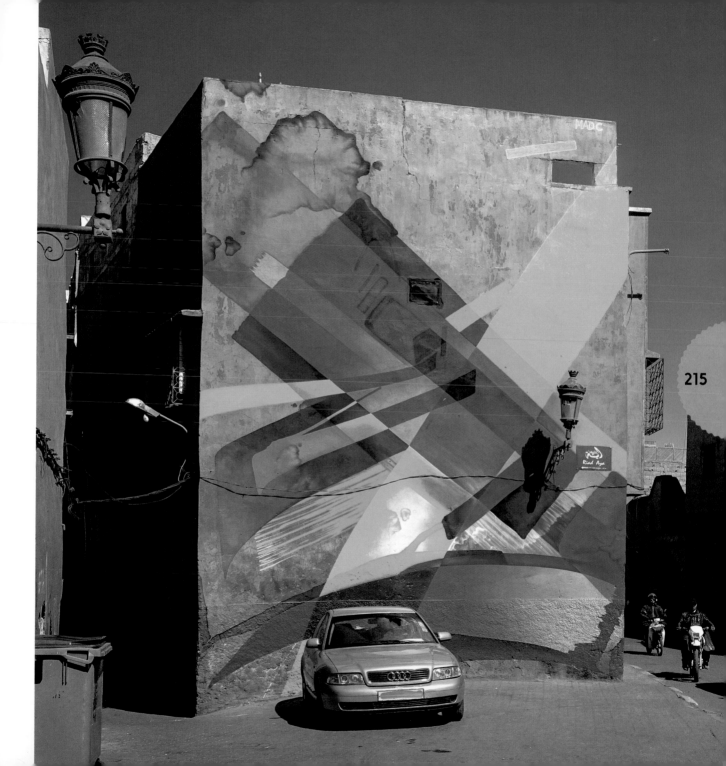

PUBLIC

Perth, Australia

www.form.net.au/public2016

PUBLIC has been transforming walls in Perth since 2014. The festival is founded and managed by FORM, a non-profit cultural organisation that develops and advocates for creativity in Western Australia. Since its inception, PUBLIC has engaged more than 200 internationally, nationally and locally renowned artists to share their visions, experiences, artistic talent and creative energy with the people of Perth. With works by the likes of Phlegm, Borondo, ROA, Gaia, Add Fuel, Hyuro and Interesni Kazki, PUBLIC is turning Perth into one of the world's great cities for street art.

PUBLIC's mural programme has also recently expanded beyond the city walls to a series of artworks across iconic regional landmarks, including Australia's first industrial silo artworks. These huge works feature art by internationally acclaimed street artists HENSE, Phlegm and Amok Island, and are located in regional centres in Western Australia.

Artist: HENSE **Photo:** Bewley Shaylor
Location: Northam-Toodyay Road, 1km West of Northam, Burlong WA →

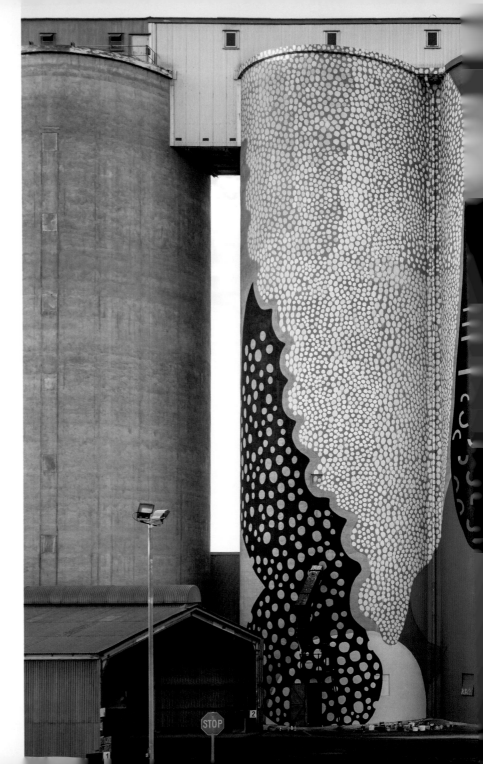

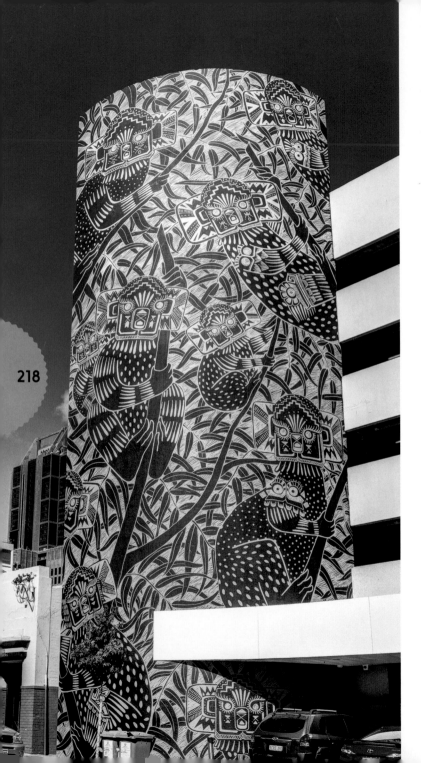

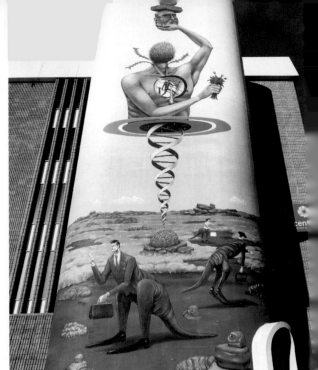

← **Artist:** Curiot **Photo:** Bewley Shaylor
Location: Hertz building, 475 Murray
Street, Perth

↑ **Artist:** AEC Interesni Kazki/Aleksei
Bordusov **Photo:** Bewley Shaylor
Location: Francis Street, Central TAFE,
Northbridge WA

→ **Artist:** Rustam QBic **Photo:** Bewley
Shaylor **Location:** 105 Building, Curtin
University, Kent Street, Bentley WA

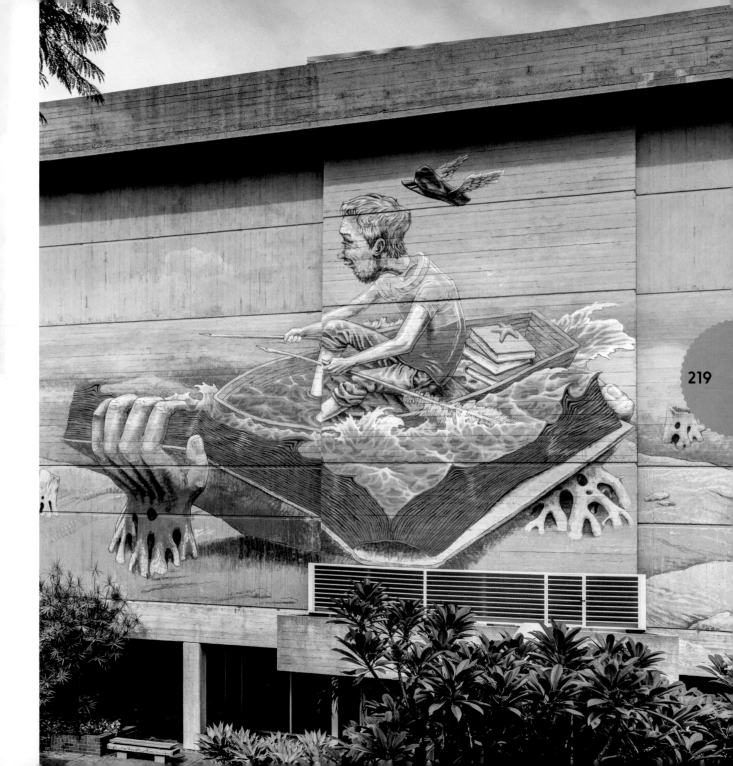

← **Artist:** Kami and Sasu of Hitotzuki
Photo: Brandon Shigeta **Location:** 575
Cooke Street, Honolulu, Hawaii

Thanks

1010, 1xRUN, 2501, Aaron Li-Hill, Above, Adam Friedman, Adnate, aestheticsofcrisis/Julia Tulke, Agathe Durand, Agostino Iacurci, Akacorleone, Akshat Nauriyal, Alana Tsui, Alexander Silva, Alexandros Vasmoulakis, Alexey Luka, Alexis Diaz, Alice Pasquini, All City Canvas, Allan Szacher, Allison Lichtenberg, Amber Dawn Pullin, Ana María, Andrea Berlese, Andre Bathalon, Andrew Haysom, Andrew Hem, Animalitoland, Anpu Varkey, Anthony Lister, Anthony Taylor, Anton Magnani, Antonio Sena, Arjun Bahl, Artscape, Aryz, Askew One, Audrey Kawasaki, Augustine Kofie, Axel Void, Barry McGee, Bart van Kersavond, Basik, Beastman, Beau Stanton, Ben Rubin, Beryl Dzambo, Bewley Shaylor, Bezt, Boicut, Bicicleta Sem Freio, Birdman Photos, Bisser, Blaqk, Blek le Rat, Bloop Festival, Bob Gibson, Borondo, Brandon Shigeta, Brian Tallman, Brock Brake, Broken Fingaz Crew, Btoy, Bu, Buff Monster, Burak, Charlotte Dutoit, Cheo, Cheung Chi Wai, Chiara Mariani, Chris Mitchell, Christian Barrett, Christian Guémy, Christina Angelina, Chrixcel, CityzenKane, CKaweekS, Clogtwo, Colasa, Colectivo Licuado, Colin Rayner, Colourourcity, Conor Harrington, Cooper Cole Gallery, Cranio, Crash, Cuellimangui, Curiot, Cyrcle, Daku, Daleast, Dale Grimshaw, Dalek, Dane Dodds, Daniel Wakeham, David de la Mano, Dean Anthony, Deih, Denial, D*Face, Diana Larrea, Dmojo, Don't Fret, Dotmasters, Dscreet, Duarte Cavalinhos, EINE, Ekundayo, Elian, Elina Metso, Ella & Pitr, Emily Evans, Ernest Pignon, Etam Cru, Ever, Evoca1, EVOL, Faile, Faith47, Faust, Felipe Pantone, Ferdinand Feys, Fin DAC, Fintan Magee, FORM, Franco Fasoli, Frankie Shea, Fredrik Åkerberg, Gaia, Gastone Clementi, Gaucholadri, George Shaw, Giacomo Bufarini aka RUN, Goin, Grenoble Street Art Fest, Guido van Helten, HALOPIGG, Hanif Kureshi, Hauser, Hebru Brantley, Hector Campbell, Hendrik Beikirch, Henrik Haven, HENSE, Herakut, HKWalls, Hsix, Hyuro, Ian Cox, Icy & Sot, INO, Interesni Kazki, INTI, Invader, Jaime Rojo, James Earley, James Finucane, Jan Bajtlik, Jan Normandele, Jarus, Jason Dembski, Jasper Wong, Jaune, Jaz/Franco Fasoli, Jen Stark, Jérome Catz, Jesse Cory, Jesse Harris, Jessica Shaefer, Jessica Stewart, Jessy Nite, Joan Brebo, John Goodridge, John Roger, Jonathan Bergeron, Jon Furlong, Jonathan Bullman, Joram Roukes, Jordan Kostelac, Jorge Rodriguez-Gerada, Julie Carbonel, Kalamour, Kami and Sasu of Hitotzuki, Karl Read, Kashink, Katharina Stoegmueller, Katie Zapatka, Katrin-Sophie Dworczak, Kenor, Kid Acne, Kim Kirkman, Kislow, Klone Yourself, Kodow, Koralie, KristopherH, Kyra Campbell, Lakwena Maciver, Landon Taylor, Lek and Sowat, Linus Lundin, Louis Masai, Low Bros, Lucy Langdon, Lucy McLauchlan, Luke Shirlaw, LXOne, Lynda Dorrington, MadC, Manolis Anastasakos, Marc Colomines, Maria Wong, Mark Jenkins, Martin Whatson, Martyn Reed, Maser, Matéo, Matt Wagner, Matthew A Eller, Mau Mau, M-city, Meggs, Meuh1246, Michael Fritz, Michał Lech, Michiel Gieben, Mobstr, Monika, Monkey Bird Crew, Mooncasket, Mr Jago, MTO, Mung Monster, Mural Festival, Naman Saraiya, Near, Neil James, NEVERCREW, Nick Walker, Nika Kramer, Noesgo, Norman Ross, Numskull, Nunca, Nychos, OG Slick, Okuda, OliveTruxi, Oliver Juric, Olivia Knapp, Olivier Varossieau, Ouizi, Pablo Peluz, Pascaline Mazac, Pat Perry, Patrick Collins, Patrick Cummins, Patrycja Podkościelny, Patryk Hardziej, Paul Riedmüller, Pavlos Tsakonos, Paweł Ryżko, Peeta, PERKUP, Peter Vahan, Pez, Phlegm, Phoebe Piku, Pierre-Alain Benoît, Pietro Truba, Pixel Pancho, Plaster, POW! WOW!, Quentin Hugard, Rafał Kołsut, Rakesh Kumar Memrot, Rebecca Eggleston, Remington Andersson, Remi Rough, Rhea Fernandez, Rhianna Pezzaniti, Ricky Lee Gordon, Risk, Robert Montgomery, ROIDS, Rone, Rowan Pybus, Ruben Sanchez, RUIN, Rustam Qbic, Ryck, Sainer, Sal Rodriguez, Scott Goldberg, Sébastien Dupuy, Senkoe, Sergio Hidalgo, Seth Globepainter, Shepard Fairey, Simon John Cooper Cole, Sites Unseen, Sixe Parades, Sket One, Skount, Snek, Sonny Boy, Spaik, SpY, St+art Festival, Stan Wu, Stash Maleski, Stephen Hayles, Stephen Thompson, Steve More, Steve Powers, Stinkfish, SupaKitch, Sybille Prou, Telmo & Miel, The London Police, Traffic Design, Tristan Eaton, Tyrsa, Upfest, urbanpresents.net, Veks van Hillik, Vestalia Chilton, Vhils, Victor Ash, Viet Nguyen, Wailok, Wild Drawing, Will Barras, William Murphy, Word to Mother, Xenz, YASH, Yasha Young, Yen Chung, Yesbee, Yoshi47, Yoshinobu Tatewaki, Zacharias Dimitriadis, Zed1, Zids, Zigor Cavero

221

Index

222

Published in April 2017 by Lonely Planet Global Limited
CRN 554153
www.lonelyplanet.com
ISBN 978 1 7865 7757 3
© Lonely Planet 2016
Printed in China
10 9 8 7 6 5 4 3 2 1

Managing Director, Publishing Piers Pickard
Associate Publisher and Commissioning Editor Robin Barton
Art Direction Daniel Di Paolo
Layout Hayley Warnham
Editors Samantha Forge, Nick Mee
Cartography Wayne Murphy, Gabe Lindquist
Print Production Larissa Frost, Nigel Longuet

Cities compiled and introduced by Ed Bartlett

With: Abigail Blasi (Copenhagen, Rome), Adam Skolnick (Los Angeles), Alexis Averbuck (Athens), Alison Bing (San Francisco, including introduction), Andrea Schulte-Peevers (Berlin), Anita Isalska (Kyiv), Anja Mutic (Lisbon), Brandon Presser (New York), Bridget Gleeson (Mexico City), Carolyn Heller (Toronto), Etain O'Carroll (Dublin & Reykjavik), Georgina Wilson (Miami), Isabel Albiston (Buenos Aires), James Bainbridge (Johannesburg), Karla Zimmerman (Amsterdam & Chicago), Kevin Raub (São Paulo), Nicola Williams (Paris), Oliver Berry (London), Sally Davies (Barcelona), Simon Richmond (George Town. including introduction), Tasmin Waby (Adelaide, Christchurch, Melbourne), Virginia Maxwell (Istanbul)

Cover images

Top row (l–r, first appearance only): Artist: Nunca, Photo: Minhal Biezynski; Artist: Jen Stark, Photo: Peter Vahan; Artist: Invader, Photo: Invader; Artist: Guido van Helten, Photo: Guido van Helten; Artist: Herakut, Photo: Herakut. **Second row (l–r, first appearance only):** Artist: Augustine Kofie, Photo: Augustine Kofie; Artist: Remi Rough, Photo: urbanrepresents.net; Artist: Jesse Harris, Photo: Jesse Harris and Cooper Cole; Artist: M-City, Photo: M-City; Artist: Invader, Photo: Invader; Artist: Nick Walker, Photo: Matthew A Eller. **Third row (l–r, first appearance only):** Artist: EINE, Photo: Fredrik Akerberg; Artist: D*Face, Photo: @birdmanphotos; Artist: Blek Le Rat, Photo: Sybille Prou; Artist: Okuda, Photo: Cheung Chi Wai; Artist: Faith47, Photo: Faith47; Artist: Cranio, Photo: Cranio. **Fourth row (l–r, first appearance only):** Artist: Telmo Miel, Photo: Telmo Miel; Artist: Kenor, Photo: Kenor. **Fifth row (l–r, first appearance only):** Artist: Phlegm, Photo: Bewley Shaylor; Artist: Faile, Photo: Faile. **Sixth row (l–r, first appearance only):** Artist: Fintan Magee, Photo: Ian Cox; Artist: Ella & Pitr, Photo: Ella & Pitr.

We have tried to contact all copyright owners and credit every artist featured in this book. If you wish to contact us about a work that appears in this book, please go to lonelyplanet.com/contact and use the Guidebook Feedback form to get in touch.

STAY IN TOUCH lonelyplanet.com/contact

AUSTRALIA
The Malt Store, Level 3, 551 Swanston St,
Carlton, Victoria 3053 T: 03 8379 8000

USA
124 Linden St, Oakland, CA 94607
T: 510 250 6400

IRELAND
Unit E, Digital Court, The Digital Hub,
Rainsford St, Dublin 8

UNITED KINGDOM
240 Blackfriars Road, London SE1 8NW
T: 020 3771 5100

ISBN 978-1-78657-757-3

MIX
Paper from responsible sources
FSC™ C021741

Paper in this book is certified against the Forest Stewardship Council™ standards. FSC™ promotes environmentally responsible, socially beneficial and economically viable management of the world's forests.